FRANCIS DANBY

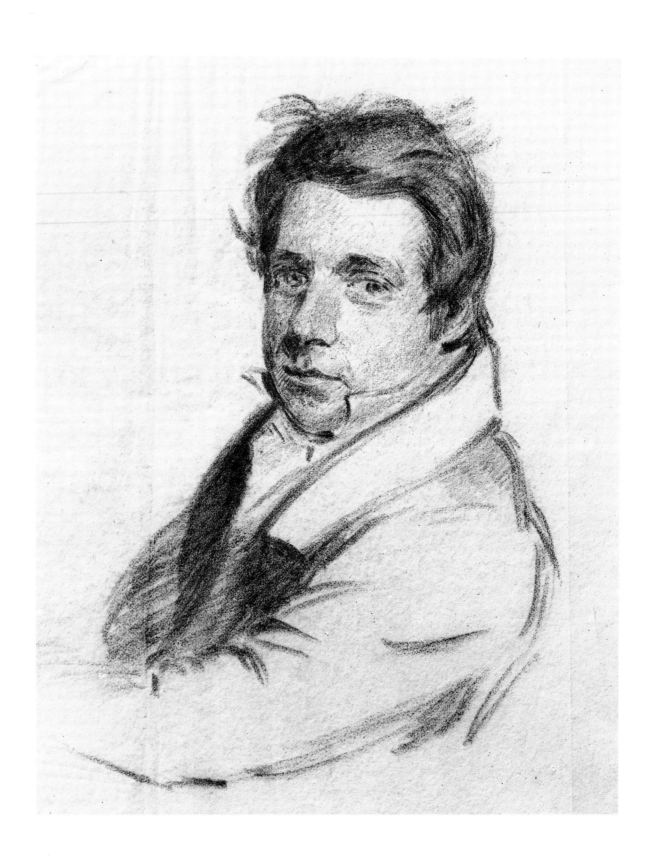

FRANCIS GREENACRE

Francis Danby

1793-1861

THE TATE GALLERY

in association with the

CITY OF BRISTOL MUSEUM AND ART GALLERY

cover
Clifton Rocks from Rownham Fields (detail)
*c.*1821 (cat.no.8)

frontispiece
Portrait of Francis Danby *c.*1825
from a lost drawing by N. C. Branwhite
(cat.no.143)

ISBN 1 85437 000 6
Copyright © 1988 The Tate Gallery and
City of Bristol Museum and Art Gallery
Printed by Balding + Mansell UK Limited
Designed and published by Tate Gallery Publications,
Millbank, London SW1P 4RG in association with the City of
Bristol Museum and Art Gallery, Queen's Road, Bristol BS8 1RL
Published by order of the Trustees 1988
on the occasion of the exhibition at the
City of Bristol Museum and Art Gallery: 5 November 1988–22 January 1989
and at the Tate Gallery: 15 February–9 April 1989

Contents

Foreword

Forty years ago the late Geoffrey Grigson wrote that 'the canon of English painting needs some stiff and sensitive revision; and Francis Danby is one man with whom such a revision might begin'. The first exhibition of Danby's work in 1961 commemorated the centenary of his death. However, the attribution of perhaps a quarter of the works exhibited then has since been questioned, evidence of the considerable problems surrounding Danby's rehabilitation. In 1969, Eric Adams, the principal architect of this process, completed his doctoral thesis on Danby, and his book *Francis Danby: Varieties of Poetic Landscape*, was published in 1973. In the same year Francis Greenacre's large exhibition *The Bristol School of Artists: Francis Danby and Painting in Bristol 1810–1840*, took full advantage of Dr Adams' research and, for the first time, effectively demonstrated the achievement and coherence of the Bristol School.

The advance of Danby's reputation since 1973 has come in great part from the remarkable number of his paintings and drawings which have been rediscovered and which have appeared on the market. Without the perspicacity and tenacity of Andrew Wyld of Thos Agnew & Sons Ltd, David Dallas, Roy Davis of Davis & Langdale Company Inc., New York, and Anthony Spink of Spink & Son Ltd, many of the works in this exhibition would still be unknown and, without their active support, many others would have been unavailable for loan.

It is a measure of the special interest of the many owners, both public and private, who were approached, that all have agreed to lend. We are extremely grateful to them and hope that as a result of their generosity a very large number of people will be able to share their enthusiasm.

Many works have been restored, reframed or remounted in anticipation of the exhibition and we are indebted to many owners for their co-operation in this respect. There were problems with the condition of Danby's paintings in his own time and his fascination with dark tones has led to the loss of several important works. The Conservation Department of the Victoria and Albert Museum has most patiently brought the 'Upas Tree' back to life thus enabling the earliest painting that Danby exhibited in London to be displayed for the first time in a hundred years.

The exhibition has been selected and catalogued by Francis Greenacre, Curator of Fine Art at the City of Bristol Museum and Art Gallery. He is greatly indebted to Dr Eric Adams for his pioneering study and to Mrs Edward Gibbons who has made available to him the correspondence between Francis Danby and his patron John Gibbons which brings such colour and detail to the greater part of Danby's career. We are most grateful to him and to all his colleagues at the City of Bristol Museum and Art Gallery for their part in the preparation and organisation of this exhibition.

Nicholas Serota *Director*

Introduction

Ireland

From the vantage point of his Genevan retreat, Danby looked back on his childhood in Ireland and claimed that 'Ireland to me is a desert without an interest'.[1] He suspected, however, that were he still there he would be a rebel,[2] and recalled a childhood 'filled by fear, distress and bloodshed'.[3]

The Danby family had been established in the parish of Killinick just south of Wexford since at least the 1730s.[4] Francis, when being tempted by an amateur genealogist in Geneva to believe that he might be the heir to the title and estates of the Earls of Danby, recalled a coat of arms in his home and remembered his father saying that the family came originally from Yorkshire.[5] He described his father as a 'country gentleman',[6] and other early references, probably more accurately, called him a 'small landed proprietor',[7] and 'a gentleman of moderate fortune'.[8]

Francis, a twin son of James Danby's second marriage[9] was born at Common, Killinick, on 16 November 1793,[10] five years before the Wexford Rebellion, the most successful and the bitterest of the bloody insurrections of 1798: 'My family like many others were destroyed by political and party feeling, many of them lost their lives on both sides of the unhappy question'.[11] James Danby moved his family into Wexford where in 1799 he prefaced his will with the words: 'Having lately escaped assassination and being convinced of the savage disposition of the majority of the people, [I] am more than ever reminded of the uncertainty of life'.[12] Later in the same year the family moved on to Dublin,[13] the native city of Danby's mother.

In 1807 Danby's father died, and most of whatever of the 'small fortune' that remained was left to the children of his first wife.[14] Danby, himself, was left 'unprovided for'[15] and his mother only gave in reluctantly to his wish to be a professional artist 'when he had reached his nineteenth year and had no very flattering prospects of advancement in any other profession'.[16]

Danby attended the drawing schools of the Dublin Society, but for how long is unknown.[17] It was here that he befriended two other landscape painters, George Petrie (1790–1866) and James Arthur O'Connor (1792–1841).[18] Early in 1813 Danby had his first painting, 'Landscape – Evening', exhibited at the Society of Artists of Ireland.[19] It sold to Archdeacon Hill for 15 guineas 'and with the proceeds of the sale, the young artist came at once to London to see what Art was doing in the great metropolis',[20] together with his two friends. Their principal goal was the Royal Academy's exhibition, 'with the wonders of which', Danby is reported to have said, 'I was so struck, that they increased my ambition, and from my twentieth year I have been *an English Artist*'.[21] There is no evidence that Danby ever returned to his native country, and he was never to admit to any affection for it.

The same article in the *Art Journal* which quoted Danby's claim to be an English artist also suggested that his 'beautiful imaginings and rich poetic feeling' were typical reflections of the Irish genius. Eric Adams justly dismissed this theory,[22] but also

allowed no Irish influence of any kind. The parallel evolution of O'Connor's work is now clearer and suggests otherwise.[23]

After O'Connor's return to Ireland, there is no reason to believe that he and Danby met again until 1822 when O'Connor visited Bristol and sketched the Avon Gorge.[24] He would probably have seen Danby's 'View of the Avon Gorge' (cat.no.10, col.pl.4), dated 1822. The combination of strong colours and polished finish and the careful observation, clarity of detail and, especially, the very contemporary figures enjoying a domesticated landscape, have very few obvious parallels in English painting of the time. Art historians have been tempted to look to the Continent for evidence of the influence of such artists as Jacques Laurent Agasse (1767–1849) or Caspar David Friedrich (1774–1840).[25] But these stylistic characteristics can also be found in O'Connor's series of paintings of Ballinrobe House and estate of about 1818 (National Gallery of Ireland).[26] These may be more prosaic and less intimate, and lack the individuality of mood of Danby's painting, but they are also more obviously in the tradition of the later eighteenth-century Irish country house portraits and landscapes of Thomas Roberts (1748–1778) and William Ashford (c.1746–1824). Danby's early Irish topographical drawings (cat.nos.61–3, col.pl.21) confirm that he had begun his career within this tradition – one of the most underrated achievements of Irish art. There is also a division in the work of both Roberts and Ashford, between their Irish views and ideal landscapes, which was to have parallels in Danby's paintings. William Ashford, especially, might well have laid the foundations of Danby's life-long admiration for Claude Lorrain (1600–1682). Ireland, despite Danby's own disclaimer, exerted a profound influence upon him.

Early Years in Bristol

At the Royal Academy exhibition of 1813 Danby especially admired Turner's 'beautiful and wonderful picture of the "Frosty Morning"' (1813, Tate Gallery).[1] There are, however, no other recollections of London and it is likely that any immediate effects of the exhibition were soon stifled by the ready market for the often rather pedestrian products of Danby's first few years in Bristol (fig.1).

After a few weeks, Petrie was summoned home from London by his father. O'Connor and Danby were now 'almost penniless' and walked the 120 miles to Bristol,[2] where they hoped to catch a sailing packet, whose captain they knew and who would give them free passage to Cork.[3]

In Bristol, the two artists succeeded in selling two watercolours of the Wicklow Mountains to John Mintorn, a stationer and bookseller of College Green. The following morning Danby, O'Connor and Mintorn's son went sketching on the Downs above the Avon Gorge, and sold the four drawings, which Danby had coloured, to Mintorn.[4] 'But', wrote Danby many years later, 'I could only get enough to pay for the passage of one' and O'Connor, whose 'poor little sisters . . . were orphans and depended on him' was given the ticket.[5]

John Mintorn Jr was to imply that it was Danby's realisation of the pictorial possibilities of the area, and the discovery that there was a market for his landscape drawings, which encouraged him to remain,[6] but a further fortuitous sequence of events also played a part. On their arrival in Bristol, Danby and O'Connor took lodgings at a

baker's shop on Redcliffe Hill. The landlord, named Fry, lived in Somerset, probably at Winscombe,[7] and invited Danby to paint family portraits in considerable numbers. It was while staying at the home of the Fry's son, a few miles away, that Danby fell in love:

> I was invited down to Somersetshire to paint some portraits amongst the farmers and drank cider. I took a great fancy to one of their servants, a little red-faced bare-footed wench, my Irish brogue I suppose was against me, I could not succeed however in any way but by promising to marry her. She, on the word of a young gentleman who was confoundedly out at the elbows, willingly consented to come with me to Bristol.[8]

The ensuing marriage took place on 4 July 1814 at Winscombe parish church. It was a year since Danby had arrived in Bristol and he was now aged twenty. Danby is described as 'of this parish' in the register which also records his bride's illiteracy for she marked her name with a cross.[9] He was later to imply that Hannah was pregnant at the time of the marriage and that he married her out of kindness.[10] More reliable is his grim statement that the marriage 'resulted in a precarious and unhappy life'.[11]

Danby's two elder sons were baptised at Compton Bishop, a village near Winscombe, in 1815 and 1817.[12] 1817 was the year that Danby was first listed in the Bristol Directories, living in Kingsdown above Bristol,[13] and it is possible that much of the first two or three years after his arrival in 1813 was spent with his wife's family in Somerset. The slight and repetitive character of several of his earliest watercolour views of the Avon Gorge, often with considerable disparity of scale (fig.1), is sometimes poor in comparison with his previous Irish watercolours (cat.nos.61–3, col.pl.21) and suggests, that Danby was out of touch with his fellow artists and, at first, seldom in Bristol.

From 1817 Danby was unquestionably resident in Bristol but until 1820 his stylistic development is a matter of guesswork. In January 1820 the 'Upas Tree' (cat.no.18), his

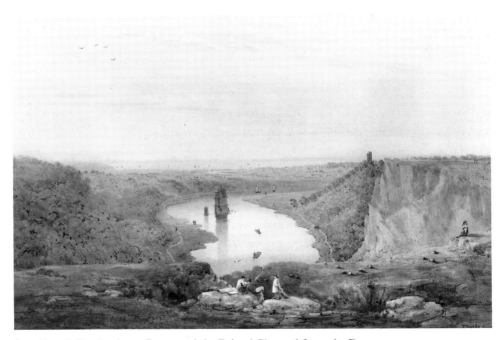

fig.1 Francis Danby, **Avon Gorge and the Bristol Channel from the Downs**
c.1815, watercolour, $10\frac{1}{2} \times 16\frac{3}{4}$ (267 × 425), whereabouts unknown

first oil painting to be shown in London, was exhibited at the British Institution and in the same month there is the earliest reference to Danby in the correspondence between George Cumberland in Bristol and his son in London.[14] From 1820 also, come both the earliest of his dated watercolours (cat.no.72, col.pl.24) and drawings (cat.no.77). The 'Upas Tree' was presumably largely painted in 1819 and it reflects the influence of the artists and amateur artists then in Bristol with whom Danby had by now become acquainted.

The Artists

In 1839 Dr John King recalled the emergence of the Bristol School, conscious that he had witnessed the evolution of something both distinctive and remarkable:

> About 40 years ago the late Edw. Bird was the only artist of talent in this city. It was here that his genius developed itself with rapid strides; his society soon became the centre of attraction to all those who had enough of good taste to appreciate his works, . . . Thus was spontaneously framed a small society of art-loving friends, from which all that Bristol now can boast of artists and amateurs has descended. One of his earliest friends and pupils was the Rev. John Eagles . . . Several other accomplished amateurs united with these in their social intercourse, and instituted periodical meetings at each member's houses, in rotation, for the purpose of sketching and conversation; these were occasionally diversified by excursions for sketching from nature in the country . . . two brothers, the late ever-lamented Francis and Henry Gold, the former an excellent, though not professional, landscape painter, were among the earliest members of this very interesting society. Several other members were more or less distinguished . . . Several professed artists, two among them who are now flourishing abroad . . . found much pleasure and advantage by contributing their share to the enjoyment and improvement of this private academy. These are E. V. Rippingille and Francis Danby, both derived from its meetings a wider and a more rapid expansion of their powers. The latter, animated by the example of F. Gold, shortly relinquished a tame style and homely scenes for daring and successful flights into the regions of imagination and poetry . . . He may be properly called the father of the present school of Bristolian landscape painters.[1]

The principal professional artists in Bristol in 1819 were Edward Bird R A (1772–1819), Nathan Cooper Branwhite (1775–1857), Edward Villiers Rippingille (1798–1859) and Samuel Colman (1780–1845). There were other minor or more peripatetic artists such as George Holmes (1776–c.1861)[2] the only other resident supplier, besides Danby, of picturesque drawings of the Avon Gorge. He was not a serious rival, however, and, as Eagles wrote, he:

> Should twenty years ago have tried
> His hand at something else beside.[3]

Of infinitely greater importance was Edward Bird, about whom the 'small society of art-loving friends' first formed. He had begun his career as a painter of tea-trays and had

come to Bristol from Wolverhampton in about 1794.[4] He became Historical Painter to Princess Charlotte, and in 1815 was elected an R A. Danby is unlikely to have had much personal contact with him, for although Bird lived nearby in Kingsdown, he died in November 1819 after a long and incapacitating illness. A large memorial exhibition was organised by his friends early in 1820. For many years he had provided a focus for those interested in the arts and he also first established that national success could come to a Bristol artist, thus heightening the ambitions of many of the artists of the next generation.

His election to the Royal Academy followed upon the success of his historical paintings (fig.2), but in Bristol it was his genre paintings which sold and which E. V. Rippingille at first so successfully imitated. Rippingille had come to Bristol from King's Lynn by 1817.[5] In 1819 he had a great success at the Royal Academy with 'The Post Office', which George Cumberland reported to be, 'full of humour and will crop his teacher's laurels'.[6] Rippingille, 'a rattling sort of odd fellow, with a desire to be thought one' as his friend, John Clare the Northamptonshire peasant poet, called him,[7] had the ability to succeed Edward Bird but his procrastination, exotic social life and multifarious interests interfered endlessly with his painting. He was to acquire John Gibbons' patronage earlier than Danby and 'The Stage-Coach Breakfast' (fig.3) with its portraits of William Wordsworth and his sister Dorothy, Samuel Taylor Coleridge and Robert Southey, and of their Bristol publisher, Joseph Cottle, is a delightful record of Bristol's remarkable literary associations around 1800. It was to be exhibited in Bristol together with Danby's 'Sunset at Sea after a Storm' (cat.no.20, col.pl.8) in 1824 before going on to the Royal Academy. At this moment the two artists enjoyed similar reputations in Bristol and, as Danby later recalled, they 'were as intimate as brothers for years'.[8]

Both Bird and Rippingille influenced Danby's painting, but N. C. Branwhite and Samuel Colman are here of more interest for what their lives and work can tell us of the arts in Bristol at this time. Branwhite had come to the city by 1810 when he was already in his mid-thirties. Only towards 1820 did he develop into an outstanding provincial portraitist in watercolour on ivory, in wash and in pencil. He joined in the excursions to Leigh Woods[9] and he was to be a mainstay of the evening sketching meetings.[10] Together with Rippingille and also Samuel Jackson, James Johnson and the artist John

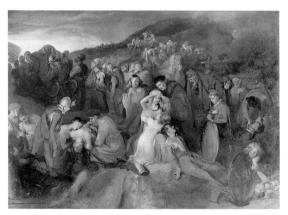

fig.2 Edward Bird, **Study for the Day after the Battle of Chevy Chase** 1811, oil on panel, 26½ × 37⅛ (673 × 942), Wolverhampton Art Gallery

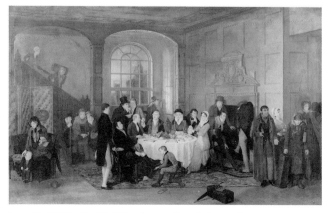

fig.3 E. V. Rippingille, **The Stage-Coach Breakfast** 1824, oil on panel, 32⅜ × 52⅝ (822 × 1340), The National Trust

King (1788–1847) he helped to organise the first exhibition of the work of Bristol artists in the winter of 1824–5[11] and he kept in touch with Danby after Danby had moved to London.[12] He well demonstrates the social cohesion of the Bristol artists in the early 1820s.

Samuel Colman,[13] on the other hand, appears to have had almost no social contact with his fellow Bristol artists. However, after his move to Bristol in about 1816, his painting was steadily transformed from the most meagre provincialism by the inspiration he found in the work of Bird, Rippingille and Danby and in the apocalyptic prints of John Martin (1789–1854). He was the only artist of the period who consistently expressed his nonconformist faith in his paintings. His earliest ambitious work 'St. John Preaching in the Wilderness' (City of Bristol Museum and Art Gallery) was exhibited in Bristol in the summer of 1821 complete with an explanatory pamphlet but it was justly criticised in the local press. His next major work, 'St. James's Fair, Bristol' of 1824 (City of Bristol Museum and Art Gallery) was certainly influenced by both Bird and Rippingille and its much increased quality is a further reminder of the peculiar strength and confidence in the fine arts in Bristol at this moment.

Samuel Jackson (1794–1869) and James Johnson (1803–1834) worked closely with Danby in 1823 on a folio of lithographs (cat.no.130) and their friendship and evident admiration for his work were no doubt useful encouragement but they had no effect on the direction of Danby's art.

There is one artist who visited Bristol only briefly but who may well have made a lasting impression on Danby. The American artist, Washington Allston (1779–1843) first came to Bristol in the summer of 1813 at much the same moment as Francis Danby.[14] Encouraged by Samuel Taylor Coleridge, he came for treatment by Dr John King to whom he had been given an introduction by the Bristol-born poet Robert Southey. Allston returned again in 1814 and held an exhibition of eleven paintings in the Merchant Tailors' Hall. The exhibition included a gigantic biblical scene of thirteen by ten feet, a humorous genre scene in the manner of Edward Bird, Italianate landscapes, one of which Dr King owned, portraits of both King and Coleridge and 'Rising of a Thunderstorm at Sea' (fig.4) which could well have influenced the conception of 'Sunset at Sea after a Storm'. Allston's later painting, 'Elijah in the Desert' (Museum of

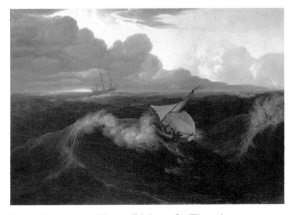

fig.4 Washington Allston, **Rising of a Thunderstorm at Sea** 1804 (exhibited in Bristol 1814), oil on canvas, $38\frac{1}{2} \times 51$ (977 × 1295), Museum of Fine Arts, Boston, USA

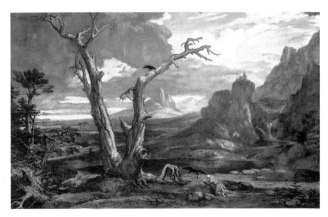

fig.5 Washington Allston, **Elijah in the Desert** BI 1818, oil on canvas, $48\frac{3}{4} \times 72\frac{1}{2}$ (1238 × 1844), Museum of Fine Arts, Boston, USA

Fine Arts, Boston, fig.5) was exhibited at the British Institution in 1818. It has some similarities with Danby's first important exhibition piece, the 'Upas Tree' (cat.no.18) shown at the British Institution two years later.

The Amateurs

George Cumberland, in his obituary notice for Edward Bird, wrote: 'for some years he was the centre of a society assembled to make drawings in the evening before supper, where the greater number of members were amateurs . . .'.[1] Cumberland, Revd John Eagles, Dr John King and Francis Gold were the principal amateur artists. Together, they provided Danby with a remarkably broad range of sophisticated interests, knowledge and, especially, contacts.

The senior of the amateurs was George Cumberland (1754–1848). He had retired to Bristol in his fifties in the very early years of the century. He had lived in Italy, written extensively on art and was both a friend and patron of William Blake (1757–1827). Patronage by purchase was now beyond his means but he took much trouble helping Bristol artists through friends and acquaintances in London, particularly Sir Thomas Lawrence (1769–1830), the Royal Academy's President, the artist Thomas Stothard (1755–1834) and Sir Charles Long, later to become Lord Farnborough, and the principal power behind the British Institution. It was, for example, typical of Cumberland to write to a friend seeking 'a good place' at the British Institution for the 'Upas Tree' (cat.no.18).[2]

Cumberland's Bristol watercolours (fig.6) are almost all small landscape studies, which in their direct and determinedly unpicturesque observation of nature come impressively close to John Linnell's small sketch-book watercolours of around 1814.

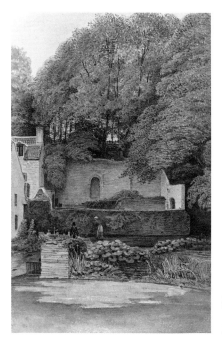

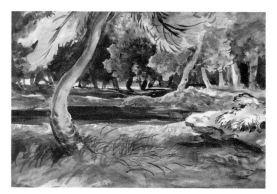

fig.7 Revd John Eagles, **Woodland Pool** c.1820, $12\frac{5}{8} \times 17$ (320 × 432), City of Bristol Museum and Art Gallery

fig.6 George Cumberland, **First Mill at Stapleton** 1822, watercolour, $9\frac{3}{4} \times 6$ (248 × 152), City of Bristol Museum and Art Gallery

There is no evidence that Linnell and Cumberland knew one another until 1818 when Cumberland's son reported that Linnell was very anxious to possess one of his father's sketches.[3] These watercolours are the opposite of John Eagles' broad watercolour and wash drawings of imaginary landscapes which Cumberland specifically entreated his son not to imitate[4] (fig.7).

From 1812 to 1822 the Reverend John Eagles (1783–1855) was curate at St. Nicholas', Bristol, before moving to Halberton in Devon.[5] He was much more than the typical amateur artist in holy orders that he might appear to have been, unsuccessfully pursuing membership of the Water-Colour Society and sending his oil paintings with their highly original but disastrously faulty technique to the Royal Academy. His conservative politics were no hindrance to a close friendship with such a radical, disbelieving and womanising artist as Rippingille and he was undoubtedly good company himself.[6] It was, perhaps, largely Eagles' enthusiasm that provided the impetus for the evening sketching meetings and, more especially, for the excursions to Leigh Woods, about which he was to write with such nostalgia in his articles for *Blackwood's Edinburgh Magazine* between 1833 and 1835.[7] His writing is quoted extensively in the following catalogue entries and although almost all his published articles date from after Danby had left Bristol, there was no significant development in his theories upon art. Central to his attitude was the idea of landscape painting as a form of escapism:

> Gentle sketcher, when you take your portfolio among the mountains, into the woods and wilds, you must learn so to half-shut your eyes, like Gaspar, that you may have the power to reject; then set your imagination free, cut the strings of tight-laced formality, and walk elastic as if you had just taken a salad of nepenthe.[8]

Landscape, he argued, 'should be a poetical shelter from the world' depicting 'the "debatable land" that lies between Fairy Land and the cold working world'.[9] Gaspard Dughet, known as Gaspar Poussin (1615–1675), was his ideal, and Eagles would certainly have ensured that Francis Danby was acquainted with the outstanding examples of Gaspard's work in the Miles collection at Leigh Court just outside Bristol.[10]

If Eagles aspired to be a professional artist, the third of the amateurs had actually been one. John King (1766–1846) had been born Johann Koenig in Berne.[11] Rejecting a career in the church he had turned to physics and the arts, and worked as an engraver in London in the early 1790s. As his nephew, the poet, Thomas Lovell Beddoes, explained: 'This failed, and . . . he took to surgery and came to Bristol, in the democratic dawn of Southey, Coleridge, etc. To the former he was closely attached, corresponded and hexameterized with him – made acquaintance with Davy, the opium-eater [Thomas De Quincey], my father [Dr Thomas Beddoes], and all that was then'.[12]

King had arrived in Bristol by 1799 and had worked with Beddoes and Humphry Davy at the Pneumatic Institute in Dowry Square. He married Emmeline Edgeworth, the sister of the novelist Maria Edgeworth. As we have seen, it was King who treated Washington Allston in 1813 and 1814 and he was also a close friend of Edward Bird R A.[13] But he was much more than a link with the past. He was an ardent supporter of the sketching excursions to Leigh Woods and of the evening sketching meetings. His letters to Danby's patron, John Gibbons, between 1822 and 1836, provide a fascinating portrait of Bristol's artistic life and particularly of the exasperating Rippingille, as well as an intriguing account of Danby in Geneva, where King visited him in 1834.

In Danby's own surviving letters to his patron there is no acknowledgement of debt to any of the Bristol artists or amateurs excepting to the surgeon Francis Gold (1779–1832), whom Danby called 'a man of great genius'.[14] Gold's forceful description of Géricault's 'Raft of the "Medusa"' (1819) undoubtedly inspired Danby, and 'Sunset at Sea after a Storm' (cat.no.20, col.pl.8), and ultimately 'The Deluge' itself (cat.no.40) may have been, in part, prompted by him. While Danby was working on the 'Upas Tree' Gold, too, was working on his first very large exhibition painting 'Hagar in the Desert', intending to send it to the British Institution at the same time.[15] But by May 1820 he had given up art altogether and, instead, he entered the service of the East India Company and went out to India where he died.[16] Rippingille, King and Eagles all also recorded their great admiration for Gold[17] and although his few surviving works are not outstanding he was clearly a particular inspiration to his friends.[18]

Leigh Woods and Nightingale Valley

In the summer of 1828 when Danby was enjoying a moment of extraordinary success in London, Dr John King wrote from Bristol to John Gibbons, Danby's patron:

> By the by, Eagles said to me the other day in Leigh Woods, where we strolled with Cumberland, Rip, Johnson and Branwhite: 'I wonder whether Danby is conscious that he could never have become what he now is if he had not had the luck to fall into the society of you and the Golds and myself . . .'.[1]

This image of the artists and amateurs amiably enjoying Leigh Woods is brought vividly to life in Danby's paintings (cat.nos.9–11, col.pls.3–5). He was himself to acknowledge that an artist's sensibilities might best be judged by his reactions to the woods: 'I know Jackson is a man of genius by being with him in Leigh Woods'.[2] And he passed judgement on the young artist Paul Falconer Poole (1807–1879) after spending 'a day in Leigh Woods with him which is an excellent place for painters to become acquainted'.[3]

Access to Leigh Woods, which are along the south side of the Avon Gorge opposite Clifton, is today easily made by the Clifton Suspension Bridge. Danby would have crossed the Avon by Rownham Ferry and then walked along the tow path before ascending Nightingale Valley. The woods were little frequented and Eagles wrote that 'you might have passed days in them, and not heard the step of human foot'.[4] Eagles preferred to visit with friends but Cumberland often went alone:

> . . . I rose at 5 o'clock and set off alone for a walk to avoid the great heats . . . I crossed the ferry, wound up the happy valley reading Dante's Paradiso, and setting down at each shady tree, it was then 7 o'clock and the rabbits ran about me like tame ones.[5]

Eagles, however, does make it clear that the delights of Nightingale Valley were not the exclusive property of the artists and amateurs. Recalling a day in the woods with Branwhite, Rippingille, Gold, Cumberland, King and Revd John Eden, Eagles describes the alacrity with which Rippingille was tempted from the party by the appearance of three ladies and the celebrated guitar player, Mr Schultz.[6]

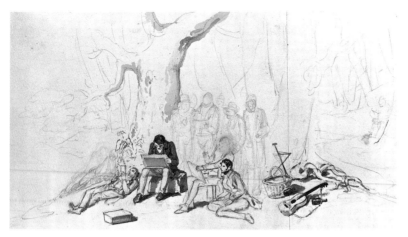

fig.8 E. V. Rippingille, **A Sketching Party in Leigh
Woods** *c*.1825, sepia wash and pencil, $6\frac{7}{8} \times 10\frac{7}{8}$ (174 × 276),
City of Bristol Museum and Art Gallery

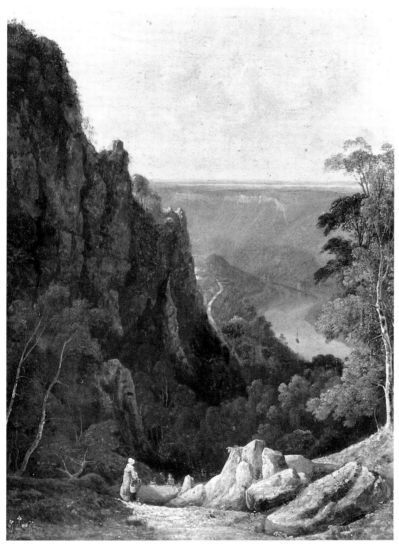

fig.9 Francis Danby, **View down the Wye Valley** *c*.1818,
oil on panel, $13\frac{1}{16} \times 9\frac{11}{16}$ (331 × 246), Yale Center for British Art,
Paul Mellon Collection

It is possible that Rippingille's drawing of 'A Sketching Party in Leigh Woods' (fig.8) is not a record of an actual visit but the first thoughts for a painting similar in concept to 'The Stage-Coach Breakfast' (fig.3). In place of the literary giants associated with Bristol, he would paint the artists, amateurs and patrons of the Bristol School gathered in Leigh Woods.

When Danby arrived in Bristol in 1813, Eagles and Cumberland were probably already often sketching together in Leigh Woods.[7] However, for perhaps the next five years Danby concentrated on panoramic views from the Downs or dramatic vistas up and down the Gorge. He was slow to return to oil painting, and the earliest oils from the Bristol years are unlikely to date from before 1818. The small painting, 'View down the Wye Valley'[8] (fig.9), of about 1818 well illustrates Danby's initial concern for the dramatic and picturesque possibilities of the landscape. But already the composition reflects his knowledge of the paintings by Gaspard Dughet at Leigh Court.[9] The development and diversification of Danby's art that follow his entry into the society of the artists and amateurs in 1818 or early 1819 are remarkable. He began a series of ambitious and demanding works for the London exhibitions, first showing the 'Upas Tree' (cat.no.18) at the British Institution in January 1820. He quickly responded to the more intimate and enclosed landscape of Leigh Woods. When he repeated the more traditional views along the Avon or from the Downs above the Avon Gorge, the subtle effects of sunset or twilight evoked a contemplative mood that easily dominates the topographical record.

Stapleton

Danby's paintings inspired by scenes along the river Frome at Stapleton form an unusually coherent group and were perhaps all painted between 1820 and 1823. At Stapleton the small river runs between steeply wooded banks and in Danby's time weirs and decaying snuff-mills turned the river into a succession of quiet pools. Today only one mill remains, but kingfishers and dippers still suggest the seclusion of this narrow valley now well within the boundaries of the City of Bristol.

Many artists had visited Stapleton for the purpose of sketching. There were, for example, three views on the river at Stapleton in Edward Bird's memorial exhibition in 1820[1] and it was said that Rippingille 'first began to paint in oil from nature at Stapleton'; this was probably in about 1817.[2]

Danby's Stapleton landscapes (cat.nos.12–16, col.pl.2 and fig.10) are strikingly varied and experimental in technique and composition but the mood of the paintings, the delight in the self-contained, innocent and contented world of childhood, is consistent. Danby may well have responded to the work of Edward Bird who so 'loved innocence for its own sake'[3] and especially to that of his close friend at this time, Rippingille, whose enthusiasm for childhood he particularly admired.[4] This enthusiasm is best expressed in Rippingille's letter to the poet John Clare, and although it was probably written a few months after Danby's move to London early in 1824, it reflects an intensity of feeling that was clearly shared by Danby. Rippingille begs the poet to come and see:

... bunches of the most luxuriant foliage hanging over a river bright as a diamond forming the darkest recesses and hollows of the richest colours, the brown earth mixing with the endless varieties of greens produced from reflections and from the sun shining thro' broad sheets of leaves: see crowds of little brats dabbling in the sparkling water and their rosy feet, shining and paddling about in the mirror of all these beautiful objects around them, their vacant joyful faces, their eyes, their hair, their hearty laugh open and free as the blue vault over their heads.[5]

After his début with the 'Upas Tree' (cat.no.18) which failed to sell at the British Institution in 1820, Danby turned to the Royal Academy, exhibiting 'Disappointed Love' (cat.no.19) in 1821 and 'Clearing up after a Shower' the following year. Both

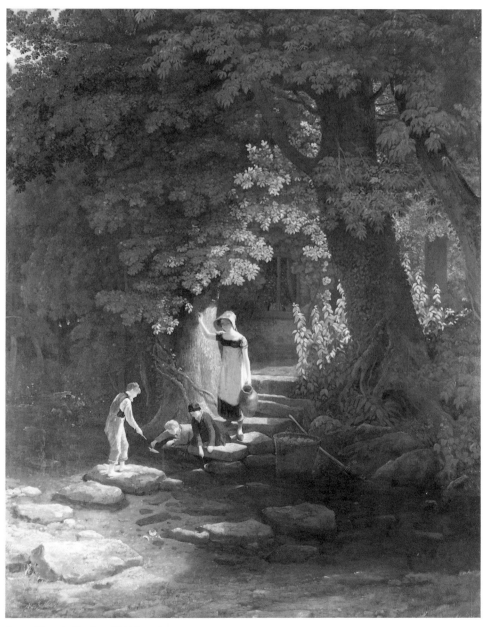

fig.10 Francis Danby, **Children by a Brook** *c*.1822, oil on panel, 29½ × 24½ (750 × 623), Yale Center for British Art, Paul Mellon Collection

paintings are closely related to the Stapleton series but, as Eric Adams observed, when 'he used local material for his exhibition pieces, he broadened its appeal by subordinating it to a sentimental interest'.[6] This was especially true of 'Clearing up after a Shower' which we only know from Richard Redgrave's enticing description. Beneath chestnut trees, 'their wetted leaves coming like emeralds off the dark cloud', children run out to play in the sunlight. A weary traveller looks on. 'The whole has a look of life, poetry and truth'.[7]

The figures, in particular, reminded Redgrave of the early works of both William Mulready and Rippingille. The scattered sunlight and backdrop of storm clouds are also to be seen in Mulready's 'The Farrier's Shop' (c.1811, Fitzwilliam Museum, Cambridge, fig.11). There are more obvious parallels between this painting and Danby's 'A Street in Tintern' (cat.no.4), and the stormy light effects are also seen in 'The Floating Harbour, Bristol' (cat.no.5). Here the group of workmen rather stiffly echoes the men in John Linnell's 'Kensington Gravel Pits' of 1813 (Tate Gallery).[8] All these paintings share strong contrasts of sunlight and dense shadows, together with a determined naturalism – almost a purposeful inelegance in subject matter, which is most confidently displayed in Danby's 'Clifton Rocks from Rownham Fields' (cat.no.8, col.pl.6).

William Mulready (1786–1863) and John Linnell (1792–1882) were close friends and George Cumberland, who first mentioned Mulready in 1817,[9] especially admired Linnell.[10] In 1819 he issued a typical admonishment to his son: 'stick to nature and Linnell'.[11] It is reasonable to presume that Cumberland encouraged Danby to visit Linnell in London and, around 1820, both Linnell and Mulready would have had many earlier unsold works in their studios. One such work might have been Linnell's 'The River Kennet, near Newbury' of 1815 (Fitzwilliam Museum, Cambridge, fig.12). It was to be retouched by the artist over fifty years later but it remains the closest parallel in English landscape painting to the most accomplished of Danby's oil-paintings of the Avon Gorge.

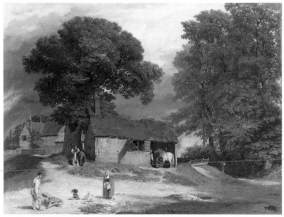

fig.11 William Mulready, **The Farrier's Shop** c.1811, oil on canvas, 16⅛ × 20½ (409 × 521), Fitzwilliam Museum, Cambridge

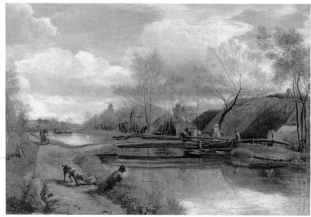

fig.12 John Linnell, **River Kennet, near Newbury** 1815, oil on canvas on panel, 17¾ × 25½ (451 × 648), Fitzwilliam Museum, Cambridge

Evening Meetings and Monochrome Drawings

As well as 'Disappointed Love' (cat.no.19) and 'Clearing up after a Shower', another of Danby's London exhibition paintings, 'An Enchanted Island' (cat.no.21, col.pl.9), exhibited at the British Institution in 1825, is also reminiscent of Stapleton in its landscape forms. In this instance Danby's response was close to that of Revd John Eagles. Eagles described the river at Stapleton as 'small, umbrageous, winding in a dell, and amid such rocks, that here jut out, show the grandeur of a cavern, and there retiring sweetly among foliage and shade, seem excavated into cells, where innocence might seek repose . . .'.[1] The accomplishment of 'An Enchanted Island' and the confidence of its fantasy owe little to Eagles' theories, however, and are instead indebted more to Danby's profound admiration for Claude Lorrain, his passion for the darker tones and his experience of the evening sketching meetings of the Bristol artists and amateurs. There is no doubt that these meetings, which had been first described by George Cumberland in 1819 in his essay on Edward Bird, were of considerable importance to Danby.[2]

Unlike the contemporary but more formally constituted Sketching Society in London, no theme or subject was set for the evening. Instead the artists usually drew imaginary landscapes in rich washes of sepia, inspired in part by the woods and valleys about Bristol.[3] We know that progressively more fantastic, even whimsical subject matter was employed, notably by William West (1801–1861) (fig.13), soon after Danby's departure from Bristol.[4] Because of the recent faking of Danby's signature and the removal of the signatures of other artists of the Bristol School (see cat.no.119) the attribution of these monochrome drawings is often particularly difficult. Eagles' only reference to Francis Danby in *The Sketcher* does however support the tenuous attribution to Danby of such fine drawings as the so-called 'Pagan Rites' (fig.14).[5] The subject of the sketch that Eagles recollects was 'the Fisherman of the Arabian Tales letting the Genie out of the vase'. The setting 'was a low shore, by an inlet of the sea, among sterile mountains', the whole faintly illuminated by a touch of magic light, 'a mere half-hour's work on a most happy conception, at an evening meeting of a few artists and amateurs, – a delightful and improving society . . .'.[6]

fig.13 William West, **The Cistern of Sultan Serai, Istanbul** watercolour, $7\frac{3}{4} \times 10\frac{3}{4}$ (195 × 275), City of Bristol Museum and Art Gallery

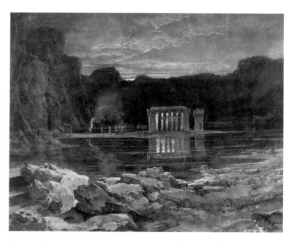

fig.14 Francis Danby, attributed to, **Pagan Rites** *c*.1823, monochrome wash drawing, $7\frac{11}{16} \times 9\frac{1}{8}$ (195 × 231), Smith College Museum of Art, Northampton, Massachusetts

Francis Danby was to remember these evenings with evident affection. In 1829 when he made a brief return visit to Bristol, he reported that he was very happy to have all his old friends about him once again and that there was a larger drawing party than there had been for some time.[7] Five years later when Dr John King visited him at Geneva, he wrote nostalgically that the sound of King's voice had suggested that he might, at any moment, 'expect to hear his invitation to the drawing party on the morrow'.[8]

Patrons in Bristol

When E. V. Rippingille wrote of a Bristol sketching society 'for the express association of the patron, the amateur, and the artist',[1] he was almost certainly thinking in particular of John Gibbons. Before he left Bristol in about 1822 Gibbons had attended some of the drawing parties[2] and throughout his life he preferred to deal directly and personally with the artists whose works he commissioned. He gave Rippingille crucial support during the 1820s and much of the 1830s. With Danby he was in nearly constant correspondence from 1825 until his death in 1851 when Danby lamented the loss of his patron 'who has patiently and effectually sustained me for nearly 30 years, against every difficulty and enmity, . . . whose generous and liberal hand was ever open to me . . .'.[3] Although Gibbons' patronage probably began with a commission, 'A Street in Tintern' (cat.no.4), most of his earlier purchases were acquired, in effect, in default of the repayment of loans. His reluctant acquisition of 'Christ Walking on the Sea' (Forbes Collection, London, fig.17), which Danby showed at the Royal Academy in 1826, is a typical example.[4] Gibbons acted as the most benevolent of bankers, listening, advising, hoping for a return but never directing or threatening his friend. His list of advances, payments and loans to Danby from 1825 to 1829 looks more like a statement of a quarterly allowance and in 1830, when Danby fled to the Continent with his mistress and children amid much scandal, Gibbons sent him a survival allowance of £10 every five weeks.[5]

After collecting paintings by several Bristol artists in the 1820s, Gibbons commissioned or purchased works by many major contemporary British artists in the 1830s and especially in the 1840s.[6] He remained loyal to Danby however, writing to William Powell Frith (1819–1909), by whom he was to own four paintings, that Danby was 'a man of original genius, and in his own walk – the romantic and poetical, the visionary (in landscape) – I think him unequalled'.[7] Of the twelve paintings by Danby that Gibbons owned,[8] 'An Enchanted Island' (cat.no.21, col.pl.9) remained his favourite and it was to this painting that he referred when he wrote: 'I have a landscape by Danby, that is Claude all over, but I like it none the less; if a man *can* pull the bow of Ulysses, to me he *is* Ulysses'.[9]

John Gibbons (1777–1851) came from a family of important coal and iron masters who had established an export branch in Bristol in the eighteenth century.[10] He returned to the Midlands in the 1820s living mostly at Corbyns Hall, between Stourbridge and Dudley.

The Bristol iron founder, Daniel Wade Acraman had been called 'the father of the Fine Arts in this city' by Samuel Taylor Coleridge in 1814 and he built up a substantial collection of Dutch and Flemish landscape and genre paintings.[11] The practice of

collecting the work of contemporary British artists was most uncommon at this time but, perhaps encouraged by John Gibbons, Acraman began to buy the work of Bristol artists in the 1820s.[12] He acquired Rippingille's 'The Recruiting Party'[13] exhibited at the Royal Academy in 1822, when Danby's own contribution, the lost 'Clearing up after a Shower' is said to have been bought by Bristol's mayor.[14] But Acraman owned only one painting by Danby, a Stapleton scene,[15] and instead, after Danby's move to London, bought romantic landscapes by James Johnson, Danby's closest Bristol follower.[16]

Another collector, Bristol's Town Clerk, Ebenezer Ludlow, who owned paintings by George Morland (1763–1804), Julius Caesar Ibbetson (1759–1817), Philip James de Loutherbourg (1740–1812) and Edward Bird, also acquired two works by Rippingille and two by Danby, a view on the Wye and a Stapleton scene. These two paintings by Danby could be the works now at Yale (figs.9 and 10).[17] If there was a recognisable trend amongst Bristol collectors it was clearly better suited to the genre paintings of Edward Bird and E. V. Rippingille. Of the buyers of several important Bristol paintings, notably the pair of 1822 (cat.nos.10 and 11, col.pls.4 and 5) and the large 'Landscape near Clifton' (cat.no.9) we are ignorant. For these more genteel landscapes it is tempting to seek a patron amongst the longer-established merchant families such as the Miles, Brights or Harfords, but there is very little evidence of their commitment to contemporary art. Instead the owners may have been less illustrious persons such as Myles Ariel, a West India Broker, who owned two watercolours of 'Kingsweston' and 'Looking up the Avon from Durdham Down' (possibly cat.nos.88 and 87), or Richard Smith, the surgeon, who owned a watercolour of 'The Mouth of the Avon from Penpole Point'[18] and also, probably, the fine 'View near Killarney' (cat.no.69) and its pair.

London

Danby had left Bristol for London 'hastily and secretly' and 'over head and ears in debt' by April 1824.[1] Within a few months the President of the Royal Academy, Sir Thomas Lawrence, had bought 'Sunset at Sea after a Storm' (cat.no.20, col.pl.8). Soon, we may assume, John Gibbons commissioned or agreed to purchase 'An Enchanted Island' (cat.no.21, col.pl.9) which Danby showed successfully at the British Institution early in 1825. Before that exhibition was over Gibbons was advancing money on the possible sale of 'The Delivery of Israel out of Egypt' (cat.no.22) with which Danby was to triumph at the Royal Academy early in the summer. It sold immediately to the Marquis of Stafford for £500. With the active support of the President, Danby was elected an Associate of the Royal Academy in November 1825, just twenty months after arriving in London.

Norway

Early in June 1825 Danby sought a further large loan from his patron against payment by the Marquis of Stafford and announced his intention of taking 'a short ramble for the purpose of study'.[1] The ramble grew into plans for a complex tour up the Rhine, and to the Grisons in Switzerland.[2] George Cumberland Jr and Samuel Jackson were to accompany Danby, and N. C. Branwhite also joined in the discussions.[3] Quite suddenly, and with only a day or two's notice to his friends, Danby left for Norway on his own on or about 21 June.[4] He took with him letters of introduction from Sir Thomas Dyke Acland,[5] who had travelled in Norway in 1807 and 1822 and who had privately published an album of Norwegian views in 1813.[6]

It is possible that Danby sailed directly to Stavanger. Revd Niels Hertzberg, whose parsonage near the junction of Hardangerfjord, Sörfjord and the Eidfjord, was a familiar haven for early tourists, wrote that Danby had come from Stavanger via Odda and that he had been sent by a wealthy Englishman to paint Norwegian views.[7] Danby stayed with the minister at Kinsarvik on 4 and 5 August.[8]

Dr Schiøtz has proposed that Danby continued on to Voss, drawing the Skjerve waterfall (cat.no.126) *en route*, and went from Voss by road to the Sognefjord, thence by boat to the Lifjord and by road to Bergen.[9] It would have been a very hurried journey, for within three weeks of staying at Kinsarvik Danby was back in London and giving Gibbons a typically equivocal account:

> I was much disappointed with Norway, it is of a totally different character from what I expected, yet there are very beautiful scenes and extremely picturesque on a small scale, indeed by far the most beautiful I ever saw but in Grandure they fall short. God knows the country is wild enough. These kind of scenes are better in pictures than reality, and faith I own I was heartily sick of them, from the extreme difficulty of travelling and the distance that I went in a short time, my sketches have been forced to be very slight.[10]

Danby may have expected something more self-evidently sublime, closer to the bleak and barren mountains of the 'Upas Tree' (cat.no.18). It was only when defending his similarly hesitant response to Switzerland's scenery that Danby described Norway as 'the country of Ossian, the most picturesque in the world'.[11] Perhaps not until he had settled in Switzerland did the contrasting memories of Norway take effect in both his watercolours and oils (cat.nos.35 and 96–8, col.pl.14). In 1834 he reported that his pictures were generally either 'of Norway or poetical'.[12]

John Martin

Having triumphed with 'The Delivery of Israel out of Egypt' (cat.no.22), and taken his study leave to Norway, Danby began almost immediately after his return on the very large 'An Attempt to Illustrate the Opening of the Sixth Seal' (cat.no.24). He worked also on John Gibbons' commission, 'The Embarkation of Cleopatra' (see cat.no.27) and on the lost work 'Solitude, the Moment of Sunset, with the Moon Rising over a Ruined City'.[1] Dr John King was to call this a 'black mass surmounted by a streak of orange beneath another of blue' and noted that the reflections of ladies' bonnets were never better seen.[2] It was this painting that Danby showed early in 1826 at the British Institution where John Martin's 'Deluge'[3] (see fig.16) dominated the exhibition. The similarities between the 'Deluge' and Danby's 'Sixth Seal', which was still on his easel, caused Danby to accuse Martin of plagiarism and to abandon this painting for two years. It is a controversy that has rumbled on ever since with additional and more damaging misunderstandings clouding the issue.

It has become a commonplace to repeat Richard Garnett's remark in the *Dictionary of National Biography* of 1888: 'Danby removed to London, partly, it has been stated, at the instance of the academicians, who wished to oppose him to their antagonist Martin. His next picture, "The Delivery of Israel out of Egypt". . . is certainly in Martin's style, and a victory over him'.[4] As we have seen, Danby left Bristol before he became, in effect, a protégé of Lawrence. There is also no evidence, as has been recently stated, that he 'was clearly promoted by the Academicians as a counter-check to Martin'.[5] The critics were, in fact, quicker than the Academicians to castigate Martin[6] and there was no need for such a conspiracy.

Garnett's implication of plagiarism by Danby has been succeeded by the repeated quoting of Dr Waagen's apparently cutting reference to 'The Delivery of Israel out of Egypt' as 'a piece painted for effect, in the style of Martin'.[7] Danby's assault on the London exhibitions was certainly calculated and he himself was to refer to the need to satisfy 'the rage for novelty in the public'.[8] It is the re-emergence of the 'Upas Tree' (cat.no.18) that confirms the depth of Danby's personal and long-standing interest in vast and dramatic works of the sublime and the terrible.

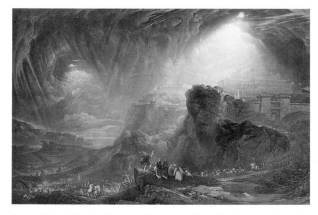

fig.15 John Martin, **Joshua Commanding the Sun to Stand Still** 1827 (based on the painting, RA 1816), mezzotint, $17\frac{1}{8} \times 26\frac{15}{16}$ (430 × 684), City of Bristol Museum and Art Gallery

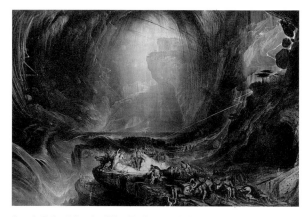

fig.16 John Martin, **The Deluge** 1828 (based on the painting, BI 1826), mezzotint, $23\frac{5}{16} \times 32$ (592 × 812), City of Bristol Museum and Art Gallery

If it was Washington Allston's exhibition in Bristol in 1814 which first set new horizons to Danby's ambitions, the figures in 'The Delivery of Israel out of Egypt' are still surprisingly close in their crisp detail and solid and bright colouring to those in Edward Bird's history pieces[9] (fig.2). It is the quantity of these figures and the limitless landscape that seem reminiscent of Martin. Although in the mid-1820s Martin's fame rested on architectural scenes of impending apocalypse such as 'Belshazzar's Feast', there were also several landscape epics in Martin's own 'retrospective' exhibition at the Egyptian Hall, Piccadilly, in 1822.[10] The closest to Danby's painting was Martin's first epic work 'Joshua Commanding the Sun to Stand Still upon Gibeon' (see fig.15), shown at the Royal Academy in 1816.[11] However, the studied naturalism of the lowering grey clouds and the scale and bravura of the overwhelming sea in 'The Delivery of Israel out of Egypt' have no parallel in Martin's earlier work. The wide and unbroken horizon may instead be indebted to contemporary popular dioramas which could have been seen in Bristol or London, and Danby's own diorama project of the later 1820s confirms his personal interest in these popular spectacles.[12]

When Danby came to paint the 'Sixth Seal' he freely admitted that he could claim no commitment to the subject matter itself: 'I need not tell you that this subject is not one after my own heart . . . except for the opportunity it affords of painting good incidents of figures and grand atmospheric effect in a mountainous country'.[13] Danby went on to say that the 'Sixth Seal' was the 'sort of picture I am at present most likely to sell'. At this moment both the 'Upas Tree' and 'Landscape with Warriors of Old Times' (RA 1823) were unsold, and when the second of these two pictures did suddenly sell in 1828 while on exhibition at the Northern Academy, Newcastle upon Tyne, Danby was unashamedly surprised: 'I had but little thought of either of those pictures selling, as they are both large and dark and therefore badly calculated for the generality of houses'.[14] Several years later in Switzerland Danby's delight at the success of 'The Baptism of Christ'[15] was the greater because 'it quite pleases the connoisseurs who like deep toned pictures as well as myself, and you know in this I am incurable'.[16] There was clearly a distinction between the very large exhibition paintings intended for the private picture galleries of collectors such as Lord Stafford and William Beckford, and those painted for the drawing-rooms of the gentry. With the 'Sixth Seal' Danby was seizing the opportunity to paint in the rich dark tones that so fascinated him.

The loyalty of Danby's Bristol friends was much in evidence after the appearance of Martin's 'Deluge' and it is perhaps fortunate that they did not precipitate a public scandal. George Cumberland wrote to his son in London on 25 February saying: 'I am sorry to hear it reported that Martin has copied Danby's great picture in a little print – if so it is infamous but I would finish it for all that if I were he – to show him up to the public'.[17] A month later he asks his son 'if the story is true about that Quack Martin'.[18] More detailed reports and rumours reached Thomas Lovell Beddoes in Göttingen, no doubt from Bristol, and he wrote to a friend:

> Have you seen Martin's Deluge; do you like it? And do you know that it is a rascally plagiarism upon Danby? D. was to have painted a picture for the King: subject the opening of ye sixth seal in ye revelations: price 800 guineas: he had collected his ideas and scene, and very imprudently mentioned them publicly to his friends & foes – it appears; . . . and lo! his own ideas stare at him out of Martin's canvass in the institution.[19]

The rumours had also reached John Gibbons and Danby's own response survives. He vehemently denied the report that the King had ordered the 'Sixth Seal'. The question of Martin's plagiarism he tackled at length:

> It was always my habit in Bristol to speak of what I had in hands without reserve and to show all I had done. This I intended to continue in London, but I have found, I hope in time, that it will not do.

Danby then relates that at Martin's house one evening he discussed the studies he had been making for some years for 'The Deluge' saying:

> ... that at present I was not prepared to commence it, that my first picture would be the Opening of the Seal. I told him all the incidents which I am now sorry for: a short time after this I heard Martin had commenced the Deluge. This surprised me but I thought it not of much consequence until a gentleman called one day on me and on seeing my picture he said this is exactly like Martin's picture in every line. This I thought impossible as Martin and myself had made a mutual agreement not to look at each other's work until they were completed, but on strict enquiry to the servants I found he called one evening when I was out, and was brought into the painting room – all this only proves he was not so noble as I thought. As sanguine as I was in my subject, I immediately gave it up and commenced another picture.[20]

This unconvincing and self-righteous letter suggests, at least, that Danby was not himself responsible for initiating the accusation. It was an isolated incident and two years later, when Danby reported the sale of the 'Sixth Seal' to Beckford, he praised Martin's 'The Fall of Nineveh' without reserve.[21]

The two paintings have a common ancestor in Turner's 'Snow Storm: Hannibal and his Army Crossing the Alps' (RA 1812, Tate Gallery), and Martin, himself, had used the composition before in an illustration engraved in 1824,[22] possibly the 'little print' to which Cumberland had referred. Martin's protagonists have readily conceded that he was to borrow from Danby's 'Sunset at Sea after a Storm', 'The Delivery of Israel out of Egypt' and the 'Sixth Seal',[23] while quite properly admiring the extraordinary fertility of Martin's invention. When similarities are to be found it is usually simply an indication of the potency of the original image unconsciously affecting the evolution of the artist's own invention. With such novel subject matter, often without precedent in the history of art, it would be surprising if one new idea did not influence the treatment of similar subjects. It would be still more surprising 'in this day of accumulated variety'[24] at the exhibitions when 'pictures are pitted against each other like champions in a ring',[25] if the artists themselves were not both jealous of their ideas and nervous of accusations of plagiarism.

Royal Academy

Danby's success at the Royal Academy in 1825 with 'The Delivery of Israel out of Egypt' (cat.no.22) had been followed by his election as an Associate of the Royal Academy. In 1828 the 'Sixth Seal' (cat.no.24) was an even greater triumph and Danby felt he had good reason to hope for full membership at the election in February 1829. He even determinedly promised to resign if he was not elected.[1]

As the election approached Danby wrote anxiously to his patron: 'the awful moment is coming . . . if Constable is put in I think I will run out'.[2] He glumly foretold the need, which his family might one day have, of the Royal Academy's funds, and suggested that Constable might get in because his wife had just inherited £30,000.[3]

In February John Constable (1776–1837) duly beat Danby by one vote. Danby responded with peculiar bitterness, accusing Constable of 'intrigue which was beyond all meaness'. He claimed that the 'first in rank' had supported him and then added, flailing blindly: 'for the Academy I have much cause to be ashamed as it lowers their value when it is so evident that they have elected Constable for his money'.[4] It was an accusation that was also to be implied by the press, and Constable's pleasure in his success was further dampened by the President, himself, who was unable to disguise his evident disappointment at the outcome.[5]

Scandal

Danby's defeat at the Royal Academy election may have precipitated the débâcle that unfolded during the winter of 1829–30.

In July 1829, within a year of earning over £1000 in a matter of weeks, Danby was asking his patron for a very large loan.[1] By November he was claiming to be on the brink of ruin but was still entertaining vague hopes of election to the Royal Academy the following February.[2] He refused Gibbons' invitation to stay, on the grounds that his creditors would still find him and announced his intention of going to Paris[3] where he arrived early in December.[4] John Gibbons soon received three letters written for Danby's illiterate wife Hannah: the creditors are persecuting her, she asks for money, and she hopes Gibbons will not send any to Mr Danby or 'he will be induced to prolong his stay'.[5] In January Danby returned very briefly to London to attend Sir Thomas Lawrence's funeral, in order to protect his reputation with the Royal Academy.[6] He found that writs were out against him and hurried back to Paris. By June 1830 he had moved to Bruges and four of his seven children had joined him.[7]

Danby now, at last, told Gibbons, amidst a mass of self-pity and hypocrisy, a little of the story. He explained that after his return to Paris in January Mrs Danby had written saying she never wished to see him again, and accused him of infidelity which he strenuously denied. Then he had learnt from an aunt that Mrs Danby, having formed an alliance the previous December, had deserted her children and was now with a man whom Danby grandly refused to name while saying quite enough to implicate the young Bristol artist, Paul Falconer Poole. And, to his particular chagrin, Mrs Danby was spending money on guitar lessons.[8]

Not until 1834 when Dr John King visited him near Geneva did Danby allude in his letters 'to the lady with whom I now live'.[9] In 1836, less than two years before her death, Danby wrote:

> I was passionately fond of music and this brought me into the society of Miss Evans of Bristol whose talent I admired exceedingly . . . from the bottom of my torn soul I grieve that in her youth and innocence I persuaded her to be mine . . .[10]

John Gibbons had long since had a fuller and more accurate version of the story from both Rippingille and Dr John King. Rippingille confirmed that Mrs Danby had disappeared 'with some young man' leaving the children with an aunt who had in turn abandoned them. Danby himself had gone off with 'a girl who lived in the house as a sort of governess to his children'.[11] John King actually knew Ellen Evans and her Bristol family well and he and Gibbons were singularly sanguine about the whole affair.[12]

Until September 1830 Danby remained with his children and Ellen Evans at Bruges.[13] Here a son, Frederick, was born.[14] We must presume that Ellen had accompanied Danby to Paris at least in January 1830 if not in December of the previous year. Mrs Danby's subsequent desertion gave her husband a shaky moral platform to which he clung for the rest of his life.

Richard Redgrave, who was a profound admirer of both the Royal Academy and Francis Danby, argued that the Academy's rejection of Danby throughout the 1840s and 1850s was not because the members did not recognise his great merit, nor because he had 'made a false step involving the council of that day in many annoyances, and bringing disgrace on art.' Instead Redgrave believed that 'this might have been overlooked as time dimmed its recollection, had not Danby defended the fault to the last rather than regretted it'.[15]

It was not just the ancient pillars of his profession that resented Danby's behaviour. Rippingille, the equal of Danby in 'infidelity and libertinism' as far as Gibbons and King were concerned,[16] cynically thanked him for the honour he was conferring on the brotherhood of artists.[17] The sculptor, Christopher Moore (1790–1863), recalled the sufferings of his 'unfortunate friend' and how, often, he had had to fight Danby's 'battles with the illiberal part of the profession, who forgetting all his good qualities of head and heart could devile on nothing but his melancholy error which none had more reason to deplore than himself'.[18]

Switzerland

Danby was in Paris from December 1829 until May 1830 when he moved to Bruges, taking with him 'The Golden Age' (see cat.nos.31 and 32) on which he had been working intermittently for nearly four years. In June 'The Golden Age' was sent to London.[1] Both Gibbons,[2] and the artist J. A. O'Connor, Danby's close friend, were very critical of it and when it was finally shown at the Royal Academy in 1831 it was, probably justly, hung high over a door.[3]

Danby remained in Bruges to finish 'a few little drawings'[4] before moving on with his family to Aix-la-Chapelle,[5] Cologne[6] and finally Neuwied near Coblenz,[7] where he settled for the winter. He now concocted plans to construct a raft and travel up the

Rhine and ultimately on to the Mediterranean coast (see cat.no.107) with his mistress and eight children.[8]

The threat of war prompted Danby to move direct to Switzerland and by May 1831 he and his family had taken lodgings in Rapperswil on the edge of Lake Zurich.[9] From here Danby sent back watercolours to Gibbons and to the watercolour painter, George Fennel Robson (1788–1833),[10] for resale. For 'On the Rhine' (cat.no.107) he apparently asked only £3[11] and for 'Scene from "A Midsummer Night's Dream"' (cat.no.109) and a watercolour of the Walensee from Wessen he hoped for a total of £25.[12] Gibbons advanced some money[13] and the Royal Academy responded generously to Danby's letter requesting assistance, with a donation of £50. Constable himself seconded the motion.[14] It was not enough, however, and after a year at Rapperswil Danby's landlord refused to allow him further credit.

In August 1832 Danby, his mistress and his children, now probably nine in number, arrived in Geneva, penniless and 'so distressed were they that the people at whose house they were went about begging charity for them to avert decided starvation'.[15] Danby indignantly refused this help but was rescued by Madame Munier, an artist and wife of the Director of the Academy of Arts. She speedily raised a subscription amongst the friends of the museum and commissioned a large painting, 'The Baptism of Christ' now in the Musée d'Art et d'Histoire (fig.18). Danby soon received portrait and other commissions from the English community (see cat.no.115),[16] and the interest created by the subscription, and the progress of the large painting led to further orders.[17]

Danby also received commissions for drawings for albums, a fashion begun in part by Mrs Haldimand for whom Danby had drawn 'Amphitrite' (cat.no.100) in about 1827. The practice reached Geneva and Madame de la Rive's album (cat.no.117) is one of the finest to survive intact. More profitable were drawings, mostly sent back to Alaric A. Watts, to be engraved for the small illustrated annuals (cat.nos.111–14, 138–41) to which Danby had first contributed in 1827 (cat.no.136).

Shortly before Danby left Geneva for Paris in 1836 he claimed to have painted fifty oil paintings 'besides <u>lots</u> of drawings'.[18] Fewer than a quarter have been identified. Very few of them were of the local scenery of which Danby gave conflicting reports, finding

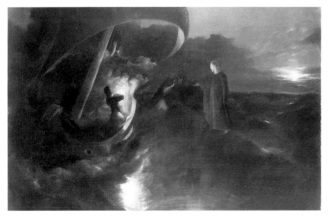

fig.17 Francis Danby, **Christ Walking on the Sea** RA 1826, oil on canvas, 58 × 86¼ (1470 × 2193), Forbes Collection, London

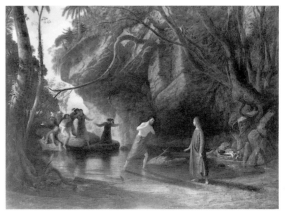

fig.18 Francis Danby, **The Baptism of Christ** 1833, oil on canvas, 42½ × 55 (1089 × 1403), Musée d'Art et d'Histoire, Geneva

it both 'extremely beautiful, calm fine weather suits it best'[19] and 'huge, stiff and unvaried'.[20] He reacted very defensively to Dr John King's visit in 1834 admitting that he had so far painted only Norwegian scenes or poetical landscapes[21] and promising to tour the mountains the following year. This he may have done as 'The End of Lake Geneva' (cat.no.36), dated 1835, and 'Mont Blanc' (cat.no.37) would imply.

In November 1834 soon after Dr King's visit, the *Chambre des Etrangers* at Geneva noted that Danby was again running into serious debt and considered expelling him.[22] A principal cause was the time that he and his sons had spent during the summer building a sailing boat.[23] Danby proudly claimed it to be the fastest on Lake Geneva.[24] Within a year, however, the *Chambre des Etrangers* reported that Danby had cleared his debts and that 'his talent as a painter is appreciated and his pictures sell well'.[25]

Danby's letters show no satisfaction at his financial recovery. Instead he regrets that he has 'never been independent enough to take a couple of months to work on a picture of speculation'.[26] He calls Geneva a 'loathesome prison'[27] and punishment for his past errors, and promises that he will no longer live like a cabbage: 'I have slept for 6 years'.[28]

Paris

By May 1836, Danby had arrived in Paris. He was elated: 'artists of all kinds are the High Priests of the present Religion of France'.[1] English painting, he reported, was popular and English artists, including himself, were being imitated. But his two-and-a-half years in Paris were to be perhaps the most unsuccessful of his career. In the winter he was occupied with 'Rich and Rare were the Gems She Wore'[2] (fig.19). It was his first large oil painting since 'The Baptism of Christ', and, on the basis of Danby's description, Gibbons justly told him that it was more suited to an historical or figure painter.[3] It was rejected by the Paris Salon in the spring[4] and was then a relative failure at the Royal Academy where Danby had now had no significant success since 1828. Not until 1841 did he again exhibit there.

In August 1837 Danby began the vast painting 'The Deluge' (cat.no.40) under an ambitious and complex agreement with the picture dealer William Jones.[5] Progress soon ceased and Danby seems to have been almost exclusively occupied for his remaining time in Paris with painting copies of works in the Louvre, mostly for John Gibbons and for Gibbons' brother, Benjamin, and his cousin William.[6] He copied paintings by Poussin, Ruisdael, Claude, Guido Reni, Rembrandt and Titian and his letters imply neither resentment nor regret at these tasks, only eagerness for more work. In October he wrote convincingly: 'I have had a pleasure from those old pictures that I would not exchange with all my poverty for millions'.[7]

On 28 November 1837 Danby informed his patron that Ellen Evans, 'My Guardian Angel', had died during the night.[8] She left him three boys 'lovely beautiful and amiable as herself'. Two months later these children were desperately ill[9] and by the summer of 1838 two sons and a daughter had died.[10]

fig.19 Francis Danby, '**Rich and Rare were the Gems She Wore**' RA 1837, oil on canvas, 48 × 64 (1219 × 1626), sold Sotheby's, Slane Castle 1981

London

In 1839 Danby was listed in a London Directory.[1] This conflicts with his own statement that he completed 'The Deluge' (cat.no.40) in 1840 in Paris,[2] but whether in Paris or London, the vast painting of 'The Deluge' would have occupied Danby throughout 1839. In May 1840 it went on show on its own at 213 Piccadilly, an event presumably stage-managed by William Jones who had commissioned it and who may already have been its effective owner. It was a moderate success, noticed and taken seriously by many critics and profusely praised by one.[3]

Danby now prepared three substantial submissions for the Royal Academy of 1841. It was his first successful showing there since 1828 and 'Liensford Lake' (cat.no.41) and 'The Enchanted Castle' (cat.no.42, col.pl.15) are dark, melancholy and expressive masterpieces of British Romantic painting.[4]

Despite the powerful assurance of these paintings, Danby himself lacked confidence. He wrote in October 1841:

> I who have for years been steeped in misery and disappointment, have lost the buoyancy that urged me to my first efforts to obtain distinction, and from being secluded have copied myself until I have become insipid and mannered, I own I did not feel it so gradually does decay creep on one.[5]

Danby was at this moment discussing drawings with his patron and there is a highly finished watercolour at Oldham Art Gallery, 'Landscape', dated 1841, which is, indeed, stiff, lifeless and mannered.[6] In 1842 he mentions working on a watercolour of the Swiss lakes[7] but there is no evidence thereafter of any further highly finished drawings.

From 1841 until his death Danby exhibited almost annually at the Royal Academy. Today only nine of the forty-eight works which Danby exhibited at the British Institution and the Royal Academy during the twenty years after his return to England, are known. Several were destroyed in the last war, but it is likely that many more dark paintings suffered a similar fate to 'The Gate of the Harem' (RA 1845, see cat.no.43) which was destroyed by order of H. M. Queen Mary in 1927.

The majority of Danby's exhibition paintings were now 'poetical' landscapes, as he called them.[8] Some years earlier he had written scornfully: 'as to landscapes without poetry or human interest I would as soon be a painter of Wales'.[9] But although the subject matter of many works continued to be imaginary, as for example, 'The Wood-Nymph's Hymn to the Rising Sun' (RA 1845, cat.no.44), there were an increasing number both of actual landscape scenes, such as 'Dead Calm – Sunset, at the Bight of Exmouth' (RA 1855, cat.no.47, col.pl.17), and of illustrations to complex literary or classical subjects, such as 'Phoebus Rising from the Sea' (RA 1860, cat.no.49). If the element of personal fantasy diminished, the enthusiasm of Danby's observation of the natural effects of light remained and was perhaps strengthened by his move to Exmouth. The late oil sketches (cat.nos.53–60, col.pls.18, 19, 20), done only for his personal pleasure, are confirmation of the depth and continuing originality of Danby's response to nature.

Danby appears to have lived frugally in London with at least one moment of despair. At first, while living in Pimlico,[10] he used the picture dealers, Colnaghi's, as an accommodation address. In the summer of 1842 he wrote from Gravesend in Kent to John Gibbons saying he was sketching and seeking 'cheaper quarters'.[11] This was apparently only half the truth for another letter, probably to his son-in-law, John Mogford, states that he is 'now seriously frightened' at his situation. He has two shillings left:

> . . . there is a speck of light on the horizon which may save me but the ship is waterlogged and must I fear <u>sink</u> before I can reach it.[12]

In 1843 and 1844 Danby recorded his address at the exhibitions as 10 Norfolk Street in Soho, London, but there are no letters confirming that he lived there. In 1844 Danby moved to Catford Hill, Lewisham in Kent, now part of south-west London.[13] It was a modest address but a practical move.

The following year Danby sold 'The Gate of the Harem' to Queen Victoria and 'The Wood-Nymph's Hymn to the Rising Sun' to Lord Northwick, who hung it as a pair to a Claude in his Gloucestershire home, Thirlestaine House (fig.20).[14] In 1846, Robert Vernon, horse-breeder and one of the principal collectors of the day, bought 'Sunrise – the Fisherman's Home' (see cat.no.45). Later in the year Danby moved with at least two of his sons to Exmouth in Devon where he was to live for the last fifteen years of his life.[15] Here he continued to enjoy the patronage of John Gibbons until Gibbons' death in 1851. During the 1850s, however, two other Midlands industrialists, Thomas Pemberton and Joseph Gillott, the manufacturer of steel pen nibs, were significant patrons.[16]

Exmouth

Exmouth was expanding fast in the 1840s and there was the expectation of the coming of
the railway, which had been planned in 1845. Danby had visited the town many years
before, while still living in Bristol and he had drawn several detailed panoramic views.[1]
He first took a small house, Rill Cottage, on the northern outskirts of Exmouth, on the
hill overlooking the River Exe.[2] Then, after ten years, he moved to the opposite side of
Exmouth, taking a long lease on Shell House (cat.no.147) on the Maer in 1856.[3] At this
time Danby had commissions from both Gillott and Pemberton as well as from the
widow of his patron, John Gibbons, from Thomas Rought, the picture dealer, and from
others. There was almost certainly a need for larger premises but it was the proximity of
the house to the sea which probably especially attracted him.

In Exmouth Danby was to spend much of the summers sailing and boat-building. His
passion was now well known and in 1848 one critic noted, somewhat ruefully, that
Danby intended to send a work to the next British Institution exhibition provided that
'his amateur boatbuilding does not interfere to prevent its completion in time'.[4] In
November he had written most evocatively to John Gibbons of the past summer:

> I do not regret having lived like a bird in the fields, or on the sands all the summer,
> for this pleasure is what I most care for in life, and I am content to fag all winter,
> for its repetition if but for <u>once</u> more and so on as long as it may please God. . . .[5]

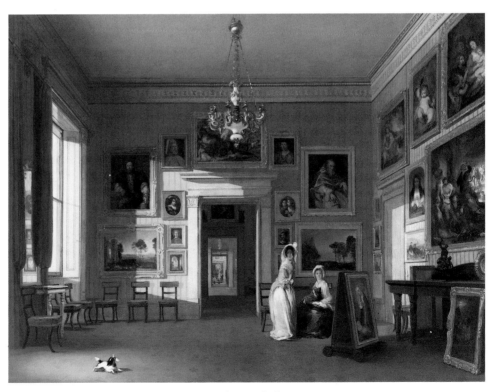

fig.20 Robert Huskisson, **Lord Northwick's Picture Gallery
at Thirlestaine House** c.1846–7, oil on canvas, 32 × 42¾
(814 × 1108), Yale Center for British Art, Paul Mellon Collection

In his last letter to his patron written on 24 August 1851, Danby could say that he had more orders for paintings than ever before. He mentions that he had 'laid up the Chase' which Dr Adams reasonably took to refer to the scramble for Royal Academy honours.[6] *The Chase*, however, was the name of his yacht, perhaps the one he had been building 'on the sands all the summer' in 1848. In May 1852 the *Western Luminary* reported:

> Exmouth – Lord Godolphin, who has been staying here some time with his schooner yacht, *Coquette*, will take a cruise at sea and along the coast two or three times a week, an example it seems, about to be followed by other gentlemen, as the yacht of W. H. Peters Esq., *The Lily of the Exe*, and *The Chase*, belonging to F. Danby Esq., are being got ready for sea. A regatta is also expected. . . .[7]

At last Danby had achieved a certain stability in his life and a pattern to his year. The mood of quiet tranquillity in 'Dead Calm – Sunset, at the Bight of Exmouth' (cat.no.47) may well reflect the contentment of his years at Exmouth.

In August 1860, *Trewman's Exeter Flying Post* phlegmatically recorded that 'Mr Danby's new yacht *Dragon Fly* has met with a mishap'.[8] *En route* for Cherbourg she had parted with her anchor and lost both mast and bowsprit. Danby, his housekeeper, a child and the crew were rescued by lifelines fired from the coastguard station. Danby, now aged sixty-six, appeared to recover quickly. Within two months he had applied for a patent for a new kind of single-fluked anchor,[9] and at Christmas he visited his old friend, Samuel Jackson, at Bristol.[10] But on 10 February 1861 Danby died suddenly at Shell House.[11] He was buried in the churchyard of St. John-in-the-Wilderness, Withycombe.

Notes

IRELAND

1 Gibbons Papers, F. Danby to J. Gibbons, 2 January 1833.
2 *Ibid.*
3 *Ibid.*
4 Vestry Minute Book of Mulranchon and Kilmannon (held by the Rector of Kilscoran Union of Parishes, The Rectory, Killinick, Co. Wexford). In 1784 and 1785 James Danby is referred to as 'of Cottage' but in 1792, when he is included in a list of twelve 'Principal Protestant Parishioners', he is 'Mr James Danby of Common'.
5 Gibbons Papers, F. Danby to J. Gibbons, 28 December 1834.
6 *Ibid.*
7 *Men of the Time*, biographical dictionary published by Kent & Co. (late D. Bogue), 1857, p.195.
8 *Art Journal*, 1855, p.78.
9 James Danby married first Susanna Harvey, daughter of Revd Ambrose Harvey of Hermitage, Co. Wexford in 1762, and secondly Margaret Watson of Dublin, 1781. He had two sons, John Henry and James, and a daughter (later Mrs Jane Boyd) by his first wife, and the twins, Thomas, who died young, and Francis, and Frances Olivia by his second wife (W. G. Strickland, *A Dictionary of Irish Artists*, Dublin and London, 1913, p.253, and H. C. Stanley-Torney (ed.), *Fern's Marriage Licences*, n.d., p.227).
10 This precise date was given by the *Art Journal*, 1855, p.78. It is uncorroborated but much of the article is clearly based on first-hand information. It conflicts with the years given and inferred by Danby himself but Danby was notoriously inaccurate in such matters (Adams, p.1).
11 Gibbons Papers, F. Danby to J. Gibbons, 2 January 1833; see also *Bristol School* 1973, p.33.
12 W. G. Strickland, *op.cit.*, p.252.
13 *Ibid.*
14 *Ibid.*, p.253.
15 Gibbons Papers, F. Danby to J. Gibbons, 2 January 1833.
16 *Art Journal*, 1855, p.70.
17 William Stokes, *Life and Labours in Art and Archaeology of George Petrie*, 1868, p.2.
18 See John Hutchinson, *James Arthur O'Connor*, exhibition catalogue, National Gallery of Ireland, 1985, pp.83–92. The *Art Journal* obituary, 13 February 1861, states that Danby received instruction in painting from O'Connor.
19 *Art Journal*, 1855, p.78; Strickland, *op.cit.*, p.253.
20 *Art Journal*, ibid.
21 *Ibid.*
22 Adams, p.3.
23 Hutchinson, *op.cit.*
24 *Ibid.*, pp.121, 128–9.
25 Adams, pp.35–7.
26 Hutchinson, *op.cit.*, pp.109–13.

EARLY YEARS IN BRISTOL

1 William Stokes, *Life and Labours in Art and Archaeology of George Petrie*, 1868, p.8.
2 *Western Daily Press*, Bristol, 13 February 1861, p.2.
3 *Ibid.*, 20 February 1861, p.4, quoted at length under cat.no.66.
4 *Ibid.*
5 Gibbons Papers, F. Danby to J. Gibbons, 29 February 1836.
6 *Western Daily Press*, 20 February 1861, p.4.
7 Joyce Fry, baker, is recorded in *Mathews's Bristol Directory* of 1819 at 27 Redcliffe St. and her name is also in the parish register of Winscombe where Danby was married; information kindly given by Miss Jane Baker.
8 Gibbons Papers, F. Danby to J. Gibbons, 29 February 1836.
9 Somerset County Records Office, Taunton: Marriages D/P Winsc 2/1/6 August 1813 – 1 July 1837, vol.4, p.3 no.8: Francis Danby to Hannah Hardedge, witnesses Elizabeth Hardigs and James Hancock. I am indebted to Miss Jane Baker for this information.
10 Gibbons Papers, F. Danby to J. Gibbons, 29 February 1836.
11 BL Add. MS 28509, F. Danby to R. Griffin, 12 April 1860, quoted in full by Adams, pp.141–2.
12 Somerset County Records Office, Taunton: Compton Bishop Parish Register: Francis James Denby [sic] baptised 13 August 1815, James Denby [sic] baptised 27 April 1817.
13 Evans' *Bristol Index*: 'Danby F.A. *painter landscape*' 21 Paul Street Kingsdown.
14 BL Add. MS 36508 fo.153, G. Cumberland Sr to G. Cumberland Jr, 2 January 1820 (misdated 1821).

THE ARTISTS

1 John King, 'Observations on the Exhibition of Paintings . . . by the Bristol Society of Artists . . .', *Bristol Mirror*, 1839 (from an album of King's reviews, City of Bristol Museum and Art Gallery (Mb3741)).
2 *Felix Farley's Bristol Journal*, 21 March 1829, p.4, letter from G. Cumberland Sr; see also Adams, p.147, fn.27.
3 [Revd John Eagles], *Felix Farley, Rhymes, Latin and English, by Themaninthemoon*, Bristol, 1826, pp.90–1.
4 Sarah Richardson, *Edward Bird*, exhibition catalogue, Wolverhampton Art Gallery, 1982.
5 *Bristol School* 1973, pp.121–7.
6 BL Add. MS 36514 fo.269, G. Cumberland Sr to G. Cumberland Jr, undated.
7 J. W. and A. Tibble, *John Clare, a Life*, 1932, pp.181–2.
8 Gibbons Papers, F. Danby to J. Gibbons, 2 September 1830.
9 BL Add. MS 36506 fo.315, G. Cumberland Sr to G. Cumberland Jr, 19 August 1818.
10 *Bristol School* 1973, pp.11 and 181–9.
11 *Ibid.*, p.181.
12 BL Add. MS 36515 fo.111, G. Cumberland Jr to G. Cumberland Sr, undated, presumed June 1825.
13 See Margaret Whidden, *Samuel Colman 1780–1845*, unpublished PhD thesis, Univ. of Edinburgh, 1985, and see also cat.no.24.
14 Gerdts & Stebbins, pp.80–8.

THE AMATEURS

1 Republished in the *Catalogue of Pictures painted by the late Edward Bird . . .*, Bristol, 1820.
2 BL Add. MS 36508 fo.153, G. Cumberland Sr to G. Cumberland Jr, 2 January 1820 (misdated 1821).
3 *Ibid.*, 36506 fo.180. G. Cumberland Jr to G. Cumberland Sr, 14 January 1818. It was George Cumberland Jr who, in 1818, introduced Linnell to William Blake: *ibid.*, 36515 fo.118, G. Cumberland Jr to G. Cumberland Sr, undated [1818].
4 E.g. *ibid.*, 36501 fo.360, G. Cumberland Sr to G. Cumberland Jr, 22 January 1809, where Cumberland also says Eagles 'did Bird a great deal of harm'; 36506 fo.48, G. Cumberland Sr to G. Cumberland Jr, 23 March 1817.
5 The information on Eagles is largely taken from the Eagles Papers in the collection of Philip Graham-Clarke.
6 Gibbons Papers, J. King to J. Gibbons, 8 April 1829.
7 Republished in one volume, *The Sketcher*, 1856.
8 Eagles, p.39.
9 *Ibid.*, p.12.
10 J. M. Gutch in a letter dated 14 January 1856 to the *Bristol Journal* (cutting in the Eagles Papers) says that Eagles published six etchings after Gaspar Poussin in Bristol in 1823.
11 Basic biographical details have been taken from an obituary notice (*Bristol Mirror*, 4 September 1847) amongst the King Papers in the

Bristol Record Office. A copy of Muriel Maby's recent unpublished biography of John King is in the Avon County Reference Library, Bristol; see also *Bristol School* 1973 (219).

12 Edmund Gosse (ed.), *The Letters of Thomas Lovell Beddoes*, 1894, pp.45–6, quoted at greater length by Adams, p.11.

13 Gibbons Papers, J. King to J. Gibbons, 15–16 November 1822.

14 *Ibid.*, F. Danby to J. Gibbons, 10 December 1829.

15 BL Add. MS 36508 fo.153, G. Cumberland Sr to G. Cumberland Jr, 2 January 1820 (misdated 1821).

16 Letter from F. Gold to R. Smith, 31 May 1820 in Richard Smith's, MS *Bristol Infirmary Biographical Memoirs*, vol.VI, Bristol Record Office 35893 (36). For further biographical details drawn largely from this source see W. D. A. Smith, 'A History of Nitrous Oxide . . .', *British Journal of Anaesthesia*, 1970, no.42, pp.352–3; M. D. Crane, 'Arthur Broughton . . .', *Archives of Natural History*, 1981, no.10, pp.317, 325, fn.7. The most extensive details of Gold's life are contained in a chronology recently compiled by Sidney F. Sabin who has generously deposited a copy with the City of Bristol Museum and Art Gallery.

17 *Art Journal*, 1860, p.100, quoted at length by Adams, p.16. See also *Felix Farley's Bristol Journal*, 2 September 1826 and fn.16 above.

18 'Hagar in the Desert' is in a private collection, London; drawings relating to it are in the City of Bristol Museum and Art Gallery (K3083).

LEIGH WOODS AND NIGHTINGALE VALLEY

1 Gibbons Papers, J. King to J. Gibbons, 8 July 1828.

2 *Ibid.*, F. Danby to J. Gibbons, 5 December 1835.

3 *Ibid.*, 23 July 1829.

4 Eagles, p.100.

5 BL Add. MS 36506 fo.276, G. Cumberland Sr to G. Cumberland Jr, 7 June 1818.

6 Eagles Papers, cutting from *Felix Farley's Bristol Journal*, November 1829, 'Leigh Woods' by 'Themaninthemoon'.

7 Regular references to Leigh Woods are made in the Cumberland correspondence from 1813 (BL Add. MS 36504 fo.95); see also *Bristol School* 1973 (295).

8 Yale Center for British Art, Paul Mellon Collection, $13\frac{1}{16} \times 9\frac{11}{16}$ in: Adams (10) as 'The Avon Gorge'.

9 See cat.no.9.

STAPLETON

1 See cat.no.19, fn.2.

2 Gibbons Papers, J. King to J. Gibbons, 23 October 1829. King clearly implies that this occurred well before the painting of 'The Post Office' exhibited at the RA in 1819. 'A Young Girl at a Garden Gate', dated 1817, $11\frac{1}{2} \times 9\frac{1}{4}$ in, with Leger Galleries Ltd, London, 1966, has particular freshness and naturalism in its colour.

3 Eagles, p.138.

4 See *Bristol School* 1973 (11).

5 BL Eg. MS 2246 fo.366, E. V. Rippingille to J. Clare, undated, probably summer 1824.

6 Adams, pp.38–9.

7 Redgrave, pp.442–3; Adams (157) and pp.39–43.

8 Katharine Crouan, *John Linnell. A Centennial Exhibition*, Cambridge, 1982 (22), illus. in col.

9 BL Add. MS 36506 fo.48, G. Cumberland Sr to G. Cumberland Jr, 23 March 1817.

10 *Ibid.*, fo.180, G. Cumberland Jr to G. Cumberland Sr, 14 January 1818 contains the earliest reference to Linnell.

11 *Ibid.*, 36507 fo.66, G. Cumberland Sr to G. Cumberland Jr, 15 March 1819.

EVENING MEETINGS AND MONOCHROME DRAWINGS

1 Eagles, p.190.

2 *Catalogue of Pictures painted by the late Edward Bird . . .*, Bristol, 1820. The essay was first published in *Felix Farley's Bristol Journal*, 3 November 1819.

3 See *Bristol School* 1973, illus. pp.12–13.

4 *Ibid.*, (240).

5 Smith College Museum of Art, Northampton, Mass. U.S.A. (1966:2), black and grey wash, $7\frac{11}{16} \times 9\frac{1}{8}$ in, purchased 1966 from Mrs Charlotte Frank: Adams (110).

6 Eagles, pp.269–70.

7 Gibbons Papers, F. Danby to J. Gibbons, 23 July 1829.

8 *Ibid.*, 17 October 1834.

PATRONS IN BRISTOL

1 E. V. Rippingille, 'Edward Bird R.A.', *Art Journal*, 1859, p.333.

2 Gibbons Papers, J. King to J. Gibbons, 15–16 November 1822.

3 *Ibid.*, F. Danby to Benjamin Gibbons, 30 August 1851.

4 *Bristol School* 1973 (21).

5 Gibbons Papers, copy of account 'sent Danby July 21 1829' totalling £1717.10.3, with balance of £717.10.3 after deduction of £1000 for the five paintings received during that period; and F. Danby to J. Gibbons, 16 June 1830 and 2 September 1830.

6 *Catalogue of Pictures from the collection of John Gibbons Esq late of Hanover Terrace, Regents Park*, Christie's 26 May 1894: see cat.no.4, fn.2.

7 W. P. Frith, *My Autobiography and Reminiscences*, 1888, vol.3, p.208, quoted by Adams, p.110.

8 Gibbons purchased: 'A Street in Tintern' (cat.no.4); 'The Avon Gorge and Clifton Down' (cat.no.7); 'An Enchanted Island' (cat.no.21); 'Solitude' BI 1826, Adams (161); 'Christ Walking on the Sea' RA 1826, Adams (162); 'The Embarkation of Cleopatra' (see cat.no.27); 'A classical landscape – upright' (sold Christie's 27 June 1831, (105)); 'The Golden Age' (see cat.nos.31 and 32); 'Calypso's Grotto' BI 1844, Adams (178); 'The Grave of the Excommunicated' BI 1846, Adams (183); 'A Ship on Fire' RA 1851, Adams (201); 'Winter-Sunset; a Slide' RA 1851, Adams (68). Mrs John Gibbons purchased 'The Evening Gun' (cat.no.48).

9 Frith, *op.cit.*, pp.202–3, quoted by Adams, p.109.

10 W. A. Smith, 'The Contribution of the Gibbons Family to technical development in the iron and coal industries', *West Midlands Studies*, Wolverhampton Polytechnic, vol.4, 1970–1, p.46.

11 *Felix Farley's Bristol Journal*, 13 August 1814.

12 Christie's sale catalogue, 22 August 1842; see also *Bristol School* 1973, p.27.

13 City of Bristol Museum and Art Gallery (K497): *Bristol School* 1973 (117) illus. p.132.

14 Redgrave, p.442.

15 'Stapleton Mill – Boys Seeking Eels': Adams (156).

16 *Bristol School* 1973, p.170, fn.31.

17 Ludlow lent 'Landscape and Figures – Swimming the Boat' to the *Fifth Exhibition of Pictures*, Bristol Institution, 1829 (100) and 'On the Wye' to the *Third Exhibition of The Bristol Society of Artists*, Bristol Institution, 1834 (10).

18 *Third Exhibition of The Bristol Society of Artists*, Bristol Institution, 1834 (101, 117, 75).

LONDON

1 BL Add. MS 36510 fo.102, G. Cumberland Sr to G. Cumberland Jr, 18 May 1824; see also cat.no.20.

NORWAY

1 Gibbons Papers, F. Danby to J. Gibbons, 1 June 1825.
2 BL Add. MS 36515 fo.111, G. Cumberland Jr to G. Cumberland Sr, undated, presumed June 1825.
3 *Ibid.*, 36511 fo.3, G. Cumberland Sr to G. Cumberland Jr, 2 July 1825; see also previous fn.
4 Yale Center for British Art, letter in the Henry Bicknell album, F. Danby to W. Brockedon, postmarked 23 June 1825; BL Add. MS 36510 fo.418, G. Cumberland Jr to G. Cumberland Sr, 22 June 1825.
5 BL Add. MS *ibid.*
6 Information kindly supplied by Dr Eiler H. Schiøtz in correspondence dated 22 September 1976 with the compiler (City of Bristol Museum and Art Gallery: artist files).
7 *Morgenbladet*, no.336, 1 December 1828, Christiania [Oslo], quoted in part by Dr E. H. Schiøtz, *Itineraria Norvegica, Foreigners' Travels in Norway until 1900*, Oslo, 1976, vol.II, pp.44–5.
8 'Prost Niels Hertzbergs Reisebok, 1806–1841' in *Den Norske Turistforenings Årbok*, Oslo, 1929, p.17.
9 Schiøtz, *op.cit.*, and correspondence (including MS map) with the compiler, 1976–1988; see also cat.nos.35 and 95, fn.2.
10 Gibbons Papers, F. Danby to J. Gibbons, 26 August 1825.
11 *Ibid.*, 25 October 1832.
12 *Ibid.*, 17 October 1834.

JOHN MARTIN

1 Adams (161).
2 Gibbons Papers, J. King to J. Gibbons, 21 June 1826. 'Solitude' was then on show at the Bristol Institution and King later showed it at his own house.
3 Present whereabouts unknown.
4 *Dictionary of National Biography*, 1888, p.457; first quoted by T. Balston, *John Martin, 1789–1854, His Life and Works*, 1947, p.185. Garnett takes his first statement from William Bell Scott, *Our British Landscape Painters*, 1872, p.92, quoted by Adams, p.79.
5 William Feaver, *The Art of John Martin*, 1975, p.89.
6 *Ibid.*, pp.62–3.
7 G. F. Waagen, *Treasures of Art in Great Britain*, 1854, vol.II, p.72; the other two sentences are complimentary and the quoted remark was probably not intentionally cynical.
8 Gibbons Papers, F. Danby to J. Gibbons, 2 March 1828.
9 E.g. 'The Day after the Battle of Chevy Chase' (BI 1812, present whereabouts unknown) which was purchased by the Marquis of Stafford. The large sketch for this painting was in the 1820 memorial exhibition at Bristol (now Wolverhampton Art Gallery).
10 Feaver, *op.cit.*, p.55.
11 *Ibid.*, fig.11, p.26.
12 Adams, p.65.
13 Gibbons Papers, F. Danby to J. Gibbons, 28 October 1825.
14 RA Library: E. B. Jupp Catalogues of the Royal Academy of Arts, vol. XI fo.263, F. Danby to H. P. Parker, 16 September 1828.
15 Musée d'Art et d'Histoire, Geneva: Adams (32).
16 Gibbons Papers, F. Danby to J. Gibbons, 2 January 1833.
17 BL Add. MS 36511 fo.129, G. Cumberland Sr to G. Cumberland Jr, 25 February 1826.
18 *Ibid.*, fo.147, 22 March 1826.
19 Edmund Gosse (ed.), *The Letters of Thomas Lovell Beddoes*, 1894, pp.96–7.
20 Gibbons Papers, F. Danby to J. Gibbons, 13 February 1826.
21 *Ibid.*, 8 May 1828. The whereabouts of Martin's painting are unknown.
22 Feaver, *op.cit.*, p.92 and pl.65b.
23 Balston, *op.cit.*, p.186; Feaver, *op.cit.*, p.91; J. D. Wees and M. J. Campbell, 'Darkness Visible' The Prints of John Martin, exhibition catalogue, Sterling & Francine Clark Institute, Williamstown, Mass. U.S.A., 1986, pp.33, 38, 42, 50.
24 *Literary Gazette*, 1825, quoted by Revd John Eagles in *Felix Farley's Bristol Journal*, 26 February 1825.
25 *Literary Gazette*, 1824, p.298, quoted by Adams, p.81, whose discussion of the relationship between Martin and Danby, pp.79–81, remains the most astute.

ROYAL ACADEMY

1 Gibbons Papers, F. Danby to J. Gibbons, 20 February 1828.
2 *Ibid.*, 1 February 1829.
3 *Ibid.*, 17 January 1829.
4 *Ibid.*, 24 February 1829.
5 Adams, p.68.

SCANDAL

1 Gibbons Papers, F. Danby to J. Gibbons, 10 July 1829.
2 *Ibid.*, 3 November 1829.
3 *Ibid.*, 22 November 1829.
4 *Ibid.*, 10 December 1829.
5 *Ibid.*, Hannah Danby to J. Gibbons, 10, 12 and 21 December 1829.
6 *Ibid.*, F. Danby to J. Gibbons, 24 January 1830.
7 *Ibid.*, 16 June 1830.
8 *Ibid.*
9 *Ibid.*, 28 December 1834.
10 *Ibid.*, 29 February 1836.
11 *Ibid.*, E. V. Rippingille to J. Gibbons, 16 December 1830.
12 *Ibid.*, J. King to J. Gibbons, 26 August 1832. Ellen Evans was possibly the sister of William Evans of Bristol, a former pupil of Danby, see *William Evans of Bristol (1809–1858)* (exh.cat.), Martyn Gregory, London, 1987: introduction by Francis Greenacre.
13 Gibbons Papers, F. Danby to J. Gibbons, 25 May 1830 and 2 September 1830.
14 1851 census: Rill Cottage, Exmouth: Frederick, aged 20, unmarried, born Belgium.
15 Redgrave, pp.443–4.
16 Gibbons Papers, J. King to J. Gibbons, 26 August 1832.
17 *Ibid.*, E. V. Rippingille to J. Gibbons, 28 June 1831.
18 *Ibid.*, C. Moore to J. Gibbons, 2 November 1838.

SWITZERLAND

1 Gibbons Papers, J. A. O'Connor to J. Gibbons, 24 June 1830.
2 *Ibid.*, F. Danby to J. Gibbons, 23 July 1830.
3 *Ibid.*, J. A. O'Connor to J. Gibbons, 17 May 1831.
4 *Ibid.*, F. Danby to J. Gibbons, 15 August 1830.
5 *Ibid.*, 9 October 1830.
6 *Ibid.*, 2 November 1830.
7 *Ibid.*, 3 December 1830.
8 *Ibid.*, 1 January 1831.
9 *Ibid.*, 19 May 1831. In the summer of 1830 there had been a number of minor revolutions throughout Western Europe.
10 For references to G. F. Robson see also cat.nos.100, 106, 109, 111.
11 Gibbons Papers, F. Danby to J. Gibbons, 19 May 1831.
12 F. Danby to G. F. Robson, 23 March 1832, letter in the Henry Bicknell album, Yale Center for British Art; Gibbons Papers, F. Danby to J. Gibbons, 13 March 1832.
13 Gibbons Papers, *ibid.*
14 RA, Minutes of the Council, 11 November 1831, quoted by Adams, p.91.
15 Gibbons Papers, J. King to J. Gibbons, 31 December 1834– 3 January 1835. King met and greatly admired Madame Amélie Munier-Romilly (1788–1875), who gave him this information.
16 *Ibid.*, F. Danby to J. Gibbons, 25 October 1832; see also previous fn.
17 *Ibid.*, 2 January 1833.
18 *Ibid.*, 29 February 1836.
19 See cat.no.36, fn.1.
20 Gibbons Papers, F. Danby to J. Gibbons, 25 October 1832.
21 *Ibid.*, 17 October 1834.
22 Häusermann, p.228.
23 Gibbons Papers, J. King to J. Gibbons, 31 December 1834– 3 January 1835.
24 *Ibid.*, F. Danby to J. Gibbons, 17 October 1834.
25 Häusermann, p.228. Häusermann lists the four (unidentified) paintings which were shown at the Musée Rath in August 1835 and

rapturously reviewed in *Le Fédéral*: 'Mountain Landscape with Setting Sun', 'View of a Norwegian Lake before the lifting of the Morning Mist', 'Entry to a Sea-port', and 'Sunset at Sea after a Storm'.
26 Gibbons Papers, F. Danby to J. Gibbons, 15 April 1836.
27 *Ibid.*, 29 February 1836.
28 *Ibid.*, 5 December 1835.

PARIS

1 Gibbons Papers, F. Danby to J. Gibbons, 16 May 1836.
2 Sold Sotheby's, Slane Castle, Co. Meath, 12 May 1981 (421): Adams (172). It illustrates a poem from *Irish Melodies* by Thomas Moore, a former acquaintance of Danby in London.
3 Gibbons Papers, F. Danby to J. Gibbons, October 1836.
4 *Ibid.*, 27 April 1837.
5 *Ibid.*, 31 August 1837.
6 *Ibid.*, (copies), F. Danby to W. Gibbons, 8 October 1837, 12 March 1838, 17 March 1838 (original MS), 28 March 1838, 26 June 1838; *ibid.*, F. Danby to J. Gibbons, 28 November 1837, 9 December 1837, 23 December 1837, 4 February 1838.
7 *Ibid.*, (copy), F. Danby to W. Gibbons, 8 October 1837, quoted by Adams, p.98.
8 *Ibid.*, F. Danby to J. Gibbons, 28 November 1837.
9 *Ibid.*, 4 February 1838.
10 *Ibid.*, (copies), F. Danby to W. Gibbons, 12 March 1838 and 26 June 1838, quoted at length by Adams, p.99.

LONDON

1 *Pigot's London Directory*, see Adams, p.159, fn.38.
2 BL Add. MS 28509, F. Danby to R. Griffin, quoted in full by Adams, pp.141–2.
3 W. M. Thackeray in *Fraser's Magazine*, 1840, p.420, quoted at length by Adams, pp.106–7.
4 For Eric Adams' masterly interpretation of 'Liensfiord Lake' see Adams, p.122. There is no evidence that Danby visited Norway a second time.
5 Gibbons Papers, F. Danby to J. Gibbons, October 1841.
6 Adams (142).
7 Gibbons Papers, F. Danby to J. Gibbons, 1 July 1842. This could be the 'Lake Landscape', Yale Center for British Art (Adams (143)), which is also stiff and soulless, and perhaps in part by one of Danby's sons.

8 Gibbons Papers, F. Danby to J. Gibbons, 17 December 1827, 23 July 1830 and 17 October 1834.
9 *Ibid.*, October 1836.
10 15 Ranelagh Grove: Gibbons Papers, F. Danby to J. Gibbons, 27 October 1841.
11 *Ibid.*, 1 July 1842. A letter from F. Danby to George Mason of Birmingham, 30 November 1842, concerning the subject matter of 'A Contest of the Lyre and the Pipe in the Vale of Tempé' (Adams (174)), gives the reply address: Post Office, Greenwich (Avon County Reference Library, Bristol: 28436).
12 Yale Center for British Art, letter in the Henry Bicknell album, F. Danby to Mogford, from Gravesend, undated.
13 Gibbons Papers, F. Danby to J. Gibbons, 21 June 1844.
14 See cat.no.44, fns.2–4.
15 The BI catalogue for the exhibition opening in January 1847, gives his address as Exmouth, Devon.
16 Gillott owned Adams (74), (209), (210), (216). Pemberton owned fourteen oil sketches (see cat.no.50) and Adams (203), (211).

EXMOUTH

1 'View of Star Cross from Exmouth', *c*.1818–20, watercolour, $14\frac{3}{8} \times 26\frac{3}{4}$ in, Sun Life Assurance, Bristol. Exmouth Public Library has a large pen and ink view of Exmouth of *c*.1930 which is described by E. R. Delderfield, (*Exmouth Milestones*, Exeter, 1948, pp.104–5) as copied from a sketch by Danby of 1826.
2 The sequence of houses listed in the 1851 census, and contemporary maps strongly suggest that Rill Cottage, Rill Lane is now the enlarged house, Yosemite, Rhyll Grove, above North Street.
3 Gibbons Papers, F. Danby to Mrs Gibbons, 5 November 1856, quoted at length by Adams, p.114.
4 *Art-Union Monthly Journal*, December 1848, p.369, quoted by Adams, p.111.
5 Gibbons Papers, F. Danby to J. Gibbons, 22 November 1848.
6 *Ibid.*, 24 August 1851, see Adams, pp.111–12.
7 *Western Luminary*, Exeter, 18 May 1852, p.3.
8 *Trewman's Exeter Flying Post*, 15 August 1860.
9 Exeter Library has a photocopy of the specification and of the lithograph of the design. The patent was granted to James Danby in April 1861.
10 *Western Daily Press*, Bristol, 13 February 1861, p.2.
11 This is the date carved on Danby's tombstone and recorded in the obituaries in the *Athenaeum* (1861, p.294) and the *Art Journal* (1861, p.118). Four local journals (see Adams, p.161, fn.44), beginning with *Trewman's Exeter Flying Post* (20 February 1861, p.5), give 9 February.

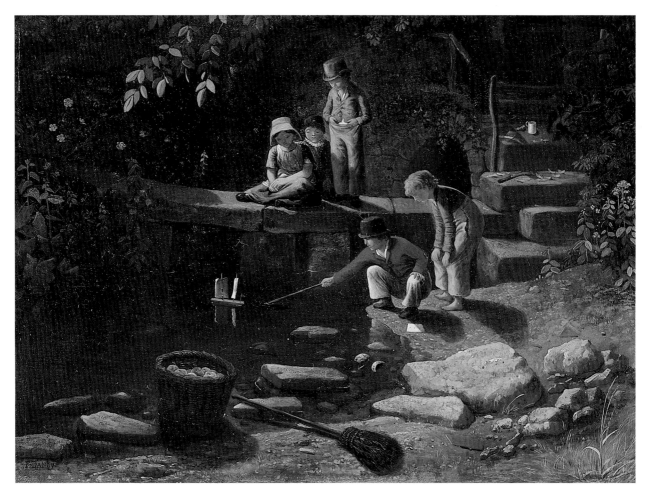

1 **Boys Sailing a Little Boat** *c.*1822
(cat.no.13)

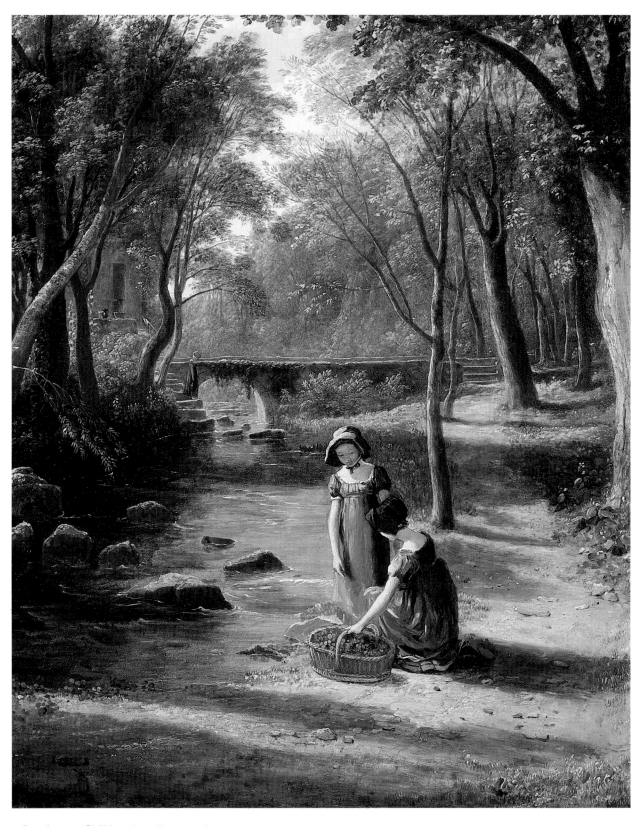

2 Landscape, Children by a Brook *c*.1822–3
(cat.no.15)

3 **Landscape near Clifton** *c*.1822–3
(cat.no.9)

4 **View of the Avon Gorge** 1822
(cat.no.10)

5 **A Scene in Leigh Woods** 1822
(cat.no.11)

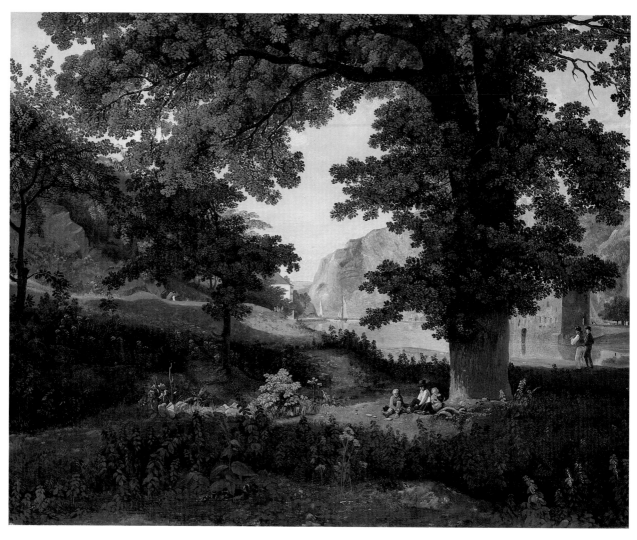

6 **Clifton Rocks from Rownham Fields** *c.*1821
(cat.no.8)

7 **River Scene with Weir and Mill** *c.*1823
(cat.no.17)

8 **Sunset at Sea after a Storm** 1824
(cat.no.20)

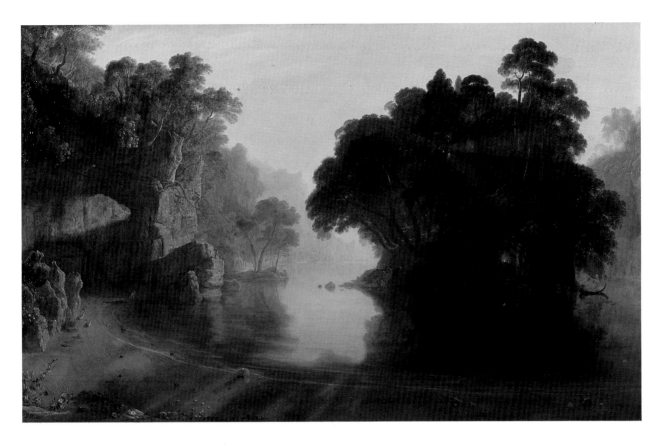

9 **An Enchanted Island** 1824
(cat.no.21)

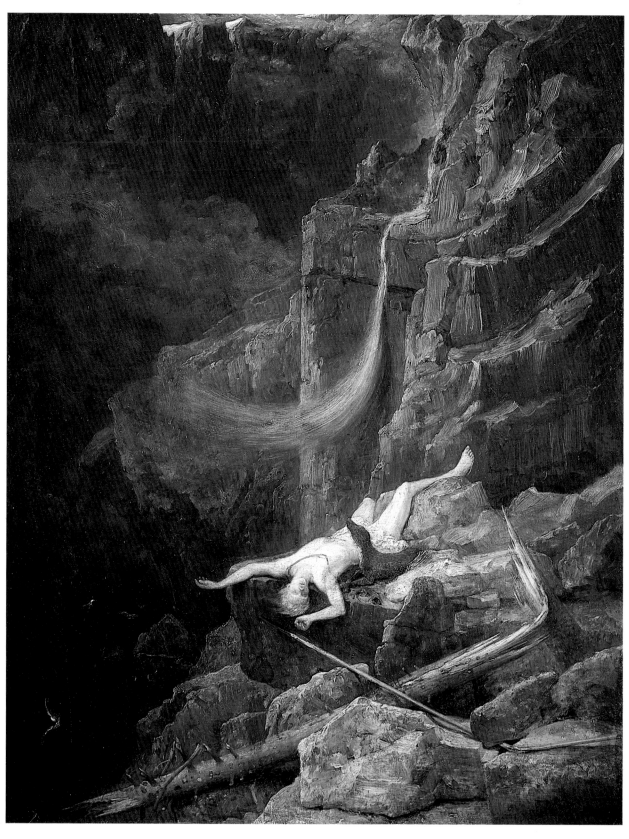

10 **The Precipice** *c.*1827
(cat.no.25)

11 **The Baptism of Clorinda** 1834
(cat.no.34)

12 **The End of Lake Geneva** 1835
(cat.no.36)

13　**Boat-building near Dinan**　*c*.1838
(cat.no.39)

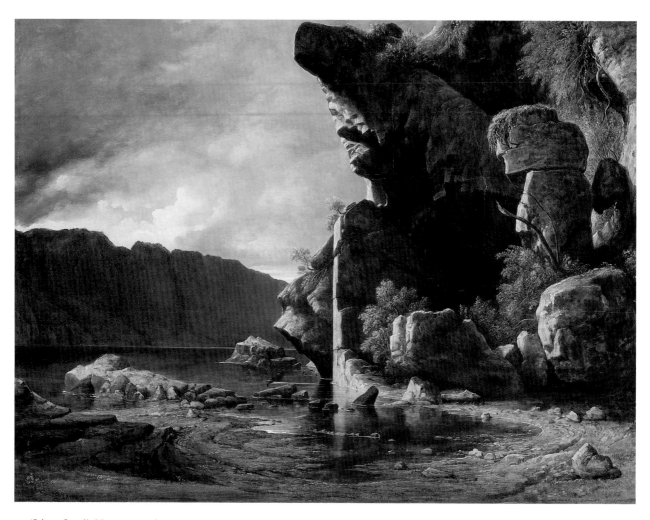

14 'Liensfiord', Norway *c*.1835
(cat.no.35)

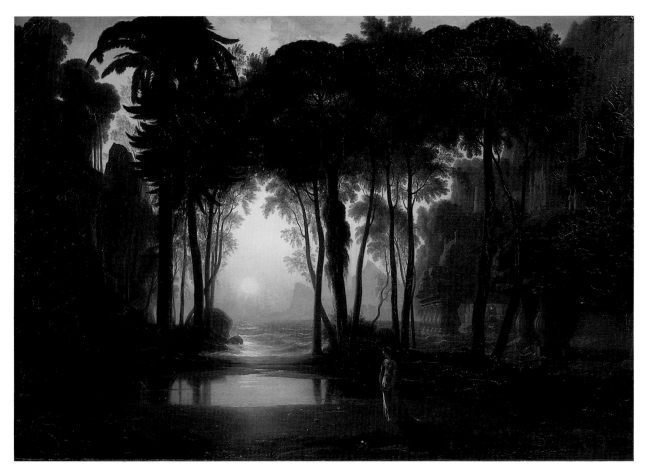

15 The Enchanted Castle – Sunset 1841
(cat.no.42)

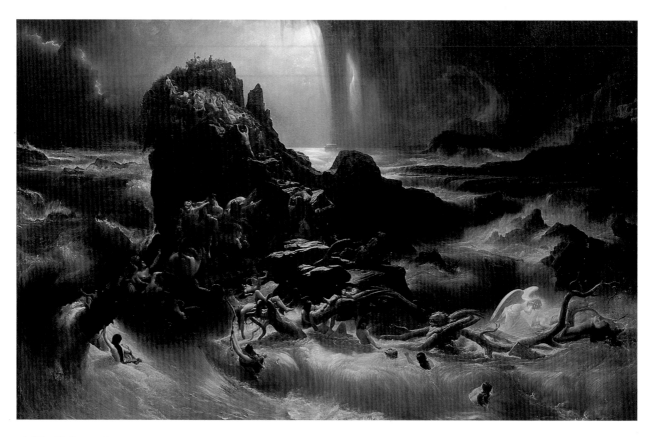

16 **The Deluge** 1837–40
(cat.no.40)

17 **Dead Calm – Sunset, at the Bight
of Exmouth** 1855
(cat.no.47)

18 View from the
Drawing Room of
the Artist's House
at Exmouth *c.*1855
(cat.no.58)

19 **Sunset across the Exe** *c*.1855
(cat.no.56)

20 **Sunset through Trees** *c*.1855
(cat.no.57)

21 **Castle Archdale on Lough Erne, Co. Fermanagh**
c.1812 (cat.no.62)

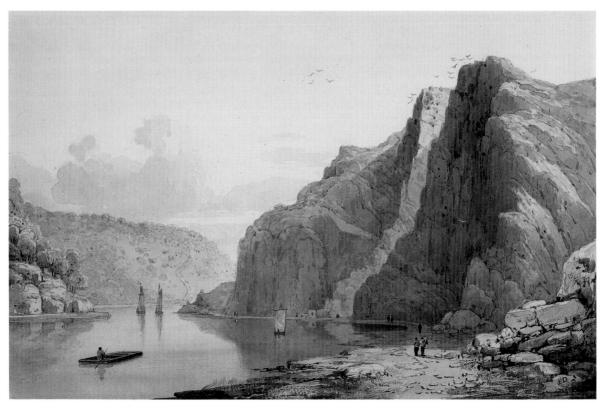

22 **St. Vincent's Rocks and the Avon Gorge**
c.1815 (cat.no.66)

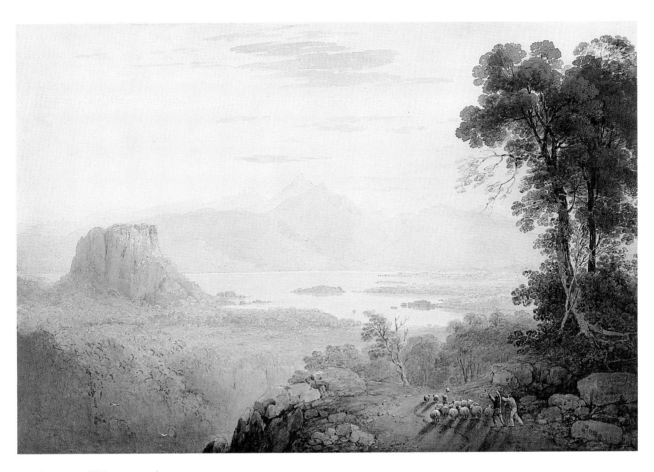

23 **View near Killarney** *c*.1817
(cat.no.69)

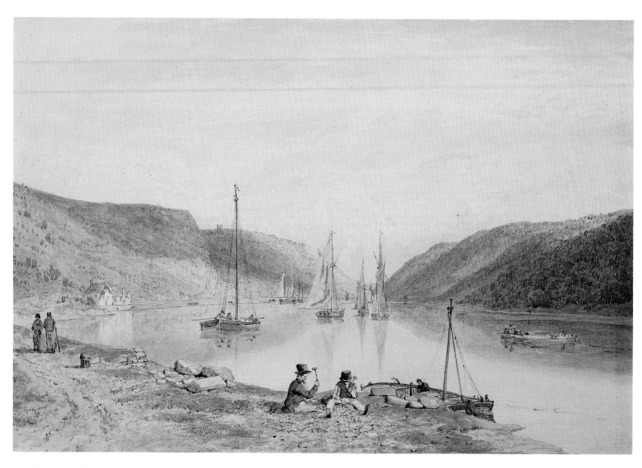

24 The Avon Gorge from beneath Sea Walls
1820 (cat.no.72)

25 **Rownham Ferry, Bristol** *c.*1820
(cat.no.82)

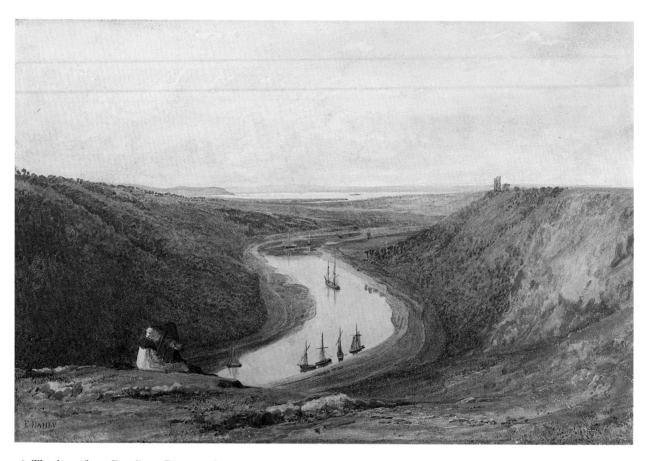

26 **The Avon from Durdham Down** *c.*1821
(cat.no.84)

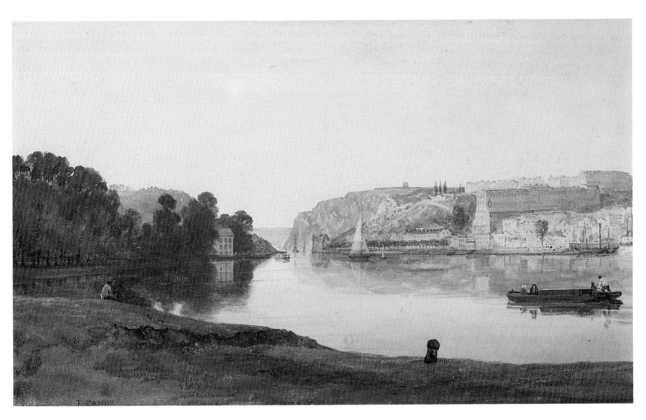

27 **The Avon at Clifton** *c.*1821
(cat.no.83)

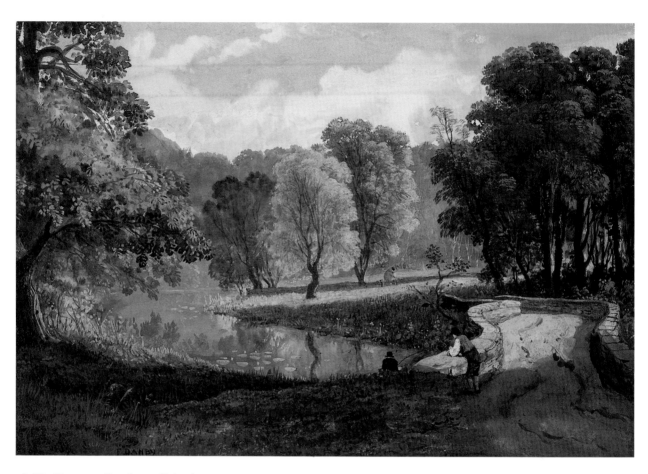

28 The Frome at Stapleton, Bristol
c.1823 (cat.no.91)

29 **River Scene with Boat and Figures**
c.1825 (cat.no.92)

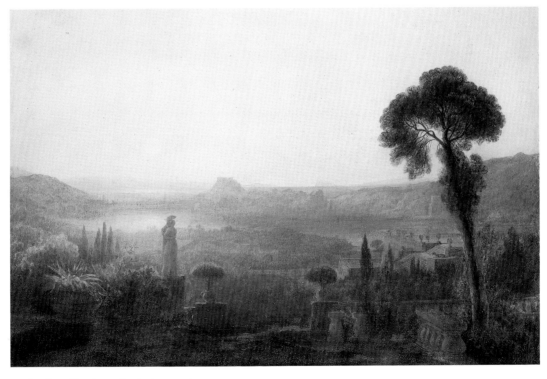

30 **Ancient Garden** 1834 (cat.no.112)

31 **Pont de la Concorde with L'Assemblée
Nationale, Paris** 1831 (cat.no.106)

32 **La Sorcière on Lake Geneva** 1832
(cat.no.108)

33 **A Mountain Lake, Norway** 1827 or later
(cat.no.98)

34 **The Procession of Cristna** *c.*1830
(cat.no.99)

35 **Oberon and Titania** 1837
(cat.no.110)

Biographical Details

1793
16 November: born at Common, near Killinick, six miles south of Wexford, Ireland; son of James Danby, small landed proprietor, and his second wife, Margaret Watson; one sister, a twin brother who dies young, a half-sister and two half-brothers.

1798
Wexford rebellion; members of his family fight on both sides.

1799
Danby family move to Dublin.

1807
James Danby dies; estate settled on children of his first marriage, Francis left unprovided for.

1813
Ends studies at the drawing schools of the Dublin Society; exhibits at Society of Artists of Ireland, 'Landscape – Evening', which he sells to Archdeacon Hill for 15 guineas.
June: arrives in London with J. A. O'Connor and George Petrie; O'Connor and Danby walk to Bristol where Danby settles.

1814
4 July: marries Hannah Hardedge at Winscombe, Somerset.

1815
4 March: first son, Francis James, born, and later baptised at Compton Bishop, Somerset. Possibly visits Wales.

1817
Second son, James, baptised at Compton Bishop, Somerset. Evans' *Bristol Index* lists 'Danby F. A. *painter landscape*' at 21 Paul Street, Kingsdown.

1818
Third son, John, born (?).

1819
Until 1822: lives at 9 Kingsdown Parade (now No. 34).

1820
'Upas Tree' (cat.no.18) exhibited at the British Institution.
January: earliest references to Danby in the letters between George Cumberland and his son.

1821
'Disappointed Love' (cat.no.19) exhibited at the Royal Academy. Fourth son, Thomas, born (?).

1822
'View of the Avon Gorge' (cat.no.10), only dated Bristol oil painting.

1823
Lives at Woodfield Cottage, Redland, Bristol.

1824
April or May: hastily moves to London leaving substantial debts behind him. 'Sunset at Sea after a Storm' (cat.no.20) exhibited at Bristol Institution, Park Street, then at the Royal Academy, where Danby's address is recorded as 4 Dove Street, Kingsdown; purchased by Sir Thomas Lawrence PRA.
July: visits John Constable's studio.

1825
'An Enchanted Island' (cat.no.21) exhibited at British Institution and added to Bristol Institution's exhibition of Old Master paintings in June.
January: first of over one hundred surviving letters written to his patron, John Gibbons. 'The Delivery of Israel out of Egypt' (cat.no.22) exhibited at the Royal Academy; sells for £500.
July and August: travels in Norway.
November: elected an Associate of the Royal Academy.
Until 1829: lives at 14 Mornington Crescent, Hampstead Road, London.

1826
February: accuses John Martin of plagiarism, abandons 'Sixth Seal' (cat.no.24).
May: has scarlet fever.
June: considers moving out of London to avoid expense.
Summer: visits North of England and North Wales.

1827
January: W. B. Cooke, engraver and publisher, asks Danby to succeed J. M. W. Turner and do drawings of the west coast of Great Britain to be engraved; nothing comes of this project.
February: family now consists of his wife, mother and six children. 'The Embarkation of Cleopatra' (see cat.no.27) exhibited at the Royal Academy.
August: fifth son, William Gibbons, born (?).
November: vists Lynmouth and Bristol. Plans diorama.

Autumn: sale of the copyright of 'The Delivery of Israel out of Egypt' (cat.no.22) for £300 rescues Danby from despair; does first watercolours for albums.
December: working again on 'Sixth Seal' (cat.no.24) whose copyright Colnaghi promises to buy.

1828

'Sixth Seal' (cat.no.24) exhibited at Royal Academy, sold to William Beckford for 500 guineas, copyright sold to Colnaghi for £300; receives prize of 200 guineas from British Institution.
Summer: visits Derbyshire, Yorkshire where four sons are at school, and Wales. Travels up the Meuse in Belgium and visits Amsterdam with William Collins, R A.

1829

February: defeated by one vote by John Constable in election to R A.
July: visits Bristol, meets the artist, P. F. Poole, attends drawing party.
November: on the edge of financial ruin.
By December: has fled from his creditors to Paris.

1830

January: returns briefly to London for the funeral of Sir Thomas Lawrence PR A.
May: moves from Paris to Bruges.
June: joined by his seven children, and, presumably earlier, by his mistress, Ellen Evans; accuses his wife of deserting their children and, by inference, of forming liaison with P. F. Poole. Son, Frederick, born in Belgium.
July: sale of pictures remaining in his London lodgings.
October: moves to Aix-La-Chapelle.
December: moves to Neuwied near Coblenz, Germany, for the winter and makes abortive plan to float on a raft up the Rhine and on to the Mediterranean with his family.

1831

May: lodges with Monsieur Curti near Rapperswil on Lake Zurich, Switzerland, together with his family; sends a parcel of drawings to John Gibbons and another, in June or July, to the artist, G. F. Robson.
11 November: council of the Royal Academy agree to send Danby £50, to help him and his family in their distress.

1832

January: completes his own long poem *Cristna* and finishes a political pamphlet; neither survives.
August: arrives penniless in Geneva with his family; stays first at Hôtel du Cheval Blanc, then Les Paquis and, by 1834, at Montalègre, Cologny outside Geneva.
By October: 'The Baptism of Christ' commissioned by the friends of the Musée Rath, Geneva; completed the following year.

1833

January: states that he is continuing a treatise on painting begun at Rapperswil.

1834

24 May: son, Alfred, born.
Summer: builds the fastest sailing boat on Lake Geneva.
October: Dr John King of Bristol visits Danby.
November: reported as heavily in debt and as having ten children, seven by his wife and three by his mistress.
December: Sir Samuel Egerton Brydges tempts Danby to believe he could be heir to an earldom.

1835

January: his poem, *Cristna* rejected by the publisher, John Murray.
Summer: exhibits four landscapes at the Musée Rath, Geneva.
October: his debts reported as paid and his resident's permit is renewed.

1836

May: moves to Paris; lives at 8 rue Vanneau, Faubourg St Germain until, at least, 1838.
November: meets the artist and entrepreneur, William Jones.

1837

William Jones commissions 'The Deluge' (cat.no.40); copies Poussin's 'Deluge' in the Louvre. Exhibits at the Royal Academy for the first time since 1831: 'Rich and Rare Were the Gems She Wore'.
27 November: Ellen Evans dies.

1838

Between February and June three of his children die. Three-year gap in the surviving correspondence with John Gibbons begins.
July: probably visits Brittany. Copies Ruisdael, Claude, Titian, Guido Reni and Rembrandt at the Louvre.

1839

Pigot's London Directory gives his address as 15 Rathbone Place.

1840

May–June: 'The Deluge' (cat.no.40) exhibited at 213 Piccadilly.

1841

Exhibits 'Liensfiord Lake' (cat.no.41) and 'The Enchanted Castle' (cat.no.42) at Royal Academy, both acquired by William Jones.
October: lives at 15 Ranelagh Grove, London.

1842

July: writes to John Gibbons from Gravesend.

1844

Until 1846: living at Catford Hill, Lewisham, Kent.

1845

'The Gate of the Harem' (see cat.no.43) exhibited at British Institution and purchased by Queen Victoria; 'The Wood-Nymph's Hymn to the Rising Sun' (cat.no.44) exhibited at the Royal Academy and purchased by Lord Northwick.

1846

Settles in Exmouth; from 1847 until 1856 recorded as living at Rill Cottage above North Street, now probably Yosemite in Rhyll Grove.

1848

Exhibits 'The Evening Gun – a Calm on the Shore of England' (see cat.no.48) at the Royal Academy. Spends much of the summer boat-building and sailing.

1851

August: John Gibbons dies. Census records Danby living with two sons, Frederick and Alfred, and a cook and housemaid; Alfred dies, probably in September.

1855

'Dead Calm – Sunset, at the Bight of Exmouth' (cat.no.47) exhibited at the Royal Academy.

1856

Until his death, lives at Shell House, on the Maer, Exmouth.

1857

April: lectures on the history of painting to an audience of 600 at Exmouth.

1860

August: shipwrecked off Axmouth in his new yacht *Dragon Fly*.
October: applies for a patent for a single-fluked anchor; to be granted to his son James in April 1861.
Christmas: visits the watercolourist Samuel Jackson in Bristol.

1861

10 February: dies at Shell House; buried at St. John-in-the-Wilderness, Withycombe, Exmouth.
15 May: posthumous sale of pictures, sketches and drawings, Messrs Foster, 54 Pall Mall, London.

Catalogue

Catalogue Notes

The pictures have been divided into oil paintings, watercolours and drawings, monochrome wash drawings, and prints. A small number of works on paper have been included amongst the oil paintings because they illustrate important oil paintings not included in the exhibition. Works are listed in approximate date order and with consideration of their likely grouping within the exhibition. Original titles have been used where possible.

As far as possible references to exhibitions have only been included if the exhibition was of relevance to the early history of the picture or if the catalogue adds to our knowledge or understanding of the work; likewise with references to literature.

Dimensions are given in inches followed by millimetres in brackets; height precedes width. Except for cat.no.27 the measurements of engravings refer to the size of the image.

Works illustrated in colour are marked * and appear between pages 41 and 72.

Abbreviations

BI	British Institution, London
BL	British Library, London
BM	British Museum, London
RA	Royal Academy, London
V & A	Victoria and Albert Museum, London

Abbreviations of frequently cited literature
(place of publication is London unless otherwise stated)

ADAMS Eric Adams, *Francis Danby: Varieties of Poetic Landscape*, New Haven and London, 1973

BRISTOL SCHOOL 1973 Francis Greenacre, *The Bristol School of Artists: Francis Danby and Painting in Bristol 1810–1840*, exhibition catalogue, Bristol, 1973

DANBY 1961 Arts Council, *Francis Danby 1793–1861*, exhibition catalogue, 1961 (written by Eric Adams)

EAGLES Revd John Eagles, *The Sketcher*, Edinburgh and London, 1856 (originally published in *Blackwood's Edinburgh Magazine*, 1833–5)

GERDTS & STEBBINS William H. Gerdts and Theodore E. Stebbins, Jr, '*A Man of Genius': The Art of Washington Allston (1779–1843)*, Boston, U.S.A., 1979

GREENACRE & STODDARD Francis Greenacre and Sheena Stoddard, *The Bristol Landscape: The Watercolours of Samuel Jackson 1794–1869*, Bristol, 1986

GRIGSON Geoffrey Grigson, 'Some Notes on Francis Danby, A.R.A.' in *The Harp of Aeolus, and other Essays on Art, Literature and Nature*, 1948

HÄUSERMANN H. W. Häusermann, 'Francis Danby at Geneva', *The Burlington Magazine*, vol. XCI, no.557, August 1949, pp.227–9

REDGRAVE Richard and Samuel Redgrave, *A Century of Painters of the English School*, 2 vols., 1866

YOUNG John Young, *A Catalogue of the Pictures at Leigh Court, near Bristol; the Seat of Philip John Miles, Esq. M.P. . . .*, 1822

Manuscript sources

Extensive use has been made of the Cumberland correspondence in the British Library and of the Gibbons Papers. The Eagles Papers are in the possession of Philip Graham-Clarke. In quoting from manuscript sources, spelling and punctuation have sometimes been modernised in order to make the meaning clear.

Oil Paintings

1 **A Lake Scene in Ireland** *c*.1813
 Oil on panel 26 × 31 (660 × 787)
 PROV: purchased in the Bristol area *c*.1930 by
 F. T. Love, thence by descent
 EXH: *Bristol School* 1973 (1)
 LIT: Adams (1); John Hutchinson, *James Arthur
 O'Connor*, exhibition catalogue, National Gallery of
 Ireland, 1985, pp.87–9
 Private Collection

There is good reason to believe that this work is by both
Danby and James Arthur O'Connor (1792–1841) and was
painted immediately after the two close friends had walked
from London to Bristol in the summer of 1813.

It once bore a label attributing it to both Danby and
another unidentified artist.[1] W. J. O'Driscoll in *A Memoir
of Daniel Maclise* (1871) states that Danby, O'Connor and
George Petrie (1790–1866) after their arrival in Bristol
'painted a kind of "joint-stock picture" on a pretty large
scale, each taking that part of the work for which he felt
himself best qualified. O'Connor did the landscape and
background, Petrie finished some architectural ruins, and
to Danby was allotted the figures and foreground. The
picture was sold by them in Bristol, and the proceeds
divided. O'Connor and Petrie returned to Dublin'.[2] Petrie
did not, in fact, pass through Bristol with his friends having
been earlier summoned back by his father to Dublin from
London.[3] Nor is the architecture in the painting of suf-
ficient substance or antiquarian interest to be likely to be by
Petrie.

Although the naive figures are close to those in
O'Connor's earliest dated oil paintings,[4] their profile faces,
Roman noses and hump backs are closer still to the figures
in the foregrounds of some of Danby's earliest Bristol
watercolours.[5] The rocks and foreground foliage, the
crowded ferry boat and carefully drawn reflections in the
water foreshadow Danby's later Bristol work, while the
trees, the distance and especially the sky are closer to
O'Connor.

It has been suggested that the scene is a view in County
Wicklow,[6] a reminder that John Mintorn, writing to the
Western Daily Press on 20 February 1861, tells us that
Danby's first sales in Bristol were 'Two small sketches of
the Wicklow Mountains, near Dublin, in a somewhat
dilapidated state'.[7] However, Mintorn also implies that
O'Connor stayed only a day in Bristol before catching the
sailing packet to Cork.

'A Lake Scene in Ireland' was not Danby's first oil
painting. He had studied at the drawing school of the

1

Dublin Society and in 1813 had exhibited 'Landscape –
Evening' at the Society of Artists' annual exhibition in
Hawkins Street, Dublin.[8] It was the sale of this landscape
to Archdeacon Hill of Dublin that enabled Danby to go to
London.[9]

1 Adams, p.169.
2 Quoted at greater length by Hutchinson, *op.cit.*, pp.88–9.
3 William Stokes, *Life and Labours in Art and Archaeology of George
 Petrie*, 1868, p.9.
4 Hutchinson, *op.cit.*, especially 'Westport Quays', 1818, collection of
 Lord Altamont, illus. in col. p.65.
5 See cat.no.70.
6 *Bristol School* 1973, p.42.
7 Quoted by Adams, p.5, almost in its entirety.
8 Danby in his letter to Richard Griffin, Adams, p.141, states that his
 first oil painting was shown at the Society of Arts, Dublin 'in the
 summer of which year I came to England' but he mis-states the year.
9 *Art Journal*, 1855, p.78.

2 **View of Clifton from Leigh Woods** *c*.1818–20
 Oil on panel $18\frac{1}{4}$ × $23\frac{7}{8}$ (463 × 606)
 Inscribed in ink on label on reverse in
 G. W. Braikenridge's hand 'View of Bristol |
 F Danby | No 17'
 PROV: purchased by George Weare Braikenridge,
 c.1824; sale of W. J. Braikenridge, Claremont,
 Clevedon, Nichols, Young, Hunt & Co., Bristol,
 9–10 June 1913 (584); G. Hamilton-Smith sale,
 Glendining, London, 21 March 1927 (157),
 purchased by Bristol Art Gallery

2

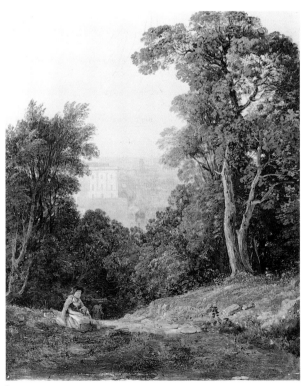

3

EXH: *Danby* 1961 (1); *Bristol School* 1973 (5)
LIT: Adams (11)
City of Bristol Museum and Art Gallery

The uneasy jump between the theatrical foreground setting and the detailed view of Clifton suggests that this is one of Danby's earliest Bristol oils. The rather mannered and conventional handling of the oak tree on the left and the ash trees on the right, together with the picturesque figure, also imply an early date. But the very carefully observed and stormy light effects, so successfully uniting the side view of Clifton, are also found in the watercolour of 'Rownham Ferry' (cat.no.82) and the small oil, 'The Floating Harbour' (cat.no.5).

Excepting 'A Lake Scene in Ireland' (cat.no.1) it is probable that Danby did no oil paintings during his first three or four years in Bristol.

This unusual view looks end-on at Windsor Terrace on its vast brick abutment, which was to cause the bankruptcy of its first developer. To the left is the end of the curving Paragon, high above St. Vincent's Parade and the avenue leading downstream to the Hotwells.[1] Immediately to the right of Windsor Terrace is the rotunda in the gardens of Goldney House above Clifton Wood. Also breaking the skyline is the truncated spire of St. Mary Redcliffe rising above Albemarle Row and Granby Hill. The very tall building near the bottom of Granby Hill was the Gloucester Hotel which took particular pride in its supply of fresh turtle. Of the group of small buildings beside the Avon only the uppermost, Hinton Cottage, survives today. The construction of Freeland Place, which was to run across the open ground to the right of Hinton Cottage, was probably well advanced by 1822.[2]

[1] Windsor Terrace and The Paragon, although begun in 1790 and 1809, respectively, were not completed until about 1812 and 1815; The Paragon was later extended, see Walter Ison, *The Georgian Buildings of Bristol*, 1952, pp.226–7 and 235–6.
[2] A pencil drawing by James Johnson (1803–1834) shows Nos. 1–7 Freeland Place erected and may be dated to 1822 or 1823 (City of Bristol Museum and Art Gallery, K5168).

3 **A View over Bristol from Leigh Woods**
c.1818–20
Oil on panel $8\frac{1}{8} \times 6\frac{5}{8}$ (206 × 168)
Inscribed in ink on reverse: 'Danby 1829'
PROV: purchased from Hall & Rohan Ltd, Bristol, 1962
EXH: *Bristol School* 1973 (3)
LIT: Adams (30)
City of Bristol Museum and Art Gallery

The viewpoint, which carefully avoids the unsightly backs of the recently completed Clifton terraces, looks towards Windsor Terrace and St. Mary Redcliffe from Rownham Hill. The abrupt division between foreground and distance in the previous work has been resolved by the easily

assimilated use of the composition of Claude Lorrain (1600–1682) 'Landscape: Hagar and the Angel' of 1646, then in the collection of Sir George Beaumont (National Gallery, London). J. M. W. Turner (1775–1851) and John Constable (1776–1837) had already been inspired by this famous painting.

Although Danby's small panel bears the date 1829, a year in which he is known to have made a brief visit to Bristol and spent a day in Leigh Woods,[1] it was certainly painted many years earlier, as the two picturesque figures most obviously imply.[2] The handling of paint is more fluent and confident than that of the previous work and similar to the early 'View down the Wye Valley' (fig.9) (Yale Center for British Art, Paul Mellon Collection).[3]

[1] BL Add. MS 36512 fo.202, G. Cumberland Jr to G. Cumberland Sr, 21 July 1829; Gibbons Papers, F. Danby to J. Gibbons, 23 July 1829.
[2] Adams, p.176, while reluctantly accepting the date 1829, points out that the composition is similar to Constable's 'Dedham Vale' (RA 1828) but this composition itself undoubtedly derived from the Claude and was first used by Constable in the 'Dedham Vale' of 1802 (Victoria and Albert Museum).
[3] Previously called 'The Avon Gorge', Adams (10) fig.19.

4 A Street in Tintern c.1820–2
Oil on panel 11 × 9 (279 × 228)
Inscribed in ink on label on reverse: 'A Street in Tintern | F. Danby'
PROV: purchased from the artist by John Gibbons; Gibbons sale, Christie's 29 November 1912 (94 part lot), probably bought by a member of the Gibbons family; thence by descent
EXH: *Bristol School* 1973 (4)
LIT: Adams (13)
Private Collection

In a letter from Geneva written in 1836 to his long-standing patron, John Gibbons, Danby referred to 'the razor grinder I did once for you'.[1] It is possible that 'A Street in Tintern' was Gibbons' first purchase from Danby and also that it was a commission which encouraged the direction and character of a significant group of Danby's Bristol paintings. Gibbons had a particular sympathy for English genre and especially for contemporary artists combining both genre and landscape painting.[2]

The uncertain perspective of the buildings, the awkward scale of the figures and the rather picturesque appearance of some of them, suggest that Danby was new to such subject matter. However, the bold effects of sunlight and shadow confidently linked by the figures, the strong colouring and the easy naturalism of the group of children and of the men outside the inn are impressive. The idea of painting a quiet and ordinary village scene in the late afternoon summer sunshine may have been prompted in part by Gibbons and by the example of the Bristol artists Edward Bird (1772–1819) and Edward Villiers Rippingille

(1798–1859), but the treatment of the subject is closest of all to Mulready and especially to his 'The Farrier's Shop' of c.1811 (Fitzwilliam Museum, Cambridge, fig.11).

There is a complete vertical break in the panel which Danby himself restored in 1828. 'I have no doubt that I can mend the small one so as not to be seen', he wrote to his patron on 2 March. By 4 June he was writing defensively that 'joining takes some time' but by 17 August the work was completed.[3]

At the same time Danby also reworked another early commission for Gibbons, 'The Avon Gorge and Clifton Down' (cat.no.7). These two paintings are also referred to in a letter of 31 January 1825 when Danby was trying to settle his accounts over the advance payments for 'An Enchanted Island' (cat.no.21). 'You ordered a Picture when I was in redland, and advanced me at that time £20, you advanced me at another time in dove Street £30. I finished the picture which I valued at £30.'[4] The only recorded time when Danby had an address in Redland, Bristol, as opposed to nearby Kingsdown was in 1823 when he gave his address to the Royal Academy as 'Woodfield Cottage, Redland, Bristol'. '4 Dove Street, Kingsdown, Bristol' was the address he gave the following year. Danby was peculiarly casual about dates and it is tempting to think that 'A Street in Tintern' is stylistically earlier than the implied date of 1822 or 1823.[5]

[1] Gibbons Papers, F. Danby to J. Gibbons, 29 February 1836.
[2] *Catalogue of Pictures from the collection of John Gibbons Esq late of Hanover Terrace, Regents Park*, Christie's 26 May 1894. Gibbons owned two or more works by Augustus Wall Callcott (1779–1844), William Collins (1788–1847), Thomas Creswick (1811–1869), Charles Robert Leslie (1794–1859), John Linnell (1792–1882), Richard Redgrave (1804–1888) and Thomas Webster (1800–1886). There were five paintings by William Mulready (1786–1863).
[3] Gibbons Papers.
[4] *Ibid.*
[5] A copy of poor quality was on the London art market in 1984.

5 The Floating Harbour, Bristol c.1822–3
Oil on panel 6 × 8 (152 × 203)
Signed: 'F DANBY'
PROV: C. H. Abbott; thence by descent
EXH: *Danby* 1961 (6); *Bristol School* 1973 (16)
LIT: Adams (17)[1]
M. V. Robinson

Despite the emphasis on incident and atmosphere the topography is accurately depicted. The view looks along the Floating Harbour from Wapping towards Clifton where the terraces and the tower of the new parish church of St. Andrew's, completed in the summer of 1822, catch the sun. Below the tower is the Limekiln Lane glasshouse and on the left beyond the house is a kiln, probably the source of the bricks which are being loaded in the foreground. An identical view in watercolour by Samuel Jackson (1794–1869) of about 1823, depicting the scene at

twilight but without the foreground figures, confirms the accuracy of Danby's detail.[2].

There are similarities between this work and the frieze of working men in John Linnell's 'Kensington Gravel Pits' of 1813 (Tate Gallery) and the light effects of Mulready's 'The Farrier's Shop' (Fitzwilliam Museum, Cambridge, fig.11). Adams points out that the vivid contrast of sunlight against the storm clouds is probably related to the missing 'Clearing up after a Shower' exhibited at the Royal Academy in 1822 and that the composition resembles Jacques-Laurent Agasse (1767–1849) 'Landing at Westminster Bridge' shown at the Royal Academy in 1818.

[1] Recent conservation has shown that the condition of the painting is good and not 'much rubbed' as Adams recorded.
[2] City of Bristol Museum and Art Gallery, K2741 : illus. in col. Greenacre & Stoddard, pl.16.

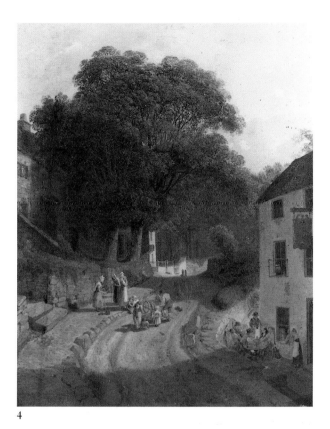

4

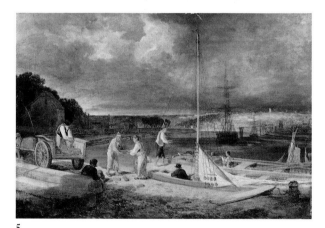

5

6 The Avon Gorge *c*.1820

Oil on panel 5 × 10 (127 × 254)
PROV: C. H. Abbott ; thence by descent
EXH: *Danby* 1961 (12); *Bristol School* 1973 (15a ex cat.)
LIT: Adams, p.172, under (17) as pupil of Danby
Private Collection

The view looks upstream to Windsor Terrace with the setting sun catching St. Vincent's Rocks. On the south bank Nightingale Valley is already in the shade. The ruined lime-kiln at the foot of St. Vincent's Rocks, which had featured prominently in many picturesque views of the Avon Gorge by visiting artists *en route* for Wales, was probably removed in 1821 or 1822 when the new road from the Hotwells to Clifton Down was constructed.[1]

The two figures on the path on the left and the uncertain scale of the figures near the lime-kiln recall those in Danby's earliest Bristol watercolours. This small oil may be the first of Danby's attempts to evoke the stillness of a summer evening. He was clearly aware of the manner in which the evening light exaggerates the character of the opposing sides of the Avon. The heavily wooded south side, softly contoured, dark, receding and with an element of mystery is contrasted with the barren projecting heights of St. Vincent's Rocks. Fires on the two trows relieve the dark shade and the two figures on the left and the vessel in the centre carefully break the hard outlines.[2]

[1] George Cumberland records the completion of the road and of the New Hotwell House in his letter to his son 20 May 1823, BL Add. MS 36509 fo.212, but a drawing by Hugh O'Neill (1784–1824), dated October 1821, shows the New Hotwell House (City of Bristol Museum and Art Gallery, M3370), and John Latimer's *The Annals of Bristol in the Nineteenth Century*, Bristol, 1887 (p.84), states that Bridge Valley Road was laid out in 1822.
[2] Adams suggested that this painting may be the work of a pupil but recent conservation has dispelled any doubts. It is in very good condition.

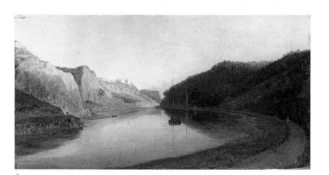

6

7 **The Avon Gorge and Clifton Down** *c.*1823
Oil on canvas $9\frac{1}{2} \times 13\frac{7}{8}$ (241 × 352)
PROV: purchased from the artist by John Gibbons;
sale of Mrs John Gibbons, Christie's 26 May 1894
(17); Fine Art Society, London 1953
EXH: *Danby* 1961 (13); *Bristol School* 1973 (15) but
not shown
LIT: Adams (18)
Lent Anonymously

This is one of the two paintings which Danby restored and reworked for his patron, John Gibbons, in 1828. The other was 'A Street in Tintern' (cat.no.4). Danby himself preferred the larger of the two, 'The Avon Gorge and Clifton Down', and undertook to 'improve the poor figures in it'.[1] Recent conservation suggests that a substantial part of the foreground and in particular the strong orange reflections may have been overpainted at this time.

Danby's letter to his patron on 31 January 1825 (quoted, cat.no.4) implies that this painting was probably executed during Danby's last summer in Bristol in 1823.

The view looks downstream from well below the entrance to Nightingale Valley. The hill and pathway on the left appear also in 'View of the Avon Gorge' (cat.no.10). The cliffs are neither St. Vincent's Rocks nor Sea Walls as they have previously been called,[2] but the main cliffs of Clifton Down, midway between the two better-known rock faces.

1 Gibbons Papers, F. Danby to J. Gibbons, 2 March 1828.
2 *Danby* 1961 (13); *Bristol School* 1973 (15).

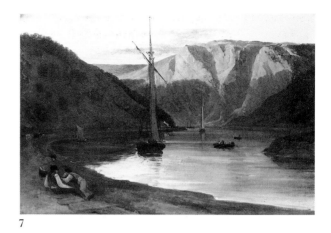

7

8

8 **Clifton Rocks from Rownham Fields*** *c.*1821
Oil on panel $15\frac{3}{4} \times 20$ (400 × 508)
Inscribed in ink on label on reverse in
G. W. Braikenridge's hand: 'Clifton Rocks | from
Rownham Fields | F. Danby | No 18'
PROV: George Weare Braikenridge; sale of
W. J. Braikenridge, Claremont, Clevedon, Nichols,
Young, Hunt & Co., Bristol, 9–10 June 1913 (585);
G. Hamilton-Smith sale, Glendining, London, 21
March 1927 (156), purchased by Bristol Art Gallery
EXH: Arts Council, *The Romantic Movement*, 1959
(94); *Danby* 1961 (10); Castle Museum, Norwich
and V & A, *A Decade of English Naturalism*, 1969
(19); *Bristol School* 1973 (12)
LIT: Adams (12)
City of Bristol Museum and Art Gallery

A surprisingly large area of the painting is devoted to the careful observation of disturbed ground and wasteland weeds. This emphasis, together with the abrupt uprights of the tree trunks, the ill-shod boys lolling in the sun and the two quarrymen, gives this work a determined naturalism that is strikingly different from the gentility of the pair of paintings of 1822 (cat.nos.10, 11). Samuel Jackson's contribution to the folio of lithographs, on which Danby, Jackson and James Johnson worked in 1823 (see cat.no.130) also shows the same scene and includes men collecting earth.[1]

The painting is likely to date from 1821 on both stylistic and topographical grounds. The Old Hotwell House seen on the right was already partly demolished by October 1821.[2] Samuel Jackson, however, certainly included the Old Hotwell House in his watercolours for the antiquarian collector, G. W. Braikenridge, for two or three years after its demolition.[3] Although Braikenridge was the first owner of Danby's painting, it seems unlikely that it was actually painted for him (see cat.no.89). Danby carefully adapts the branches of the oak tree to reveal the lime-kiln beneath St. Vincent's Rocks and the ruined windmill which the artist William West (1801–1861) was soon to convert to an observatory.

The contrasts of light and shade are stronger, the outlines sharper and the foreground details much crisper and bolder than the dated pair (cat.nos.10, 11) of 1822. It is

likely that this painting falls between those works and 'Disappointed Love' (cat.no.19) which would have been begun in 1820 and which is stiffer and less assured in technique.

1 Greenacre & Stoddard, pl.59.
2 See cat.no.6, fn.1.
3 Greenacre & Stoddard, pls.22–4.

9 **Landscape near Clifton*** c.1822–3
 Oil on canvas 36 × 28 (914 × 711)
 EXH: The Iveagh Bequest, Kenwood, London,
 Gaspard Dughet . . . and his influence on British art,
 1980 (85)
 LIT: Adams (16)
 Yale Center for British Art, Paul Mellon Collection

9

The view looks out across the Avon from a point in Leigh Woods just below that from which the Clifton Suspension Bridge now springs. The afternoon sun catches the end of Windsor Terrace to the right of which the masts and smoking funnel of a steamboat can be seen. Far below are a vessel's sails demonstrating the steepness of the cliff and the separation of the two opposing sides of the river. Danby appears to emphasise the detachment of the 'regions of beauty and enchantment',[1] as Revd John Eagles called Leigh Woods, from 'the cold working world',[2] but without needing to break free from being the mere 'remembrancer of localities', whom Eagles contemptuously condemned.[3] Danby paints an enclosed and intimate scene of pleasant retreat whose spectacular setting adds considerable drama. It is far from the escapist fantasy that Eagles recommended but certainly reflects the influence of the congenial visits of the artists and amateurs to Leigh Woods.

Eagles was not only the chief enthusiast of Leigh Woods but also of Gaspard Dughet whose imitation he endlessly advocated. He had copied two of the Gaspards in the Miles Collection at Leigh Court, near Bristol,[4] one of which, 'The Cascatellas at Tivoli',[5] is particularly close to Danby's painting. Not only is the composition similar but Windsor Terrace replaces Tivoli and, as Eric Adams succinctly observed, the figures are 'Gaspard's Virgilian shepherds done from life'.[6] The elegantly curving and intertwined tree trunks and branches also recall Gaspard and Eagles, and are a feature too of 'Landscape, Children by a Brook' (cat.no.15). Both works are painted with a light touch and a silvery grey-green palette that is very different from the harder and brighter colouring of most of the Bristol landscapes. This distinctive technique is also to be seen in John Linnell's masterpiece 'The River Kennet, near Newbury' of 1815 (Fitzwilliam Museum, Cambridge, fig.12),[7] although evidence of specific influence cannot be established (see introduction p.21).

A soft-ground etching entitled 'Clifton' by John Sell Cotman (1782–1842) reverses the composition of a draw-ing taken from almost exactly the same spot. It was published in his *Liber Studiorum* in 1838 but drawn and probably also etched many years earlier.[8]

It is tempting to try to identify the figures in this painting and, to a lesser degree, those in 'A Scene in Leigh Woods' (cat.no.11). Eric Adams tentatively recognised the man seated in the foreground as Edward Bird RA and the resemblance is close.[9] Bird died in 1819 and Adams suggests the painting was, in effect, a memorial to him. If Danby had followed the practice of his close friend, E. V. Rippingille, he would have used his friends as models in his painting, but although Bird did occasionally visit Leigh Woods, the idea of a memorial in this form is uncharacteristic, and the likeness is probably fortuitous.[10]

1 Eagles, p.151.
2 *Ibid.*, p.12.
3 *Ibid.*, p.11.
4 Eagles Papers, label in green album.
5 Young (40) illus. The present whereabouts of this painting are unknown.
6 Adams, p.32.
7 Exh: *Society of Painters in Oil and Watercolours*, 1816 (13). Linnell substantially repainted the sky many years later.
8 Exh: The Iveagh Bequest, Kenwood, London, *Gaspard Dughet . . . and his influence on British art*, 1980 (89) illus.
9 Adams, p.34. Eric Adams discusses this painting at length on pp.27–34.
10 Eagles, p.132, where Eagles implies Bird went to the woods for the sake of company rather than art.

10 **View of the Avon Gorge*** 1822
Oil on panel $13\frac{5}{8} \times 18\frac{3}{8}$ (346 × 466)
Signed and dated: 'Fr DANBY | 1822'
PROV: purchased with cat.no.11 from Hall & Rohan
Ltd, Bristol, 1956
EXH: *Danby* 1961 (8); *Bristol School* 1973 (13)
LIT: Adams (8)
City of Bristol Museum and Art Gallery

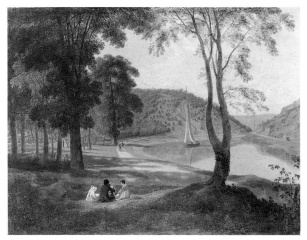

10

The view looks downstream across the entrance to
Nightingale Valley, the favourite haunt of the artists of the
Bristol School. A quarry barge is being towed up the Avon,
and Sea Walls is in the far distance. Bridge Valley Road,
which was to cut steeply up and around the bank on the
right was almost certainly under construction by the
summer of 1822, but Danby has not allowed anything to
disturb the tranquillity of the scene.

There can be little doubt that 'A Scene in Leigh Woods'
(cat.no.11) which is a view of the uppermost part of
Nightingale Valley, was painted as a pair to this painting.
Such an ambitious undertaking is very likely to have been a
commission. The patron is unknown but it is tempting to
consider a member of the important Bright family who
lived nearby and amongst whose family papers, some
drawings and watercolours by Danby have recently been
found (cat.nos.78–80).[1] There is an elegance about these
two paintings, a sense of being on the fringes of a country
gentleman's park, that is very different from 'Clifton Rocks
from Rownham Fields' (cat.no.8).

[1] Richard Bright of Ham Green, near Bristol, purchased the 'Surrender
of Calais' by the Bristol artist Edward Bird in about 1822: Eagles
Papers, red morocco album, letter from Mr Moore to J. Eagles,
21 April 1823.

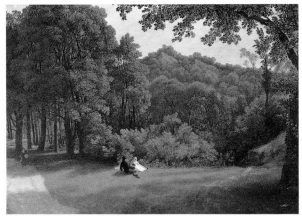

11

11 **A Scene in Leigh Woods*** 1822
Oil on panel $13\frac{7}{8} \times 19\frac{7}{8}$ (352 × 504)
PROV: purchased with cat.no.10 from Hall & Rohan
Ltd, Bristol, 1956
EXH: Arts Council, *The Romantic Movement*, 1959
(95); *Danby* 1961 (9); *Bristol School* 1973 (14)
LIT: Adams (9)
City of Bristol Museum and Art Gallery

There is a remarkable boldness in the relatively unrelieved
greens of this painting. The variation of colour is very
carefully recorded and there is exact control of the
changing tones and tints of the distance. In both this
painting and its companion the sun seems to penetrate
more naturally within the foliage, and the shadows are no
longer so dense.

The artist gives the impression of having retreated a
short distance from his companions, two sketchers in this
instance and a father and perhaps his three daughters in the
previous work, in order to record not only a delightful
landscape but also the relaxed enjoyment of his friends.

Revd John Eagles' nostalgic reflections in *The Sketcher*
evoke the *camaraderie* of the artists' excursions to Leigh
Woods. His descriptions of the scenery itself show how
easily his enthusiasm might have affected the younger
artists: 'Beautiful June! Why is it that all painters have
failed to represent the many green hues of this luxuriant
month?'. After describing Leigh Woods as 'the very best
painting-ground of a close kind', he describes these greens:

> they were of all shades, but rich as if every other colour
> had by turns blended with them, yet unmixed, so
> perfect in predominance was the green throughout. So
> varied likewise was the texture, whether effected by
> distance, by variety of shade, by opposition, or by
> character of ground. There was much of the emerald,
> not in colour only, but in its transparent depth.[1]

[1] Eagles, pp.296–7.

12

12 The Snuff Mill, Stapleton *c.*1822
Oil on *papier mâché* board 8¾ × 12 (222 × 305)
Inscribed in ink on label on reverse in
G. W. Braikenridge's hand: 'Landscape & | Figures.
F. Danby | No.22 near | Stapleton'
PROV: George Weare Braikenridge; sale of
W. J. Braikenridge, Claremont, Clevedon, Nichols,
Young, Hunt & Co., Bristol, 9–10 June 1913 (579
part lot); G. Hamilton-Smith sale, Glendining,
London, 21 March 1927 (158), purchased by Bristol
Art Gallery
EXH: *Danby* 1961 (11); *Bristol School* 1973 (8)
LIT: Adams (7)
City of Bristol Museum and Art Gallery

The weir and part of the snuff mill depicted here survive in Snuff Mill Park on the river Frome, in Bristol. With the exception of the earliest of the series of Stapleton paintings, 'Figures at Wickham Bridge, Stapleton',[1] the location of the other scenes can no longer be identified and in some instances is generalised.

Danby has used a *papier mâché* panel, perhaps to take advantage of its ready-made smooth surface and to avoid the necessity of building up a gesso ground on wood or canvas. He may also have hoped for effects of greater depth and transparency in the shadows. Unfortunately more of the black ground is now seen through the paint and the painting as a whole has darkened. The strong sunlight, in particular, has lost its brilliance.

[1] Sotheby's 7 October 1981 (221), oil on canvas, 15⅛ × 15¼ in, purchased Spink & Son Ltd, private collection; not seen by the author but the stylised foreground foliage suggests a date of *c.*1819–20.

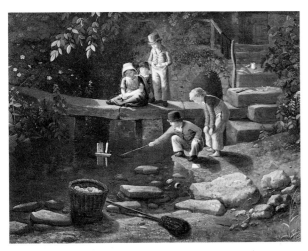

13

13 Boys Sailing a Little Boat* *c.*1822
Oil on panel 9¾ × 13¼ (247 × 336)
Signed: 'F. DANBY'
Inscribed in ink on label on reverse in
G. W. Braikenridge's hand:
'Boys sailing a little | Boat F. Danby | No.19 |
Stapleton near | Bristol'[1]
PROV: George Weare Braikenridge; sale of
W. J. Braikenridge, Claremont, Clevedon, Nichols,
Young, Hunt & Co., Bristol, 9–10 June 1913 (579
part lot); Mrs N. Garland; purchased by Bristol Art
Gallery, 1954
EXH: *Danby* 1961 (7); *Bristol School* 1973 (11)
LIT: Adams (15)
City of Bristol Museum and Art Gallery

One of the children has been sent to peel the potatoes that remain forgotten in the basket in the foreground. On the steps is the knife that has, instead, been used to carve the sailing boat. Much delightfully observed detail encircles the children emphasising their innocent concentration.

The narrative element becomes of secondary importance before this sensitive image of the self-contained world of childhood.

The enclosed and sky-less scene has a peculiar intimacy. There is considerable confidence and originality in the concept and the composition of the painting, and a sympathetic affection for children is reflected in their varied poses. Although the emphasis on childhood in the Stapleton paintings may well have been encouraged by E. V. Rippingille and perhaps indirectly by the poet, John Clare, it should not be forgotten that Danby's own first four sons were born in 1815, 1817, 1818 and 1821 and that he probably also already had a daughter.

[1] The last three words may be by a later hand.

14 Children by a Brook *c.*1821

Oil on canvas laid on panel $13\frac{9}{16} \times 18\frac{1}{8}$ (345 × 460)
PROV: Sotheby's 7 July 1982 (47), bought Spink & Son Ltd
LIT: *The Tate Gallery, 1982–4: Illustrated Catalogue of Acquisitions*, 1986, p.16
Trustees of the Tate Gallery

The three figures are repeated in the very much larger painting of the same title at the Yale Center for British Art (fig.10).[1] In that work there is a glimpse of the sky. Here the density of the shade is emphasised and the three separate vistas, although illuminated with strong shafts of sunlight, are cut off, creating an almost claustrophobic feeling. Although this is probably an imaginary scene, such enclosed effects are typical of the steep wooded hillsides of the Frome at Stapleton.

The limited variety of the greens in comparison with 'A Scene in Leigh Woods' (cat.no.11) of 1822 suggests that this work is close in date to 'Disappointed Love' (cat.no.19) exhibited in 1821.

[1] 'Children by a Brook' $29\frac{1}{2} \times 24\frac{1}{2}$ in: Adams (14) fig.23.

14

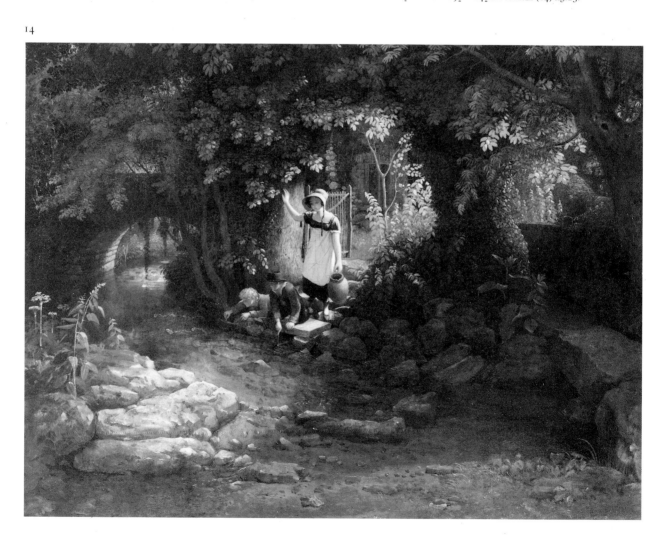

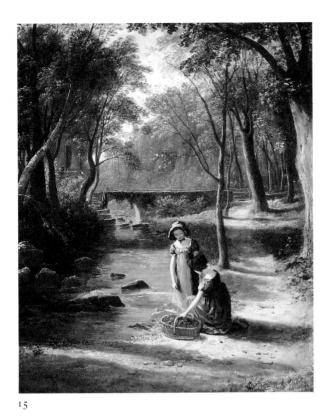

15

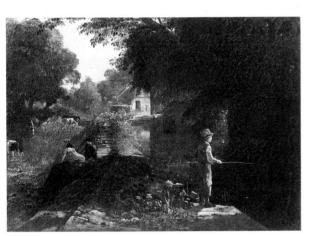

16

15 Landscape, Children by a Brook* c.1822–3
Oil on panel $13\frac{1}{2} \times 10\frac{3}{4}$ (340 × 275)
Inscribed on label on reverse: 'Landscape – by Blake
| Royal Artist – <u>good</u> picture | Frederick Tolcher's –
1857 – | This picture and the other on | same wall by
Condy | is an equivalent for the Family | Portrait
above by Northcote'
PROV: Tolcher family; Christie's 12 May 1877
(107); Mrs E. Turner, Sotheby's 18 November 1987
(84), bought Spink & Son Ltd
*By kind permission of His Grace, the Duke of
Westminster, D.L.*

This painting has the freedom of technique, broader
brushwork, and the softer, less enamel-like colouring
found in Yale's large 'Landscape near Clifton' (cat.no.9).
There is also a similar and conscious elegance in the
curving and overlapping tree trunks, quite different from
the straighter and stouter trunks of some of the other
Stapleton paintings. The difference may well reflect the
influence of Revd John Eagles who was to advise artists to
'take some few liberties with the forms of boughs, and make
them bend to each other, and give them a more social and
conversational repose than you see'.[1]

[1] Eagles, p.67.

16 Boy Fishing, Stapleton *c.*1822–3
Oil on panel $5\frac{1}{8} \times 7\frac{1}{4}$ (130 × 184)
Inscribed in ink on label on reverse in
G. W. Braikenridge's hand:
'Boy Fishing | F.Danby No.24'
PROV: George Weare Braikenridge; sale of
W. J. Braikenridge, Claremont, Clevedon, Nichols,
Young, Hunt & Co., Bristol, 9–10 June 1913 (579
part lot); G. Hamilton-Smith sale, Glendining,
London, 21 March 1927 (159), purchased by Bristol
Art Gallery
EXH: *Danby* 1961 (4); *Bristol School* 1973 (9)
LIT: Adams (5)
City of Bristol Museum and Art Gallery

This small painting is composed with great care. The
figures are judiciously placed and as naturally part of the
landscape as the cows. These beasts are reminiscent of
those in the first of Constable's 'six-footers', 'The White
Horse', shown at the Royal Academy in 1819.[1] However, it
is the more broken colour and brushwork that suggests the
specific influence of Constable. Danby could have seen
'The Hay Wain' at the Royal Academy in 1821 as well as at
the British Institution in 1822.[2] The subject matter of
Danby's small painting, with its emphasis on the children
fishing, is also seen in 'The Young Waltonians', the second
of Constable's six-foot canvases, which was shown at the
Royal Academy in 1820.[3]

Constable had been elected an Associate of the Royal Academy in 1819 and there is no evidence of particular antagonism between the two artists until they became rivals for full membership. We know that Danby 'was delighted' by his first visit to Constable's studio in 1824 and Constable himself recorded that he 'rather liked the young man'.[4]

The same mill and weir appear in another painting which is very different in style, confirming the personal and experimental nature of the present work.[5]

[1] 'A Scene on the River Stour' ('The White Horse'), Frick Collection, New York.
[2] 'Landscape: Noon' ('The Hay Wain'), National Gallery, London.
[3] 'Landscape' ('Stratford Mill') known as 'The Young Waltonians', National Gallery, London.
[4] R. B. Beckett (ed.), *John Constable's Correspondence*, Ipswich, vol.2, 1964, p.355.
[5] 'A Wooded River Landscape with Boys Fishing in a Stream', oil on panel, 10 × 15 in, Phillips 12 December 1977; exh. Spink & Son Ltd, *English Oil Paintings*, 1978 (32) illus; private collection. Painted in a similarly crisp technique to 'Children by a Brook' (cat.no.14), it is earlier than cat.no.16, and is probably the painting lent by D. W. Acraman, the Bristol iron-founder and important collector, to the Bristol Institution in 1829: 'Stapleton Mill – Boys Seeking Eels'.

17

17 River Scene with Weir and Mill* *c*.1823

Oil on canvas 15¼ × 24¾ (387 × 628)
Signed: 'F.DANB[Y]'
PROV: purchased from H. G. Simpson, Bristol, 1956
EXH: *Danby* 1961 (5); *Bristol School* 1973 (10)
LIT: Adams (3)
City of Bristol Museum and Art Gallery

Danby's fascination with rich and deep shadows and with the effects of sunlight shining through trees, is here taken to an extreme. He appears to set himself a deliberate challenge, bringing off a technical *tour de force* with marvellous assurance. The flickering sunlight emphasises the quiet seclusion of the scene. The variety and experimental nature of many of the Stapleton paintings seem impressively demonstrated by this work. It cannot, however, be grouped with them with absolute assurance.

Although purchased by Bristol Art Gallery as a painting of the Snuff Mill at Stapleton, none of the known mills on the Frome is depicted and the topography of the scene suggests it is not a scene on the Frome at all.[1]

It has very recently been realised that the apparent maker or supplier of the canvas, Alfred Hill, whose name and address are stamped clearly on the back, was in business on his own only from 1850 to 1858.[2] The painting is on a prepared artist's canvas with a ready-made white ground, unlined and on its original stretcher. Alfred Hill, carver, gilder, picture dealer and artists' colourman, appears to have retired by 1859 having taken over from his father, W. C. Hill, who had supplied frames to Danby's patron, John Gibbons.[3]

It is quite possible that the canvas was stamped by Alfred Hill in the 1850s when he may have reframed or restored the painting. Alternatively, this work, once seen as one of Danby's earliest oil paintings,[4] was actually painted in the last decade of his life. Its free, bold and confident technique can be compared to the small oil sketches (cat.nos.53–60) and the scenery could be the gentler valleys behind Exmouth, but no other paintings of similar size and subject matter of this period are known.

The situation is further complicated by the painting's provenance. It was purchased by Bristol Art Gallery in 1956 from a local dealer who was often optimistic with the signatures he added to paintings and drawings. The signature in this instance has been adjudged original although the possible date, which was once interpreted as 1819, is quite illegible.

[1] The compiler is indebted to Mr O. H. Ward for this observation.
[2] Stamped: 'FROM | ALFRED HILL'S | Artists Repository | Frame Maker etc | No 12 Clare Street | BRISTOL'; *Mathews's Bristol Directories*.
[3] Gibbons Papers, letters to J. Gibbons, 1825–1830; for W. C. Hill see G. Beard and C. Gilbert (eds.), *Dictionary of English Furniture Makers 1660–1840*, Leeds, 1986, p.431.
[4] Adams, p.20, and *Bristol School* 1973, p.51.

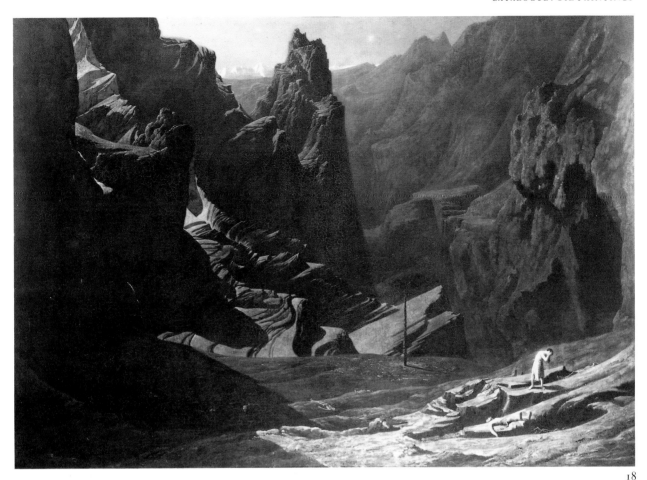

18

18 **The Upas, or Poison Tree in the Island of Java** 1819
Oil on canvas $66\frac{1}{2} \times 92\frac{3}{4}$ (1688 × 2354)
PROV: purchased from the artist by
Revd C. H. Townsend, 1829 or 1830, by whom
bequeathed, 1868
EXH: British Institution, 1820 (246); Northern
Academy, Newcastle, 1828; Carlisle Academy, 1828
(101); Royal Scottish Academy, 1828 (154)
LIT: G. F. Waagen, *Galleries and Cabinets of Art in
Great Britain*, 1857, p.177; Redgrave, pp.439–40;
Grigson, p.63; Adams, pp.14–17 (2)
Board of Trustees of the Victoria and Albert Museum

This vast painting, now displayed for the first time for over
a hundred years, marked Danby's entry to the London
scene. It was exhibited at the annual exhibition of the
British Institution early in 1820. Richard Redgrave re-
membered it as 'a wonderful first attempt' and he noted
that to 'succeed in such a subject required a poetical mind,
joined to powers of the highest order: no mere landscape
painting, no mere imitation of Nature, would suffice to
picture to us the gloomy horrors of this land of fear'.[1]

It is Redgrave, also, who provides the most succinct
description of the subject:

This fabulous tree was said to grow on the island of
Java, in the midst of a desert formed by its own
pestiferous exhalations. These destroyed all vegetable
life in the immediate neighbourhood of the tree, and all
animal life that approached it. Its poison was
considered precious, and was to be obtained by
piercing the bark, when it flowed forth from the
wound. So hopeless, however, and so perilous was the
endeavour to obtain it, that only criminals sentenced to
death could be induced to make the attempt, and as
numbers of them perished, the place became a valley of
the shadow of death, a charnel-field of bones.[2]

The fable was based very loosely on the existence of the
poisonous anchar tree. It was embellished and given
sudden credence in an article in the *London Magazine* in
December 1783. Six years later Erasmus Darwin popula-
rised the story in his *The Loves of the Plants*, a very long
poem expounding the Linnaean botanical system, inter-
spersed with even longer notes.[3] It is to these notes that
Danby referred in his appendage to the title of the painting
when it was exhibited at the British Institution: 'Vide
Darwin in his *Loves of the Plants*'.[4]

Erasmus Darwin's work would certainly have been well-
known amongst Danby's acquaintances in Bristol for

Darwin was in regular correspondence with Dr Thomas Beddoes, brother-in-law of Danby's friend, Dr John King.[5] The Upas soon became a familiar literary image. Samuel Taylor Coleridge, who was often in Bristol until 1814, twice notes the Upas Tree in a memorandum book of the 1790s, and Robert Southey, Bristol-born and, likewise, a friend of King, mentions it in his epic poem *Thalaba*, published in 1801, which Danby certainly read.[6] It occurs in Byron's *Childe Harold's Pilgrimage* published in parts between 1812 and 1818, in which latter year appeared the first English article seeking to sort fact from fable.[7] In 1828 a critic reviewing the painting at Newcastle upon Tyne referred to the story's 'superstition or intentional false-hood',[8] and in 1833 *The Penny Magazine* felt obliged to fancy that there were few of its readers 'whose imaginations, at least in childhood' had not been delighted and terrified by the story.[9]

One event peculiar to Bristol would certainly have led many to be reminded of the fable. In 1817 a cobbler's daughter, Mary Willcocks, proved herself one of the cleverest of all imposters. With the aid of beautiful manners, peculiar habits, a strange language and a crooked Portuguese sailor, she persuaded many worthy citizens of Bristol for some three months that she was the victim of piracy and shipwreck and was, in truth, the Princess Caraboo from the island of Javasu in the East Indies.[10]

If the painting marks Danby's début in London, it also documents his move into the society of Bristol's amateur artists and intellectuals. It is with references to the 'Upas Tree' that we first hear of Danby in the letters from George Cumberland to his son in London, in January 1820:

> Mr Danby is going to send up a landscape in oil of 9 feet by 8 – called the Upas Tree of Java – it is a grand scene of desolate rocks by moonlight. I wrote to Mr Rogers about it to befriend him – take it on yourself and say it has great merit and he not one friend in London – we want a good place for his first exhibition at the Institute.[11]

The letter well reflects the nature of the support that Cumberland could give the artists of Bristol. It was followed by another the following day, 3 January 1820: 'Danby sends up his great landscape of the Upas and Gold his of the Desert and Hagar, Eagles I believe some landscapes and is going up himself . . .'.[12] Several weeks later George Cumberland Jr remembered to report back: 'Mr Danby is in a good place and much admired'.[13]

There is no further mention of Francis Gold (1779–1832) until March when he is again working on his 'Hagar in the Desert'.[14] Gold had presumably decided not to send up his painting after all. By May he had resolved to quit art altogether[15] and instead 'studied and mastered the Persian language, a task of a million times greater difficulty, entered the service of the East India Company, went out and died'.[16] He was, however, to be remembered with enor-mous enthusiasm by his friends in Bristol. Rippingille remembered him as 'a man of a highly cultivated mind . . . whose power as an artist far transcended any I have ever known possessed by anybody'.[17] Danby himself was to remember Gold as 'a man of great genius'.[18]

Gold's painting of 'Hagar in the Desert' (private collection) has very recently been rediscovered. We can now understand George Cumberland's emphasis on Gold's long and patient study of the rocks and cliff faces of the Avon Gorge and his conclusion that it would have 'been better if it was a complete solitude'.[19] Except for a portrait only two other oil paintings by Gold are recorded: a landscape 'of wild scenery', exhibited at the Royal Academy in 1820 and a 'Moonlight'.[20] It was clearly the example and especially the imagination of Gold that gave Danby the impetus to attempt so vast and novel a work as the 'Upas Tree'.[21]

Both Gold and Danby would almost certainly have seen the exhibition of paintings by Washington Allston (1779–1843) in Bristol in 1814. Championed by Coleridge and in the medical care of John King, Allston, who was enjoying one of the first one-man exhibitions ever to be held outside London, would have been much discussed by the artists and amateurs of Bristol. His large and bleak landscape of 'Elijah in the Desert'[22] (fig. 5) exhibited at the British Institution in 1818 has similarities with the 'Upas Tree', but in character, colouring and scale it is closer to Gold's 'Hagar in the Desert'.

One London reviewer made a more obvious but possibly more misleading comparison: 'There is a grand and solemn tone in this picture, which partakes much of Mr Martin's style'.[23] He was perhaps thinking of John Martin's mountainous landscape, 'The Bard' of 1817,[24] or possibly the very much smaller and also mountainous 'Macbeth'[25] shown at the British Institution at the same time as the 'Upas Tree'. Martin's 'Fall of Babylon'[26] shown the previous year, 1819, was an architectural landscape and has nothing but its size in common with the 'Upas Tree'. The reference to Martin (1789–1854) was probably nothing more than critical convenience, as Eric Adams has argued.[27]

With sound foreboding George Cumberland had written in January 1820 of the pictures of Gold, Danby and Revd John Eagles (1783–1855): 'Deserts and Upas Trees will not sell I fear nor imitations of Poussin'.[28] Danby's painting was not sold until January 1830 when he was on a hurried return trip from Paris to attend the funeral of Sir Thomas Lawrence (1769–1830). The £150 went straight to his creditors.[29] The buyer was probably the Revd Chauncy Hare Townsend who certainly owned the work by 1837.[30]

Danby's first exhibition piece was impressively and courageously dark: 'The dinginess of colour in this picture came over us, amidst the gauds and gaities of the collection, like the darkness of a thundercloud. A sublime depth and intensity characterize the solitude of the scene . . .'.[31] It

soon became darker still. After Dr Waagen had seen it in Townsend's collection he recorded in 1857 that it had 'much darkened on account of defective technical treatment; in a few years more it will hardly be visible'.[32] Soon after it was bequeathed to the Victoria and Albert Museum it was 'judiciously cleaned and revarnished' but was recognised as 'still much more dim and obscure than when first painted, owing to change of colour'.[33] By 1910 it was being described as a wreck,[34] and, still more recently, Eric Adams felt obliged to treat it as, in effect, a lost work.

It has now been most patiently and still more judiciously restored. Many layers of very thick and very discoloured varnish have been removed. It was the varnish that was the principal cause of the painting's increasing darkness. The drying cracks and the granular nature of the ground, which probably prompted the successive varnishes over the years, still reflect the light rather awkwardly and make the painting much harder to see, but the colour itself is probably close to its original appearance and the general tonality only slightly darker.

When in the Townsend collection the painting had 'a massive black and gold frame supported by Egyptian griffins on black plinth',[35] a just compliment to this extraordinarily ambitious illustration of an exotic and terrifying tale.

[1] Redgrave, pp.439–40.
[2] Ibid., pp.438–9.
[3] E. Darwin, Botanic Garden, pt II canto III, 1789.
[4] When the painting was shown at Carlisle in 1828, the catalogue entry included eleven lines of bad blank verse, possibly by Danby himself.
[5] Adams, p.146, fn.15.
[6] Gibbons Papers, F. Danby to J. Gibbons, 13 March 1832.
[7] All the above literary references including also those in William Blake are discussed by Geoffrey Grigson in his essay 'The Upas Tree' in The Harp of Aeolus and other Essays . . . , 1947, pp.56–65.
[8] The Tyne Mercury, 2 September 1828. I am grateful to Paul Usherwood, Senior Lecturer, History of Art, Newcastle upon Tyne for telling me of this excellently written review.
[9] The Penny Magazine, no.89, 24 August 1833, pp.321–3.
[10] Her portrait was painted by Edward Bird RA (City of Bristol Museum and Art Gallery, K4104: Bristol School 1973 (94)) and drawn by Nathan Cooper Branwhite (1775–1857) (City of Bristol Museum and Art Gallery, M3157).
[11] BL Add. MS 36508 fo.153, 2 January 1820 (misdated 1821).
[12] Ibid., fo.155, 3 January 1820.
[13] Ibid., 36507 fo.270, 23 February 1820.
[14] Ibid., fo.284, 23 March 1820 and fo.286, 4 April 1820.
[15] Letter from F. Gold to R. Smith, 31 May 1820 in Richard Smith's MS Bristol Infirmary Biographical Memoirs, vol.VI, Bristol Record Office 35893 (36).
[16] Art Journal, 1860, p.100, E. V. Rippingille on Sir Augustus W. Callcott RA, whose advice Gold was unwise enough to seek.
[17] Ibid.
[18] Gibbons Papers, F. Danby to J. Gibbons, 10 December 1829.
[19] BL Add. MS 36507 fo.284, 23 March 1820 and fo.286, 4 April 1820, G. Cumberland Sr to G. Cumberland Jr.
[20] Both were exhibited at the first exhibition of the Bristol Society of Artists in 1832 at the Bristol Institution (142) and (124), and the landscape was described in a review probably by John King in Felix Farley's Bristol Journal: a cutting is in Richard Smith's MS, see fn.15 above. Both paintings were certainly executed in 1820 or earlier.
[21] Eric Adams (p.147, fn.9) points out that both Gold and Dr John King would have had special interest in the story of the Upas Tree.

Gold had translated Bichat's Physiological Researches on Life and Death which was partly concerned with asphyxiation. King was closely involved with Dr Thomas Beddoes and his research into nitrous oxide at the Pneumatic Institute in Dowry Square, Bristol.
[22] Museum of Fine Arts, Boston, U.S.A.; illus. in col. Gerdts & Stebbins, p.67. For details of the pictures exhibited at Bristol, see ibid., pp.81–7.
[23] R. Ackermann, Repository of Arts, II, no.9 (1820) p.180, quoted by Adams, p.15.
[24] Laing Art Gallery, Newcastle upon Tyne, illus. in W. Feaver, The Art of John Martin, Oxford, 1975, pl.14.
[25] National Gallery of Scotland, illus. in Feaver, op.cit., pl.30.
[26] Present whereabouts unknown, illus. in Feaver, op.cit., pl.26.
[27] Adams, p.15.
[28] BL Add. MS 36508 fo.155, 3 January 1820.
[29] Gibbons Papers, F. Danby to J. Gibbons, 24 January 1830. He also sold the copyright for £80.
[30] Ibid., 9 December 1837. The painting was 'on approval' with Charles Hare of Bristol in March 1826 (ibid., 29 March 1826) and in 1829 Danby briefly thought that he had sold it, but the cheque bounced (ibid., 10 July 1829).
[31] London Magazine, I, 1820, p.448.
[32] G. F. Waagen, Galleries and Cabinets of Art in Great Britain, 1857, p.177.
[33] Art Journal, 1870, p.90; extract in V & A files.
[34] Interleaved copy of Catalogue of Oil Paintings, V & A, 1907 (in Dept. of Designs, Prints and Drawings).
[35] V & A, Revd C. H. Townsend registered file, 1868.

19 Disappointed Love 1821
Oil on panel $24\frac{3}{4} \times 32$ (628 × 812)
Signed: 'F DANBY'
PROV: John Sheepshanks by 1850 (included in 1850 handlist), by whom presented, 1857
EXH: Royal Academy, 1821 (210); Arts Council, The Romantic Movement, 1959 (93); Danby 1961 (3); Bristol School 1973 (7)
ENGR: see cat.no.131
LIT: Redgrave, pp.440–2; Adams (6)
Board of Trustees of the Victoria and Albert Museum

'Disappointed Love' was Danby's first work to be shown at the Royal Academy. He was to exhibit there annually from this year, 1821, until 1829 and thereafter sporadically. Since its presentation to the Victoria and Albert Museum by John Sheepshanks in 1857, 'Disappointed Love' has become one of his best-known paintings but it was purchased at the Royal Academy by an earlier and unknown collector and, in effect, disappeared from public view for the first thirty years of its life.

The scenery of 'Disappointed Love' is based on the dark recesses of the River Frome near Stapleton. On stylistic grounds it is difficult to regard any of Danby's other Stapleton views (cat.nos.12–16) as significantly earlier than 1820 when 'Disappointed Love' would have been begun. Although the Stapleton paintings were to be one of the most personal and original of Danby's achievements, it must be expected that the conception of this careful assault on the Royal Academy owes much to Danby's colleagues in Bristol.

19

Bristol's amateur artists such as George Cumberland (1754–1848) had already enjoyed walks at Stapleton for many years[1] and in Edward Bird's memorial exhibition held in 1820, a year after his death, there were three paintings of Stapleton.[2] Rippingille 'first began to paint in oil from nature at Stapleton', before 1819.[3] Each of these artists produced minor works depicting a girl seated alone in a wooded landscape, a reminder, as Eric Adams pointed out, that 'a distressed female in a white dress . . . and often in a wild spot, was one of the commonplaces of sentimental illustration in the 1790s'.[4] An engraving after Bird, illustrating James Thomson's *Seasons* (1730), 'with firm, clasped hands and visage downward bent; | Her faulting tongue thus gives to feeling vent', was published in 1809 and is closest in pose to Danby's desperate figure.

However, Danby was little affected by either the variety of human expression or the strong narrative element in the genre paintings of Bird and Rippingille. Nor was he moved, apparently, by the success of Rippingille's 'Post Office'

which was shown at the Royal Academy in 1819 when the critics 'licked and beslobbered' him.[5] The strength and simplicity of the image of 'Disappointed Love' have no parallels in their work. The details of Danby's narrative are incidental: the torn letter, the miniature portrait, the loose strap at her bodice and the tear in her dress. It is her pose, the sharp contrast of her muslin-clad figure with the dank, dark and solitary setting, and the brambles and drooping plants that tell the story.

'A deep, gloomy and pathetic influence pervades the picture . . . There are, however, defects in the executive part of his work, which might be obviated by more attention'.[6] This review of the Royal Academy exhibition was to be echoed by Redgrave who found the painting 'heavy, the figure ill-drawn, the weeds in the foreground outrageously out of proportion'.[7] The painting does have the character of an uneasy accumulation of on-the-spot studies, perhaps 'the faults of a young man' to which Redgrave referred, but the carefully studied figure may be a

product of Bristol's recently formed life academy which George Cumberland mentioned in January 1820.[8] For Redgrave the painting's faults were far outweighed by its 'poetical invention'.[9] It showed 'how from the first the painter had a higher aim than mere landscape painting; sought indeed to treat his picture as a poem . . .'.

Today, discoloured varnish encourages the greens to appear monotonous and the handling to be rather stiff. Full conservation of this work may well suggest a new chronology for the Stapleton paintings as well as demonstrating the care and subtlety of Danby's observation.

Eric Adams has demonstrated the affinities between 'Disappointed Love' and two poems by Samuel Taylor Coleridge, *The Picture: or the Lover's Resolution* and *To an Unfortunate Woman, Whom the Author Had Known in the Days of Her Innocence*, both published in Bristol in 1817 in *Sibylline Leaves*.[10] He also suggested that the drooping plants demonstrate Danby's understanding of one of the arguments of Erasmus Darwin's *The Loves of the Plants* to which Danby had referred in the title of the 'Upas Tree'. Darwin believed that plants were capable of pleasure and pain and Adams argues that 'Disappointed Love' 'is in part a romantic illustration of Darwin's parallel between human and vegetable love'.[11] Less convincingly, Adams also suggests the possible influence of William Blake's illustrated books and in particular of *Songs of Innocence and of Experience* (published 1794) and *The Book of Thel* (1789).[12] George Cumberland, by now clearly regularly in touch with Danby, knew Blake well, calling him 'our simple honest friend' and purchasing 'nearly all his singular works'.[13] However, there is no reason to expect Danby to have felt any natural sympathy for Blake's art.

[1] BL Add. MS 36504 fo.41, G. Cumberland Jr to G. Cumberland Sr, 10 April 1813.
[2] *Catalogue of Pictures painted by the late Edward Bird*, Bristol, 1820: (4) 'A Snuff-Mill on Stapleton River'; (7) 'Stapleton Bridge'; (48) 'Scene at Stapleton, near the Snuff Mill'.
[3] Gibbons Papers, J. King to J. Gibbons, 23 October 1829.
[4] Adams, p.19. George Cumberland's frontispiece to his own poem *Lewina, The Maid of Snowdon*, 1793, is close in spirit (City of Bristol Museum and Art Gallery, K3082. 43) and E. V. Rippingille's drawing is probably a product of one of the earliest of the evening sketching groups (City of Bristol Museum and Art Gallery, K3083). Robert Rosenblum pursues the theme further in the exhibition catalogue *De David à Delacroix*, Paris, 1974, p.347.
[5] BL Eg. MS 2246 fo.72, E. V. Rippingille to John Clare.
[6] R. Ackermann, *Repository of Arts* II, no.11 (1821) p.367, quoted by Adams, p.17.
[7] Redgrave, pp.440–2.
[8] BL Add. MS 36508 fo.257, G. Cumberland Sr to S. Cumberland, 9 January 1820: 'George's Mill is much admired here by all the artists, who now have a life academy.'
[9] This is also the implication of the reference to the painting by R. H. Horne, *Exposition of the False Medium and Barriers Excluding Men of Genius from the Public*, 1833, p.267, quoted by Adams, p.17.
[10] Adams, pp.22–3.
[11] Adams, pp.24–5.
[12] Adams, pp.23–4.
[13] BL Add. MS 36512 fo.60, G. Cumberland Sr to G. Cumberland Jr, 26 December 1827.

20

20 Sunset at Sea after a Storm* 1824
Oil on canvas $33\frac{3}{10} \times 46\frac{1}{4}$ (845 × 1174)
PROV: purchased from the artist by Sir Thomas Lawrence PRA, 1824; his sale, 15 May 1830 (115); Edward W. Lake, Christie's 11 July 1843 (64), bought Hogarth; Christie's 13 June 1851 (95), bought J. Warrender; Gambart, Christie's 3 May 1861 (278); Sotheby's 17 March 1982 (68), from a foreign collection, bought Thos Agnew & Sons Ltd, from whom purchased, 1982
EXH: Royal Academy, 1824 (350); British Institution, 1825 (119)
ENGR: mezzotint by F. C. Lewis, published 2 January 1826 by Messrs Hurst Robinson & Co; line engraving, see cat.no.135
LIT: Redgrave, p.443; Adams (159)
City of Bristol Museum and Art Gallery

1824 marked the fifth successive year in which Francis Danby had exhibited a single major work in London. Three of the previous four paintings had been noticed in the reviews, but with every compliment there had been a qualification.[1] 'Sunset at Sea after a Storm', however, astonished everyone and even the sour-tempered artist Benjamin Robert Haydon (1786–1846) thought it one of only three pictures worth looking at.[2] More important still was its purchase by the President of the Royal Academy, Sir Thomas Lawrence. It was, wrote Redgrave, the 'work that made the painter's reputation'.[3]

For a short period before they were sent up to the Royal Academy, 'Sunset at Sea after a Storm', E. V. Rippingille's 'The Stage-Coach Breakfast' (fig.3),[4] and a painting by the artist John King (1788–1847)[5] were shown at the Bristol Institution in Park Street. It was a novel event reflecting a new awareness and pride in Bristol's art. A long account of the exhibited pictures, together with others by James Johnson, Nathan Cooper Branwhite and William West which were also about to be sent up to London, appeared in the local press. Besides alluding to the presence

of a shark in the painting, the newspaper tells us that Danby had sold it before it was half finished.[6] Neither statement may have been correct at the time, but George Cumberland also noted that each of the works by Danby, Rippingille and Johnson had already been sold in Bristol.[7] Had the pre-exhibition buyer of 'Sunset at Sea after a Storm' been Sir Thomas Lawrence, with whom George Cumberland was well acquainted, Cumberland would undoubtedly have mentioned such a remarkable coup. He had written at length to Lawrence two years earlier to introduce Danby and to solicit a good position at the Royal Academy for 'Clearing up after a Shower'[8] (RA 1822, present whereabouts unknown) and he was now in regular correspondence with the President on other matters.

A year before Danby died, he was to write that it was on Lawrence's advice that he moved to London. Although this has been generally accepted, it was almost certainly his debts that drove him from Bristol.[9] If we can trust Danby's memory just two years after the exhibition,[10] when he said he had been in London for two years and three months, then he left Bristol in April 1824.[11] On 18 May, still well before the Academy exhibition opened, George Cumberland wrote: 'Danby is a good artist but very opinionated, and is I fear a ruined man. He has a wife and children and pupils, but I believe through total thoughtlessness is over head and ears in debt – he left this place hastily and secretly'.[12] Sir Thomas Lawrence's purchase probably occurred in June and may well have encouraged Danby to stay on in London, but its price at £100 fell far short of his Bristol debts.[13]

It was partly debts that were to drive Danby on to Paris five years later. At the Louvre he enjoyed only one modern French painting – Théodore Géricault (1791–1824) 'Raft of the "Medusa"', 1819, 'the finest and grandest historical picture I have ever seen'. It had been shown in London in 1820, but, wrote Danby, 'though I had never seen it in England I highly respected it for I had heard it described and most highly praised by a man of the first taste, I mean Frank Gold of Bristol . . . I stored what he said of this picture up in my memory . . .'.[14] This gigantic canvas filled with dramatic figures told a dreadful story, the subject of great political controversy. It appears to have little in common with Danby's poetic landscape. However, Francis Gold's forceful and imaginative description of Géricault's painting would have had a power of its own and Danby would naturally have pictured the scene in landscape terms.[15] Like Constable, he believed in the expressive power of landscape.

Gold's description may have prompted memories of another dramatic sea-piece: Washington Allston's 'Rising of a Thunderstorm at Sea' (fig.4).[16] This had been exhibited in Bristol in 1814 together with ten other paintings by this American artist. In its simplicity of conception, its actual size as well as the scale of the figures and especially in the crisp diagonal outline of the great bank of clouds, it is strikingly close to Danby's 'Sunset at Sea after a Storm'.

There is no doubt that Danby's is the most lasting image. 'Forty years have passed', wrote Redgrave, 'since we saw this picture yet we could almost describe from memory the lurid red of the setting sun, the broken waves of the subsiding storm, the few survivors of the wreck, alone on a raft on the limitless ocean'.[17] John Martin and Turner himself were to be inspired by the image.[18]

Danby sought to capitalise on his success by having 'Sunset at Sea after a Storm' engraved. He selected the excellent engraver F. C. Lewis, a regular correspondent with Danby's mentor, George Cumberland. Sir Thomas Lawrence gave instructions for the release of the painting to Lewis at the end of the exhibition.[19] The project proceeded slowly, however, almost certainly because of Danby's inability to pay his engraver.[20] When the print appeared in January 1826, Lewis' name was given as the publisher and both he and Danby tried to market it.[21] A mezzotint after Danby's next successful exhibition painting 'An Enchanted Island' (cat.no.21) became part of the project. It was a failure and impressions are now very rare. From the vantage point of the successful sale of the copyright of 'The Delivery of Israel out of Egypt' (cat.no.22) for £300 to Colnaghi, Danby reviewed the project: 'I began too soon with the Enchanted Island and the Sunset. I have not got a shilling by them, but I managed them badly. I ought not to have published them myself'.[22]

A superb small oil sketch of this painting is in the private collection of Mr and Mrs Paul Mellon. Differences in the sky and the aptness of the scale of the detail to its size suggest that it is not a study but a remarkably bold, personal reminiscence of the painting which brought renown to the artist.

1 No review has been found which mentions 'Clearing up after a Shower' RA 1822.
2 *A Descriptive and Critical Catalogue to the Royal Academy*, 1824, cutting in RA Library, Anderdon Coll. vol.XIX.
3 Redgrave, p.443.
4 Purchased by John Gibbons; now The National Trust.
5 'Jeremiah writing his prophetic denunciations against Jerusalem', present whereabouts unknown.
6 *Bristol Mirror*, 3 April 1824.
7 BL Add. MS 36509 fo.326, G. Cumberland Sr to G. Cumberland Jr, undated.
8 RA Library, Lawrence Letters, vol.3, fo.266, 24 March 1822.
9 BL Add. MS 28509, Danby's letter to Richard Griffin, quoted in full by Adams, pp.141–2; Adams, p.45.
10 Gibbons Papers, F. Danby to J. Gibbons, 15 June 1826.
11 Adams states, p.46, that Danby's London address appears in the 1824 RA catalogue, but the two Anderdon examples of the catalogue at the BM Print Room and the RA give his address as 4 Dove Street, Kingsdown, Bristol.
12 BL Add. MS 36510 fo.102, G. Cumberland Sr to G. Cumberland Jr, 18 May 1824.
13 Gibbons Papers, F. Danby to J. Gibbons, 15 June 1826, says he has paid off £240 of Bristol debts; *ibid.*, 9 June 1830 refers to sale of 'Sunset at Sea after a Storm' at £107, £7 more than Lawrence paid for it. £100 was not really a 'liberal price' as mentioned in 1857 (*Men of the Time*, biographical dictionary published by Kent & Co. (late D. Bogue), p.195) nor probably the 'much higher sum than the painter's price', referred to by Redgrave, p.443. Redgrave was

probably responding to the letter from J. Hogarth in the *Art Journal*, 1860, p.317, correcting E. V. Rippingille's earlier article on Lawrence: 'The fact is, Sir Thomas felt it a disgrace to Art that a picture like the "Sunset" should be unsold at £50, and liberally paid Danby £100 for it.'

14 Gibbons Papers, F. Danby to J. Gibbons, 10 December 1829, quoted *Bristol School* 1973, p.47.

15 See also cat.no.18.

16 Museum of Fine Arts, Boston, illus. in col. Gerdts & Stebbins, p.33. Adams (159) points out that Danby's painting may have a connection with the poem *The Repose of the Storm*, published in the *Bristol Cornucopia* in May 1823.

17 Redgrave, p.443.

18 Adams, p.80, fig.42 (acknowledged by W. Feaver, *The Art of John Martin*, Oxford, 1975, p.91) points out the debt of 'The Destruction of Pharoah's Hosts' and Andrew Wilton (*Turner and the Sublime*, 1980, p.139) suggests that Danby's painting may have inspired Turner to work on his 'Little Liber' mezzotints in which he took marvellous advantage of the medium's potentially dramatic light effects.

19 RA Library, Anderdon Coll. vol.XVII, fo.216, letter Sir T. Lawrence PRA to the porters of the BI.

20 Gibbons Papers, F. Danby to J. Gibbons, 19 April 1825.

21 BL Add. MS 36511 fo.150, G. Cumberland Sr to G Cumberland Jr, undated, and 36516 fo.90, F. C. Lewis to G. Cumberland Jr, 19 January 1827, quoted by Adams, pp.63–4.

22 Gibbons Papers, F. Danby to J. Gibbons, 17 December 1827.

21 An Enchanted Island* 1824

Oil on canvas 36 × 58 (914 × 1472)
Signed: 'F.DANBY'
PROV: purchased from the artist by John Gibbons; by descent; Christie's 29 November 1912 (90), bought Charles Gibbons, thence by descent
EXH: British Institution, 1825 (59); Bristol Institution, 1825; Royal Birmingham Society of Artists, 1829 (199); Worcester Society of Artists, 1838 (135); *Bristol School* 1973 (19)
ENGR: see cat.no.132
LIT: Adams (19)
Private Collection

Rays of warm evening sunlight fall on a familiar landscape. The cliff, limestone rocks and over-hanging trees, and the cave and tunnel might all be found in the Avon Gorge, along the banks of the Frome at Stapleton or on the Wye above Chepstow. But a bird of paradise and a flamingo replace the kingfisher and heron, and exotic sea shells are scattered along the water's edge. On the island itself the cave is lit by the cooler colours of a lamp. The unobtrusive figures of nymphs, fairies and mermaids can be seen. It is a poetic landscape, a landscape of Danby's imagination, bound up with inspired observation.

We should not look for any text in poetry or prose that it might illustrate. The assurance of the fantasy reflects only Danby's close involvement in the evening sketching meetings and summer expeditions of the Bristol artists and amateurs.

21

Ye Landscape Painters, fly, pursue,
Where nature hides herself from view,
By cavern'd rock, by haunted streams,
All visited by fairy-dreams;

These lines are from *Felix Farley, Rhymes, Latin and English, by Themaninthemoon*, a satirical poem by Revd John Eagles published in Bristol in 1826. All his writing was done after his departure from Bristol in 1822 but much of it nostalgically recalls his sketching expeditions with the artists and amateurs. Ceaselessly he tells the landscape artist to improve upon nature and most often to follow Gaspard Dughet. He went further still: 'you must have a convertible power, and have enjoyed visions of Fairy Land; and you must people your pastoral, or your romantic, or your poetical, with beings that are not on the poor's books'.[1] One old Bristol friend[2] who knew Eagles long before 1822, was very much aware of his pioneering enthusiasm for fairies: 'Mr Eagles' poetical fancy, it may be said, luxuriated amongst fairies, their haunts, their habits, their machinery and their gambols'.[3] Eagles was the most sociable, articulate and enthusiastic of the amateurs and he had the clearest and narrowest of aesthetic philosophies, but his influence was peculiarly limited. It must at least be allowed that he introduced Danby to the mythology of fairies.

It was almost certainly Eagles who wrote a long article on 'An Enchanted Island' in *Felix Farley's Bristol Journal* on 26 February 1825.[4] Eagles uses Danby's success to berate the citizens for failing to support Bristol's artists. There is no evidence that he had actually seen the painting. Instead he quotes at great length from the London reviews. The *Sunday Monitor* had 'not been so pleased with any modern picture for a long time' and the 'glow of sunshine' reminded the critic of the Dutch painter Jan Both (*c*.1618–1652). The *Examiner* thought of 'the sunny effulgence' of Aelbert Cuyp (1620–1691) and felt the title to be fully justified: '... such a golden and lustrous light shines through and over the trees, the water is so limpid, the atmosphere so calm, the caverned recesses so cool in their deep perforations and leafy embowering and the nymphs bathe . . . with so

felicitous a grace'. *The Literary Gazette* called it a 'novelty' and referred to Claude. In an intriguing comment on the taste of the time, the writer suggests that the painting is surprisingly light-toned: 'It is truly a bold experiment to enter thus, into open day, with a subject so visionary. In scenes of poetical character, a partial obscurity is a great advantage; and in the Enchanted Castle of Claude, this quality of the mysterious and the obscure is the charm which sets the imagination at work . . .'.[5]

Danby's painting owes no specific compositional debt to Claude, and the character of the great 'Altieri' Claudes, then at Leigh Court near Bristol, is very different.[6] However, the depth of Danby's admiration for Claude was to be shown in the companion painting 'The Embarkation of Cleopatra on the Cydnus' (see cat.no.27). Both Claude and Turner overshadow that work, but the originality of 'An Enchanted Island' is not in doubt.

John Gibbons had agreed to purchase the painting well before its completion and it may have been a commission.[7] However, although the subject of the companion painting was to be arrived at in consultation with Gibbons,[8] it is probable that the acquisition of 'An Enchanted Island' evolved from an initial loan. Danby was to be paid in advance for each of the twelve pictures which Gibbons acquired and he advanced Danby £50 for 'An Enchanted Island' sending a further £100 in January 1825.[9] A surviving letter from Danby to John Young, Keeper of the British Institution, appears to confuse this issue. Danby informs Young that he has submitted 'An Enchanted Island' and prices it at £200. He recalls Young's letter to him after he had exhibited the 'Upas Tree' and says that, accordingly, he has sent a smaller painting this time.[10] Entries to the British Institution were expected to be for sale and Danby's quoted price was probably a subterfuge, for he had clearly referred to the picture as 'your painting' when writing to John Gibbons.[11]

Many references in the correspondence with Gibbons make it clear that 'An Enchanted Island' was Gibbons' favourite painting by Danby and one to which Danby often referred with pride. It became the cornerstone of Gibbons' extraordinarily patient and persistent support of an exasperating artist.

Before it was delivered to Gibbons the painting was added to the Bristol Institution's exhibition of Old Master Paintings in the summer.[12] This was a quite exceptional compliment to a contemporary artist, underlining both the stature of Danby in Bristol and the power of the press. Eagles' article in February, quoted above, must have played its part. The painting's appearance at Bristol was delayed by work on the print[13] and the plate continued to be worked upon until October when only the lettering was unfinished.[14] Danby was the publisher at this stage and, as with the mezzotint after 'Sunset at Sea after a Storm', the project was a failure.[15]

'An Enchanted Island' was particularly influential in Bristol. 'Sunset through a Ruined Abbey' in the Tate Gallery was inspired by it and is almost certainly by James Johnson, a close friend of Danby.[16] Samuel Jackson and James Baker Pyne (1800–1870) were affected by it and a new impetus was given to the element of fantasy in the drawings of the evening sketching meetings.[17]

1 Eagles, p.11.
2 Editor, publisher and journalist, John Matthew Gutch.
3 J. M. Gutch's preface to *A Garland of Roses gathered from the poems of the late Rev. John Eagles MA . . .*, privately printed, 1857. Several of the poems involve fairies. Fairies are repeatedly mentioned in Eagles' articles for *Blackwood's Edinburgh Magazine* in the early 1830s, both in those to be republished in *The Sketcher* and in several others: September and November 1831 and May 1834.
4 Quoted at length by Adams, p.48, who attributes it to Eagles and omits Eagles' reference to Rippingille's most memorable remark: 'It is a fact that has been ascertained by actual experiment that artists will die of starvation if they are not fed.'
5 'The Enchanted Castle' ('Landscape with Psyche at the Palace of Cupid'), 1664, National Gallery, London; *The Examiner* actually called it the 'Enchanted Island'. Adams, p.51 and p.152, fns.23 and 24, notes other references in the Bristol newspapers.
6 Now The National Trust, Fairhaven Collection, Anglesey Abbey, Cambridgeshire.
7 Gibbons Papers, F. Danby to J. Gibbons, 23 January 1825.
8 *Ibid.*, 23 February 1825.
9 *Ibid.*, 31 January 1825.
10 BM Print Room, Anderdon Coll. vol.IX, 1825, undated letter, F. Danby to J. Young. John Young had written the *Catalogue of the Pictures at Leigh Court, near Bristol*, published in 1822.
11 Gibbons Papers, F. Danby to J. Gibbons, 23 January 1825.
12 *Felix Farley's Bristol Journal*, 25 June 1825. Danby reported Bristol's request to borrow the painting to John Gibbons on 19 April 1825.
13 Gibbons Papers, F. Danby to J. Gibbons, 6 June 1825.
14 *Ibid.*, 14 October 1825.
15 See cat.no.20.
16 Adams (21), illus. in col. pl.3.
17 *Bristol School* 1973, e.g. pp.20, 22, 26. Adams (19) notes the existence of a nineteenth-century copy on the London art market in 1968; see also cat.no.142.

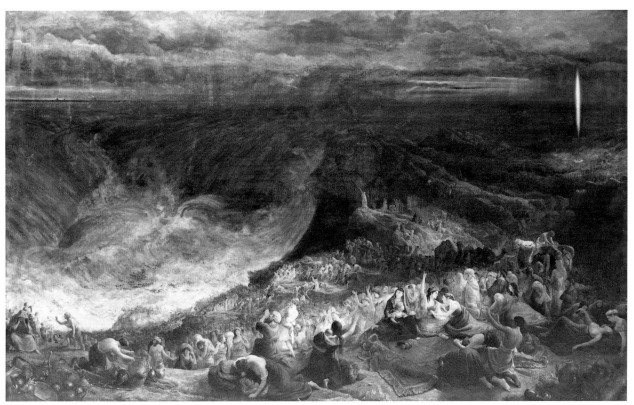

22

22 The Delivery of Israel out of Egypt 1825

Oil on canvas $58\frac{3}{4} \times 94\frac{1}{2}$ (1491 × 2398)

PROV: purchased from the artist by the Marquis of
Stafford, later Duke of Sutherland; by descent,
Sutherland sale, Christie's 8 February 1908 (8),
bought Sampson; John Gregson of Fulwood,
Preston by 1915; presented by his widow
Mrs Margaret Gregson in 1932

EXH: Royal Academy, 1825 (287); *International
Exhibition*, London, 1862 (244); Royal Academy,
Winter 1875 (208); *Bristol School* 1973 (20)

ENGR: mezzotint, see cat.no.133; aquatint by Jazet
with title in French (impression in BM Print Room)

LIT: *Art Journal*, 1855, pp.78–9; Redgrave,
pp.443–5; Adams (22)

*By kind permission of Harris Museum and Art
Gallery, Preston*

Danby had followed his move to London in 1824 with the
great success of 'Sunset at Sea after a Storm' (cat.no.20)
which was shown at the Royal Academy and purchased by
its President. Early in 1825 he showed 'An Enchanted
Island' (cat.no.21) at the British Institution to general
acclaim. Then at the Royal Academy's summer exhibition
he triumphed. 'The Delivery of Israel out of Egypt' was
immediately sold for £500 to the Marquis of Stafford,
President of the British Institution. Sir Thomas Lawrence
tells us that the Marquis having seen it at the private view
rode immediately to Danby to purchase it, forestalling
Lord Liverpool by an hour.[1] Danby quickly repeated the
story to his patron John Gibbons.[2]

It was later to be reported that Sir Thomas Lawrence
now became quite open in his championship of Danby:
'Yielding to the out – door pressure, and the unqualified
opinion of their President, the Royal Academy elected Mr.
Danby . . . an Associate of their body'[3] in November 1825.

The wash drawing of 'The Delivery of Israel out of
Egypt' (cat.no.124) has been called a study for this
painting. However, there is no reason to believe that Danby
executed studies for his paintings in the manner of the
monochrome wash drawings and this drawing is more
likely to be an independent work. If the drawing's inscribed
date of February 1824 is to be trusted, it does demonstrate
that the painting's subject and general composition were
conceived very shortly before Danby left Bristol.

The relationship of 'The Delivery of Israel out of Egypt'
to the work of John Martin is discussed in some detail in
the introduction (p.27). There it is argued that it was
probably Washington Allston's exhibition in Bristol in
1814 that first alerted Danby to the idea of such ambitious

works, and that it was the treatment of the figures in Edward Bird's history paintings that was the most direct influence. Danby's painting is essentially a landscape and should be contrasted with the architectural emphasis in Martin's 'Belshazzar's Feast' which was being shown in Bristol at the same time as Danby's painting was hanging in the Royal Academy. Where there is common ground it is often in the work of J. M. W. Turner. His 'Snowstorm: Hannibal and his Army Crossing the Alps' (RA 1812, Tate Gallery) is possibly recalled by Danby's turbulent Red Sea, and the column of light in Turner's 'The Field of Waterloo' (RA 1818, Tate Gallery) may have prompted Danby's rather abrupt pillar of light. Certainly the studied naturalism of the lowering grey clouds in 'The Delivery of Israel out of Egypt' and the scale and bravura of the overwhelming sea have no parallels in Martin's earlier work. Instead the wide and unbroken horizon may be indebted to contemporary popular dioramas. Danby's own diorama project of the later 1820s confirms his personal interest in these popular spectacles.[4]

Richard Redgrave, who clearly followed Danby's career with particular interest from the time of his first London exhibition, summed up with his habitual fairness:

> It has been said that in 'The Delivery of Israel out of Egypt', and in pictures of that class, Danby was but an imitator of Martin; and certainly it is true that the multitude of figures, and the vastness of the scene, have some of the characteristics of that master. But the grand ideality of his treatment was truly Danby's own, and was kindred to the feeling which had already produced 'The Upas Tree,' the 'Sunset at Sea', and 'Disappointed Love'; Even in this 'Passage of the Red Sea' there is far more of colour, far more of terrible grandeur, and less of the tricky and mechanical qualities of art than in Martin.[5]

[1] W. T. Whitley, *Art in England 1821–1837*, Cambridge, 1930, p.86.
[2] Gibbons Papers, F. Danby to J. Gibbons, 5 May 1825. A month later, 1 June 1825, Danby asked Gibbons for a £250 loan against the sale. He acknowledged the loan on 6 June.
[3] *Men of the Time*, biographical dictionary published by Kent & Co. (late D. Bogue), 1857, p.195.
[4] BL Add. MS 36512 fo.56, G. Cumberland Sr to G.Cumberland Jr, 3 December 1827; fo.60, G. Cumberland Sr to G. Cumberland Jr, 26 December 1827; fo.63, G. Cumberland Jr to G. Cumberland Sr, undated, before 3 December 1827.
[5] Redgrave, pp.444–5.

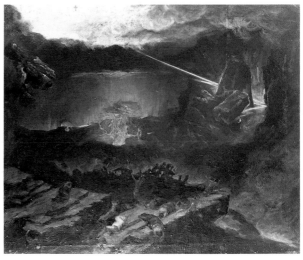

23

23 **Study for 'The Sixth Seal'** c.1825–8
Oil on canvas 25 × 30 (635 × 761)
PROV: presented by Alfred Jones, 1909, and presumed to have been purchased locally
EXH: *Bristol School* 1973 (23)
Victoria Art Gallery, Bath City Council

There is little evidence that Danby did studies in oil for any of his paintings. Like the small and brilliant version of the 'Sunset at Sea after a Storm',[1] this may be a personal record rather than an exploratory study. In both of these works the figures are larger in relation to the paintings' size but the details are similar, if incomplete.

When Danby wrote to John Gibbons on 14 October 1825 describing the 'Sixth Seal', he said: 'my picture is already sketched and a great deal of the effect upon the canvas, it is a little larger than my picture at the Marquis of Stafford's . . .' (cat.no.22).[2] This may be interpreted in different ways. One possibility is that Danby moved directly from small drawings to sketching out on the final canvas. Compositional changes do not occur during the progress of the paintings, however, and significant *pentimenti* have not been noted. When Danby had difficulties, as with 'The Embarkation of Cleopatra',[3] it was effects of light, colour and depth which led to endless reworking, rather than problems with the composition.

[1] Collection of Mr and Mrs Paul Mellon.
[2] Gibbons Papers, F. Danby to J. Gibbons, 14 October 1825.
[3] Private collection; see cat.no.27.

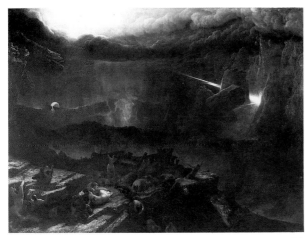

24

**24 An Attempt to Illustrate the Opening of the
Sixth Seal** 1828

Oil on canvas 73 × 101⅝ (1854 × 2580)

PROV: purchased from the artist by William
Beckford, 1828; sold 1832 or 1833; John W. Brett by
1843; Sharpe, Christie's 24 April 1847 (107), bought
in; Francis Edwards by 1857; purchased for the
National Gallery of Ireland 1871

EXH: Royal Academy, 1828 (340); Academy of Fine
Arts, Barclay Street, London, 1833; Bristol
Institution, 1835–6; Rochdale, 1843; Bristol
Institution, 1843; Manchester, *Art Treasures*, 1857
(395); Guildhall, London, *Works by Irish Painters*,
1904 (79); Royal Academy, *The First Hundred
Years*, 1951–2 (409); *Danby* 1961 (19); *Bristol
School* 1973 (24)

ENGR: see cat.no.134; republished by John W. Brett,
1843, with alterations

LIT: Adams (26)

National Gallery of Ireland

The most popular painting in the Royal Academy's
exhibition of 1828, the 'Sixth Seal' was moved to a distant
gallery because of the crowds it attracted.[1] Its success
elicited the grudging admiration of John Constable who
wrote cynically to Archdeacon Fisher on 11 June 1828:

> There is a grand but murky dream by Danby. It is
> purchased by 'Beckford' – the subject is from the
> Revelations but might pass for the burning of Sodom –
> 500 gns – copyright to Mr Colnaghi 300 – British
> Institution with a letter of thanks 200. I only wish you
> could see the work which has elicited all this.[2]

William Beckford, author of the gothic novel *Vathek* and
builder of Fonthill, Wiltshire, which was already in ruins,
also commissioned four overdoors for his new house above
Bath (see cat.no.30). Colnaghi's agreement to buy the
copyright of the 'Sixth Seal' was made in December 1827

and had followed closely on his purchase of the copyright of
'The Delivery of Israel out of Egypt'[3] (cat.no.22) also for
£300. Danby implies quite clearly that it was Colnaghi's
agreement that led him to work again on the 'Sixth Seal'
after a lapse of at least eighteen months.[4] His prize from
the British Institution, at which he had not exhibited since
1826, was 200 guineas and Danby suggested it was
prompted simply as a 'mark of esteem'.[5]

The 'Sixth Seal' perhaps marks the most successful
moment of Danby's career. His failure, however, to follow
it up with election to the Royal Academy in February 1829,
when he was defeated by Constable by one vote, made
Danby still more vulnerable to the coming débâcle (see
introduction p.29).

Danby began the painting soon after his return from
Norway. He wrote to John Gibbons on 14 October 1825
describing the works he had in hand:

> The third picture is a subject that I fear I ought to
> blush for venturing upon, but though it cannot be
> painted with entire truth yet it is the grandest subject
> for a picture, I think in the Bible, it is the opening of
> the Sixth Seal in the Revelations of St John: the great
> day of wrath, chapter 6 from verse the 12 to the ending
> of the chapter . . . my picture is already sketched and a
> great deal of the effect upon the canvas, it is a little
> larger than my picture at the Marquis of Stafford's . . .
> I am determined at all events to pursue it with
> indefatigable labour, if I fail entirely it will be from
> sheer want of talent and consummate conceit . . . I wish
> you would read the passage – the people calling on the
> mountains, to fall on them, and hide them from the
> wrath of God is fine . . .[6]

It is this moment that Danby depicts together with the
opening line of the passage: 'And I beheld when he had
opened the sixth seal, and, lo, there was a great earthquake;
and the sun became black as sackcloth of hair, and the moon
became as blood; And the stars of heaven fell unto the earth
. . .'. The distinctive clouds illustrate the heavens vanishing
'as a scroll when it is rolled together'.

There is one departure from the text of Revelations and
it is a striking contemporary reference. In the centre of the
rocky platform in the foreground there is the 'figure of a
slave, (erect and fearless, amid the warring elements),
shaking his manacles from his hands and tossing his
liberated arms to heaven'.[7] These words come from the
broadsheet which accompanied the painting's exhibition in
Bristol in the winter of 1835–6. It also calls the incident 'a
poetical representation of the freedom of the oppressed'
and goes on to describe the 'king fallen to dust, his crown
and sceptre lying at the foot of the slave may be supposed to
represent the final doom of pride, oppression and power'.

Danby himself was still in Switzerland when this was
written but any doubts about the original and intentional
topicality of the slave are dispelled by the kneeling figure

with clasped hands, clearly illuminated and alone on the upper ledge. The pose is precisely that of the slave in the Wedgwood ceramic cameo that had become the familiar symbol of the committee for the abolition of the slave trade.[8]

Clerics of the day found no difficulty in binding contemporary moral and political issues to the potent imagery of millenianism and the Old Testament. Dr Margaret Whidden points out that the Bristol minister William Thorp, when speaking passionately and at length at an anti-slavery meeting in Bristol's Guildhall in 1826, had declared that 'Nineveh herself had not more cause for putting on sackcloth and lying in ashes than Great Britain has at this moment, under this load of national guilt'.[9] Edward Irving, the radical Divine, also regularly used apocalyptic imagery in his awful threats concerning the consequences of Catholic emancipation and he had equated the opening of the Sixth Seal with the French Revolution.[10]

The slave trade had been abolished in 1807, but the movement towards the ending of slavery itself began in earnest in 1823 with the formation of the Anti-Slavery Society. The Bill for the abolition of slavery was passed in 1833 when Danby's painting was again shown in London. With no broadsheet to prompt them, two critics made particular reference to the figure of the slave, whose meaning was obvious to them.[11]

Although it had been begun in the autumn of 1825 the 'Sixth Seal' was not completed for nearly three years. It was apparently the exhibition of John Martin's 'The Deluge' at the British Institution early in 1826 that led Danby to temporarily abandon it, privately accusing Martin of plagiarism as he did so (see introduction p.28).

The 'Sixth Seal' had a somewhat chequered history between its sale by William Beckford, probably in 1832 or 1833, and its purchase by the National Gallery of Ireland in 1871.[12] It was exhibited in London in 1833 and in Bristol in the winter of 1835–6. When it was next shown in Bristol in 1843 it was then owned by John Watkins Brett of London, son of a Bristol cabinet-maker and himself a picture dealer, entrepreneur and pioneer of submarine telegraphy.[13]

Before it appeared in Bristol it had been on tour and at Rochdale, on 29 April, 'some miscreant . . . cut a piece, about 12 inches by 8, out of the centre of it . . . The slave with uplifted hands, with the prostrate King and warrior in armour, is the part cut out and taken away, and no trace whatever is left of the parties who did the execrable deed'.[14] A Bristol paper reported that nothing but mischief was intended as the hands of the slave were left on the canvas.[15] Danby himself restored the painting, working on much more than just the damaged area. It was now brighter and clearer and 'yet more mellow . . . and so much has been most happily done to it, that it has been found necessary to bring up the plate to this amended condition of the picture'.[16] John Brett was the organiser of the Old Masters exhibition at the Bristol Institution to which the 'Sixth Seal' was

added and to which he lent several works which were also for sale. The exhibition catalogue itself explained 'The Plan of Disposal' by which two thousand two hundred shares at one guinea each were available at various discounts to subscribers who received one copy of the mezzotint 'with some striking improvements suggested by Mr DANBY', and a chance of winning the painting itself.[17] It was, in effect, a glorified raffle.

1 Adams, p.66; R A Library, Anderdon Coll. vol.XX, fo.146.
2 R. B. Beckett (ed.), *John Constable's Correspondence*, Ipswich, vol.6, 1968, p.236.
3 Gibbons Papers, F. Danby to J. Gibbons, 17 December 1827.
4 *Ibid.*, 20 February 1828.
5 *Ibid.*, 8 May 1828.
6 *Ibid.*, 14 October 1825.
7 Broadsheet or advertisement for the exhibition at the Bristol Institution of 'Danby's celebrated Painting Opening of the Sixth Seal . . .', BL 1757.6.13 (1); this illustrated broadsheet is not dated. The 1843 exhibition at Bristol had a separate and very different pamphlet.
8 The cameo is actually illustrated in Erasmus Darwin's *The Loves of the Plants* which Danby unquestionably knew, see 'Upas Tree', cat.no.18. Samuel Colman also used the pose in 'St. John Preaching in the Wilderness', exhibited in Bristol in 1821 and at the Royal Academy in 1822 (City of Bristol Museum and Art Gallery, K4323). I am especially indebted to Margaret Whidden's perceptive section on Colman and anti-slavery, pp.195–205, in her unpublished PhD thesis, *Samuel Colman 1780–1845*, Univ. of Edinburgh, 1985.
9 Whidden, *op. cit.*, p.202. Samuel Colman was a member of Thorp's church.
10 Adams, p.78.
11 *The New-York Mirror*, 19 October 1833, p.126 and *Knickerbocker*, November 1833, p.399; photo-copies of these references are in the files of the N.G. of Ireland.
12 Adams, p.175 under (26), was informed by Mr Boyd Alexander that the Beckford papers, now in the Bodleian Library, Oxford, showed that he was offered £300 by an American in 1832 which he first refused and later accepted. It had presumably been sold by the time of its exhibition at the Academy of Fine Arts, Barclay Street, London in 1833.
13 Adrian Le Harivel, *Illustrated Summary Catalogue of Drawings . . .*, The National Gallery of Ireland, 1983, introduction by Homan Potterton, p.x.
14 *The Times*, 6 May 1843, p.7.
15 *Felix Farley's Bristol Journal*, 23 September 1843.
16 *Ibid.*
17 The 'Sixth Seal' received effusive notices in the local press, *Bristol Mirror*, 23 September and 7 October 1843 and *Felix Farley's Bristol Journal*, 16 and 23 September 1843.

25 The Precipice* *c.*1827

Oil on panel $17\frac{1}{4} \times 13\frac{3}{4}$ (438 × 349)
Signed: 'F.DANBY'
PROV: John Miller; Alexander Dennistoun, Golfhill,
his sale, Christie's 9 June 1894 (8) as 'Death of an
Alpine Hunter'; 1958, purchased from a sailor by the
father of Hans Kurt Wojcik, Denmark, by whom
sold at Sotheby's 10 July 1985 (92) as 'The Climber
of Helvellyn'; bought Colnaghi, from whom
purchased 1986
ENGR: by J. Romney
LIT: Adams (163) as 'The Climber of Helvellyn'
City of Bristol Museum and Art Gallery

In June 1826, when woefully adding up his debts and
regretting his failure to sell the 'Upas Tree' (cat.no.18) and
'Christ Walking on the Sea' (fig.77),[1] both very dark
paintings, Danby wrote: 'I think I am almost cured of
painting dark pictures, but I shall ever like them best'.[2]
'The Precipice' reflects that fascination. Its rich, dark
depths and distances look back to the 'Upas Tree' as well as
to Danby's recent visit to Norway in the summer of 1825.
The encircling mountains enhance the sense of solitude
and the blasted pine, barren rocks, howling wind and
mourning hound all add to the drama.

Although Francis Danby sets his scene in a distant land
and a far distant time, he was certainly inspired by the story
of the climber of Helvellyn. In 1805 a gentleman sketcher,
named Charles Gough, fell from Striding Edge while
climbing Helvellyn in the English Lake District. Three
months later his dog, an Irish terrier, was found faith-
fully guarding his remains. Later that year William
Wordsworth, Walter Scott and Humphry Davy climbed
Helvellyn together.[3] Francis Danby would probably have
read Wordsworth's poem *Fidelity* and Walter Scott's poem
Helvellyn. Both poems describe the tragedy, emphasising
the heroic and faithful dog. Wordsworth's guide to the
Lakes first appeared in 1822 and included a stirring account
of the accident.

The title of the painting, 'The Precipice', is taken from
the inscription on a small engraving after the painting.[4] It
has recently been known as 'The Climber of Helvellyn' and
was sold in 1894 as 'Death of an Alpine Hunter'.[5]

It is possible that Danby executed this work in order that
it should be engraved. Although dark it is legible through-
out, requiring no interpretation from the engraver, and the
scale of the figure and foreground are larger than one might
expect in comparison to the vastness of the landscape itself.
Another painting, 'Fête Champêtre' (see cat.no.136),
which was engraved for the *Literary Souvenir* in 1828 has
recently been rediscovered. Slightly larger in size it is now
in poor condition but was probably rather hurried in its
technique. There is no evidence of such haste in 'The
Precipice'. Neither work is mentioned in Danby's corre-
spondence with John Gibbons in the 1820s. Danby could

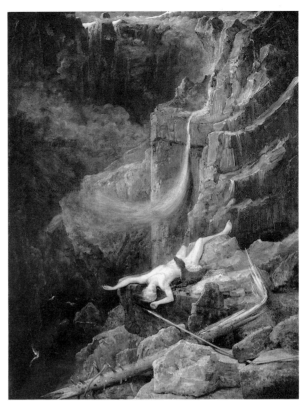

25

not expect to keep his patron in the dark about major works,
but since he was so heavily in debt to Gibbons and there
was the almost constant need to secure further loans from
him, there were advantages in not telling him of income
from the sale, or sale of the copyright, of smaller paintings.

Danby's image may well have influenced the com-
position of Edwin Landseer's (1802–1873) painting
'Attachment' of 1829, a work which specifically illustrates
Walter Scott's poem and concentrates on canine love rather
than sublime landscape.[6]

1 RA 1826; Forbes Collection, London: Adams (162), *Bristol School*
 1973 (21).
2 Gibbons Papers, F. Danby to J. Gibbons, 15 June 1826.
3 Peter Bicknell (ed.), *The Illustrated Wordsworth's Guide to the Lakes*,
 Exeter, 1984, p.62.
4 Collection of David Dallas, London, inscribed in the plate:
 'J. Romney The Precipice Painted by F. Danby ARA'. The publisher's
 name has been lost by trimming. John Romney did work for *The
 Amulet* and probably for other annuals, for one of which 'The
 Precipice' was at least intended, if not published.
5 See provenance, above.
6 Richard Ormond, *Sir Edwin Landseer* (exhibition catalogue),
 Philadelphia Museum of Art and the Tate Gallery, 1981, (60) p.102;
 sold Sotheby's 23 June 1987 (11). Richard Ormond points out that
 another painting illustrating Scott's poem was exhibited by Hugh
 Irvine (fl.1808–1829) at the British Institution in 1813 (169).

26 A Mountain Chieftain's Funeral in Olden Times *c.*1827
Oil on canvas 13¾ × 21⅝ (349 × 549)
PROV: H. W. Häusermann, Geneva; Mrs Charlotte Frank, London, 1963; Mr and Mrs Paul Mellon
EXH: *Danby* 1961 (30)
LIT: Adams (61)
Yale Center for British Art, Paul Mellon Collection

By 1827 Danby had painted three large works in which moonlight was an important feature: the 'Upas Tree', 1819 (cat.no.18), 'Solitude, the Moment of Sunset, with the Moon Rising over a Ruined City'[1] and 'Christ Walking on the Sea'[2] both exhibited in 1826. Only one, 'Solitude', had sold and that was to John Gibbons. Danby's enthusiastic response to an apparent commission from Gibbons for a moonlit scene over water, confirms his commitment to such unpopular subjects. He wrote in January 1827 to his patron:

> You ask me if I have thought of the moonlight . . . I have a subject which I intend to paint, but as there is no water it would not do – it is a Funeral procession by Moon and Torchlight . . . another the moon rising over mountains and a lake with a vulcano in the Horizon, a third Pirates preparing to attack a large vessel in the distance the moon labouring in clouds.[3]

Danby soon got the opportunity to execute the second of these two paintings, 'Moon Rising over a Wild Mountainous Country', exhibited at the British Institution in 1829. Mr Thorpe of Oxford had commissioned two poetical landscapes and it is typical of the problems of Danby's darker works, that of the pair, only the brighter more colourful 'Sunset' (Graves Art Gallery, Sheffield) should have survived (see cat.no.29).

The third subject was never executed but sounds close to 'A Ship on Fire: A Calm Moonlight Far at Sea' exhibited at the Royal Academy in 1851.[4] It may be that Danby waited almost as long to execute the first subject, for the present painting appears to be a smaller version of the missing painting exhibited at the British Institution in 1849, 'A Mountain Chieftain's Funeral in Olden Times'.[5] It is from this work that the title of the present painting is taken.[6]

However, it seems more likely that this painting dates from the later 1820s. It comes close in character to several Bristol School sepia drawings and the foreground landscape is close to Danby's Norwegian watercolours (cat.nos.96–8). In December 1827 Danby reported to Gibbons that he had been 'employed principally at the small things I had ordered in London' and also at drawings for albums,[7] and it could be that this painting and some of the Norwegian watercolours are being referred to here.

1 BI 1826 (129): Adams (161); present whereabouts unknown.
2 RA 1826 (305); Forbes Collection, London: Adams (162), *Bristol School* 1973 (21).
3 Gibbons Papers, F. Danby to J. Gibbons, 6 January 1827. On 15 November 1826, Danby had written to Gibbons: '. . . the moment the Cleopatra is done I shall set about the moonlight, and get it ready also for Somerset House'.
4 Adams (201); present whereabouts unknown.
5 Adams (196); present whereabouts unknown.
6 A label on the reverse bears the title 'The Burial of Alaric'.
7 Gibbons Papers, F. Danby to J. Gibbons, 17 December 1827.

27 Cleopatra Embarking on the Cydnus 1828
Line engraving on India proof paper by E. Goodall after Francis Danby 2⅞ × 4½ (72 × 114)
Inscribed in the plate: 'Painted by F. Danby A.R.A. Engraved by E. Goodall. | CLEOPATRA EMBARKING ON THE CYDNUS. | Published by Longman, Rees, Orme Brown & Green, Novr 1828 Printed by McQueen.'
Published in the *Literary Souvenir*, 1829[1]
Trustees of the British Museum

This engraving reproduces the painting, 'The Embarkation of Cleopatra on the Cydnus', exhibited at the Royal Academy in 1827.[2]

John Gibbons had commissioned a pair for 'An Enchanted Island' (cat.no.21) early in 1825 and Danby commenced work in August of that year, immediately after his return from Norway.[3] In October he described the picture:

> . . . the effect is morning . . . it will be a cooler and fresher tone than the Island, with the principal richness about the Queen, the Barge, and Figures; this subject admits of introducing some fine Egyptian architecture and a fresh beautiful morning in the East . . . you desired me to make plenty of water, this I did not forget.[4]

Progress was slow. There were delays while Danby worked to finish first 'Solitude' for the British Institution, then 'Christ Walking on the Sea' for the Royal Academy.[5] In April 1826 he made substantial changes but illness, debts and travels took up his time and 'Cleopatra', now more than fully paid for by further loans, was doubtless set aside for paintings which might bring in ready money.[6] In November he said he had re-done the painting twenty times.[7]

On New Year's Day 1827 Danby wrote wearily to his patient patron: 'I am more convinced than ever that Mr Claude did not get his reputation for nothing', adding with wry and affectionate respect that his painting 'is to one of Claude's as a piece of gilt gingerbread is to a wedge of solid gold'.[8] 'Cleopatra' continued to be trouble until April when it was only just ready for the Royal Academy.[9]

In working so closely to illustrate a specific subject and with a compositional format that is so inevitably reminiscent of the seaports of both Claude and Turner, Danby

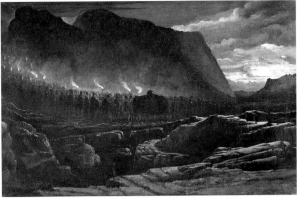

26

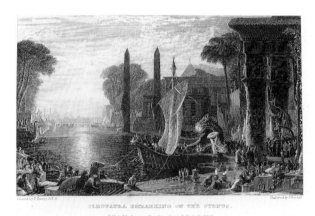

27

28

was constrained. For the moment, the condition of the painting emphasises the laboriousness of its technique and 'the lightness of the fantasy and the atmosphere of dream-like lethargy' are obscured.[10]

1 Together with an engraving after a work by John Martin it was the third most popular engraving published in Alaric Watts' *Literary Souvenir* between 1825 and 1829: Thomas Balston, *John Martin, 1789–1854, His Life and Works*, 1947, p.93.
2 Private Collection, Worcestershire: Adams (24), *Bristol School* 1973 (22). It was also exhibited at the Royal Birmingham Society of Artists, 1830 (74) and the Worcester Society of Artists, 1838 (135).
3 Gibbons Papers, F. Danby to J. Gibbons, 23 February 1825 and 26 August 1825.
4 *Ibid.*, 14 October 1825.
5 *Ibid.*, 29 March 1826; see cat.no.26, fns.1, 2.
6 Gibbons Papers, F. Danby to J. Gibbons, 19 April, 29 May, 6 July, 16 October 1826.
7 *Ibid.*, 15 November 1826.
8 *Ibid.*, 1 January 1827.
9 *Ibid.*, 1 March and 6 April 1827.
10 Adams, p.174; the painting is sound in condition but marred by discoloured varnishes and by extensive drying cracks.

28 Scene from 'The Merchant of Venice' 1828

Oil on canvas $27\frac{1}{2} \times 35\frac{1}{8}$ (698 × 891)
PROV: commissioned by John Soane, 1827
EXH: Royal Academy, 1828 (234)
LIT: Adams (27)
By Courtesy of the Trustees of Sir John Soane's Museum

In the autumn of 1827 Danby received a commission from the architect, John Soane RA, for a painting at the agreed figure of £100.[1] There is no indication as to how precise the commission was, but Danby, who had earlier received an unresolved request from John Gibbons for a moonlit scene, would have had plenty of time to consider possible moonlight subjects.[2]

The full Royal Academy catalogue entry was as follows:

Merchant of Venice: scene, Belmont, in the garden of Portia's house; Lorenzo and Jessica.

Lorenzo: How sweet the moonlight sleeps upon this bank;
 Here will we sit and let the sounds of music
 Creep into our ears, soft stillness and the night
 Become the torches of sweet harmony.
 Sit, Jessica: Look how the floor of heaven
 Is thick inlaid with patterns of bright gold.

Danby had chosen an especially evocative and pictorial passage from Shakespeare. It required that he depict moonlight, stars and 'soft stillness' and that he imply the 'sounds of music' as well as 'sweet harmony'. It is a measure of Danby's belief in the potential of poetic landscape painting that he attempts all. Bathos is avoided by his subtle observations of moonlight effects. Only the complexities of the architecture detract from the pervasive mood of quiet wonder.

A year later Danby learned that Soane had voted against him in the election for full membership of the Royal Academy when he was defeated by Constable by one vote, and Danby records that he fell out with Soane, presumably as a consequence.[3]

[1] Gibbons Papers, F. Danby to J. Gibbons, 17 December 1827. Soane paid Danby £100 on 2 January 1828: Soane, *Journal*, vol.6, p.550 (Sir John Soane's Museum).
[2] Gibbons Papers, F. Danby to J. Gibbons, 15 November 1826, 6 January 1827, 7 February 1827.
[3] *Ibid.*, 25 March 1829.

29

29 a) Sunset and **b) Moon Rising over a Wild Mountainous Country** 1829
Pen, ink and wash on paper (within a letter)
EXH: *Bristol School* 1973 (26)
Mrs Edward Gibbons

These two drawings, in a letter to John Gibbons, 1 February 1829, depict the pair of paintings which Danby sent to the British Institution early in 1829 and which he mistakenly hoped would boost his chances of election to the Royal Academy in February. They had been commissioned late in 1827 by a Mr Thorpe of Oxford who had also ordered paintings from William Etty (1787–1849) and William Collins, both friends of Danby.[1]

'Sunset', now in the Graves Art Gallery, Sheffield,[2] has been extensively over-cleaned in the past. The Grecian galley in the middle distance, for example, looks more like a rock. 'Moon Rising over a Wild Mountainous Country' has disappeared altogether, a consequence, no doubt, of its ever-darkening appearance.

Danby was given a free rein by Mr Thorpe: 'They are to be two poetical attempts and left to myself'.[3] He was to acknowledge that he could not hope to sell such a dark painting as the 'Moonlight' except on commission and the much lighter 'Sunset' was doubtless compensation for Mr Thorpe's trust.[4]

When Danby wrote this long letter of 1 February 1829, in which these two paintings are sketched, he reported that they both had good places at the British Institution and he drew the crowded walls of the relevant gallery to show how prominently they were hung. He described them both at length:

My Moonlight over a mountain country, is a little of the character of the scene of the Upas Tree – a deep valley all in shadow from the moon but faintly lit by a glimmering light from a vulcano on the horizon. In the foreground are a couple of wolves skulking for their prey, the moon is just rising its broad dirk from the edge of a rocky mountain and shining on a small part of the foreground. All the other part of the picture is in deep shadow of night. Of course it is a tremendously dark affair, some people think me mad for sending such

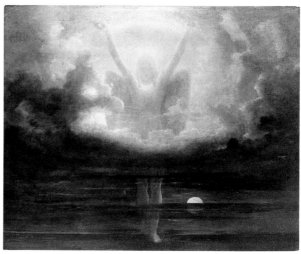

30

a piece of black canvas to an exhibition and calling it a picture, some think it is decidedly my best. . . .

Danby went on to describe the second painting as:

a sunset over the sea, when the wind, blowing from the horizon, makes the water of a deep dark blue and though there is but little wind, the sea breaks heavily on the shore as there is some swell. Two lovers are sitting in the foreground looking at the golden glories of the setting sun. This is an impudent attempt but as it has been attempted by others and a sort of conventional representation of the sun allowed, I have ventured, I believe this will be a favourite with the public at least more than the other.

On the page with the drawing he adds a few more words of description:

Sun Set. the sky is the principal subject. the two figures are in old costume, and in the distance is [a] Grecian Gally rowing towards shore catching the rays of the sun on the glancing oars and gilded side.

1 Gibbons Papers, F. Danby to J. Gibbons, 17 December 1827.
2 30¼ × 41½ in: Adams (29), *Bristol School* 1973 (25).
3 Gibbons Papers, F. Danby to J. Gibbons, 17 December 1827.
4 See also *ibid.*, 6 January 1827, quoted cat.no.26.

30 **Subject from 'Revelations'** 1829
Oil on canvas 24¼ × 30¼ (615 × 768)
PROV: sold July 1830 at auction in London;
Mrs Charlotte Frank, London, from whom
purchased 1966
EXH: Royal Academy, 1829 (317)
LIT: Adams (31)
Robert and Jane Rosenblum

At the same time as Danby triumphantly told John Gibbons of the sale of the 'Sixth Seal' (cat.no.24) to William Beckford for 500 guineas, he announced that Beckford had ordered four small paintings to go in a special room in his new tower on Lansdown, near Bath.[1] He was perhaps planning a smaller version of the Revelation Chamber at Fonthill. The latter project for an exclusive inner sanctum above the chapel was never finished, although Benjamin West (1738–1820) had completed six scenes from Revelations including 'A Mighty Angel Standeth upon the Land and upon the Sea' shown at the Royal Academy in 1798.[2]

Having completed his three paintings for the British Institution in early January 1829, Danby only then began work on Beckford's commission and with some reluctance: 'I do not like the task, in fact there are not many paintable subjects in them; they are not understandable in writing much less painting'.[3] In February Danby would have been distracted by the coming election at the Royal Academy

and then by his defeat. He writes in March that he will not exhibit at the Academy's forthcoming exhibition, not out of pique, but because he does not wish to be judged as 'the revelation painter'.[4] But, just in time, Danby sent two of the four paintings to the exhibition although all four were now complete.[5] He was soon expressing fears that Beckford would not buy 'these foolish subjects',[6] and in July he anxiously sought a loan of £250 from John Gibbons, admitting that Beckford 'has thrown the pictures on my hands'.[7] The débâcle had begun. A year later, Danby having fled abroad, the paintings were auctioned off for £59 6s. for the benefit of his London landladies.[8]

Danby wrote defensively that the paintings were 'sketchy as they are for overdoors'.[9] However, the main reason for the survival of only one of the four was, perhaps, that they were once again relatively dark paintings. It is probable that each was dominated by the figure of an angel, together with dramatic and contrasting light effects.[10]

The text for the present work, which the artist paraphrased as 'The Angel swearing there will be time no longer',[11] was taken from Revelations 10:1, 2, 5, 6:

1. And I saw another mighty angel come down from heaven, clothed with a cloud: and a rainbow *was* upon his head, and his face *was* as it were the sun, and his feet as pillars of fire:
2. And he had in his hand a little book open: and he set his right foot upon the sea, and *his* left *foot* on the earth,
5. And the angel which I saw stand upon the sea and upon the earth lifted up his hand to heaven,
6. And swore by him that liveth for ever and ever . . . that there should be time no longer:

The *Art Journal* was later to admit that the paintings met with 'comparative indifference', but bravely agreed that 'each was distinguished by a grandeur of conception which no other living painter could put forth'.[12] It is unlikely that the writer was here referring obliquely to William Blake. Blake had illustrated the same text, including also the two missing verses which Danby side-stepped.[13] Blake's work was as visionary as the text that inspired him. Danby, however, could only interpret the text as a painter of poetic landscapes and he clearly found it difficult to integrate a sublime and supernatural figure into a naturalistic landscape of clouds and sunset.

There is no reason to think that Danby knew of Blake's marvellous treatment of the subject, but between Benjamin West's distinctly baroque interpretation and Danby's painting there is a familiar intermediary, Washington Allston.[14] Allston's 'Jacob's Dream' was begun four years after his Bristol exhibition of 1814 but it was shown at the Royal Academy in 1819 and again at the British Institution in a loan exhibition in 1825.[15] Many years later Danby's friend, the Bristol surgeon John King, recalled its 'mild, mysterious, dreamy, moonless moonlight emanating from a vast mass of clear light'.[16]

1 Gibbons Papers, F. Danby to J. Gibbons, 8 May 1828.
2 Morton D. Paley, *The Apocalyptic Sublime*, New Haven and London, 1986, pp.44–5.
3 Gibbons Papers, F. Danby to J. Gibbons, 17 January 1829.
4 *Ibid.*, 25 March 1829.
5 *Ibid.*, 15 May 1829.
6 *Ibid.*, 1 June 1829.
7 *Ibid.*, 10 July 1829.
8 *Ibid.*, J. A. O'Connor to J. Gibbons, 12 July and 16 July 1830. The only other picture auctioned was a 'landscape view in Wales' which had hung over his parlour chimney-piece and was perhaps the 'Scene near the Falls of Conway', BI 1829 (356), Adams (166), sold for £21 (see also *Bristol School* 1973, p.66).
9 Gibbons Papers, F. Danby to J. Gibbons, 25 March 1829.
10 The other subjects were: Revelations 8:12–13, 'The Angel flying through heaven weeping for the destruction of the world', also exhibited at the RA 1829 (4); 18:20–21, 'The Angel throwing the stone'; 20:1–3, the angel locking Satan into the bottomless pit. They are listed in Danby's letter to J. Gibbons, 25 March 1829 (Gibbons Papers).
11 Gibbons Papers, F. Danby to J. Gibbons, 25 March 1829.
12 *Art Journal*, 1855, p.80.
13 'And the Angel Which I Saw Lifted up His Hand to Heaven', *c.*1805, Metropolitan Museum of Art, New York, illus. in Morton D. Paley, *op.cit.* pl.40.
14 Other possible sources for the composition are considered by Adams, pp.176–7, Morton D. Palcy, *op.cit.*, p.176, and John Gage, *Colour in Turner: Poetry and Truth*, 1969, p.244, fn.99, who also suggests that Danby's Revelations paintings influenced Turner.
15 The National Trust, Egremont Collection, Petworth House, Sussex: Gerdts & Stebbins, pp.97–9, illus. p.190.
16 *Bristol Mirror*, 6 October 1838.

31

31 The Golden Age 1827
Pen, ink and pencil on paper (within a letter)
EXH: *Bristol School* 1973 (27)
Mrs Edward Gibbons

This drawing, in a letter to John Gibbons, 6 January 1827, is a study for the painting exhibited at the Royal Academy in 1831.

32

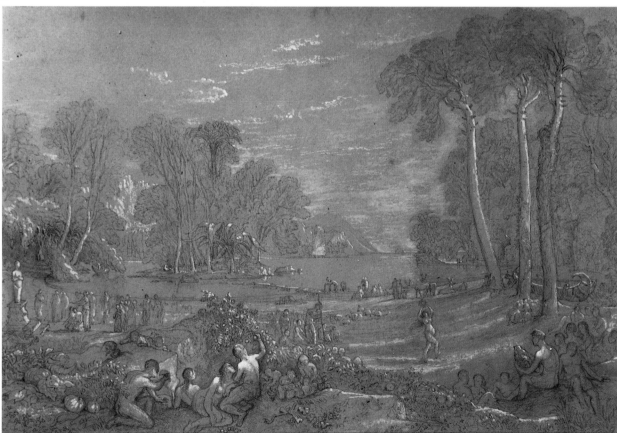

32 Study for 'The Golden Age' 1827
Pencil and bodycolour on grey paper $7\frac{1}{8} \times 10\frac{3}{4}$
(181×273)
PROV: purchased from the artist by John Gibbons,
February 1827
EXH: Bristol Institution, *First exhibition of the Bristol
Society of Artists*, 1832 (196); *Bristol School* 1973 (28)
LIT: Adams (130)
Mrs Edward Gibbons

The disappearance of the large oil painting 'The Golden
Age' probably does Danby's reputation no harm. When it
was shown at the Royal Academy in 1831 he was living in
Switzerland. It was a failure at the Academy and he was
furious. He blamed Turner for its position high over a door
and argued that even the best Claude would have met with
disgust in such a spot. He promised never to exhibit there
again.[1]

James Arthur O'Connor, Danby's loyal friend who had
taken much trouble over the painting's submission in
Danby's absence, wrote that it was liked by neither the
artists nor the public: 'it is too heavy and much too hot in its
tone of colour'.[2] But O'Connor praised Turner and blamed
Constable for 'his illiberal and little conduct as to the
placing of the pictures'.

'The Golden Age' had been conceived nearly five years
earlier. Danby first mentioned it to John Gibbons in
October 1826 when he should have been working on
'Cleopatra'.[3] He had to reassure his patron that he was
struggling on with 'Cleopatra' and had abandoned 'The
Golden Age' as too big a project on which to speculate.[4]

In January 1827, when he sent the letter here displayed
(cat.no.31) he was still hard at work on 'Cleopatra' and
included a sketch of the painting, describing it in detail:

> . . . in the middle of the picture, No. 1, is a large
> chestnut tree in full blossom, on the left of it is a group
> of light ashes over arching a vista to a distance. I have
> attempted the evening sunshine on a rock in the
> distance. On the right of the tree in blossom you look in
> a dark wood over a small meadow on which are
> sporting some young people in sunshine, relieved
> brightly on the gloom behind. On the right, No 3, is a
> group of high pine trees, through which the sun is
> shining on the dancing figures, and touching rich
> colour'd bark with evening light . . . as for this being an
> illustration of the Golden Age, I believe it is not poetical
> enough . . . I fear the general conception is too local.

Rather than learning from the troubles he was having
with 'Cleopatra', Danby failed to realise the pitfalls of
illustration or that the success of 'An Enchanted Island'
(cat.no.21) was founded on its very 'localness' and the
independence of its fantasy. In the belief that Lord de
Tabley, a patron of Turner, wished to buy one of his major
works, he now rubbed out all the work he had done on

canvas and substantially altered the composition, opening
it up and adding many more figures. The chestnut tree was
replaced by an impossible palm, the pines became dis-
tinctly Turneresque and, for his own peculiar intimacy, he
substituted Claudian conventions.

The present drawing was prepared in January 1827 and
sent to Lord de Tabley who proved to be too sick even to
look at it.[5] Danby sent it instead to John Gibbons with a
long explanation tinged with a new and growing cynicism.
He intended 'the incidents of figures to illustrate the
invention of the Arts' including painting, wine making,
'which is surely one of the fine Arts', music, dancing,
shipbuilding, architecture and sculpture. All the inhabi-
tants are 'young innocent and happy; not one old wise acre
amongst them'. On the left there is even a marriage
ceremony 'for even in the Golden Age, I take it that Dog
weddings could not be productive of happiness even
though I have heard Rippingille assert the contrary –
probably I may leave out the priest . . .'.[6]

Danby continued with more embittered remarks and
very depressed complaints of the burdens of supporting a
wife, mother and six children. He implied that he was in
danger of the debtors' prison and asked for a £300 loan.
Substantial loans did follow and Gibbons appeared to agree
to take the painting.[7]

With 'The Golden Age' effectively mortgaged, Danby
moved on to other things particularly 'small things . . . to
keep the wolf from the door',[8] and we do not hear of Danby
working on the painting again until May 1829 just after he
has finished Beckford's Revelations paintings (cat.no.30).[9]
But as with 'Cleopatra', he was soon reporting endless
problems.[10] In December Danby fled to Paris, returning
briefly in January 1830, when he took the painting back
with him to Paris,[11] and thence to Bruges.[12] In June 1830
the painting arrived in London and was delivered to the
care of O'Connor.[13] Gibbons, who was soon keen to part
with the picture, was unable to put it into the British
Institution which would not accept works for sale unless
they were owned by the artist. O'Connor warned Gibbons,
however, that the painting might be seized by Danby's
creditors if Danby was listed as the owner.[14] It went instead
to the Royal Academy where, as we have seen, it was very
badly hung and did further injury to Danby's already
battered reputation. John Gibbons was to sell the painting
in 1843.

1 Gibbons Papers, F. Danby to J. Gibbons, 25 August 1831. A year
 earlier, 22 April 1830, Danby had apologised for not completing 'The
 Golden Age' for the RA, writing: 'the picture would have suffered at
 Somerset House as it is of a rich warm tone and their light is bad.
 Turner might have put one of his firebrands beside it.'
2 *Ibid.*, J. A. O'Connor to J. Gibbons, 17 May 1831.
3 *Ibid.*, F. Danby to J. Gibbons, 16 October 1826.
4 *Ibid.*, 15 November 1826.
5 *Ibid.*, 23 January 1827, 1 February 1827.
6 *Ibid.*, 7 February 1827; for E. V. Rippingille's attitude to marriage
 see *Bristol School* 1973, p.125.

[7] Gibbons Papers, F. Danby to J. Gibbons, 15 February 1827.
[8] *Ibid.*, 17 December 1827.
[9] *Ibid.*, 15 May 1829.
[10] *Ibid.*, 17 August 1829, 25 September 1829, 3 November 1829.
[11] *Ibid.*, 24 January 1830.
[12] *Ibid.*, 14 May 1830.
[13] *Ibid.*, J. A. O'Connor to J. Gibbons, 2 July 1830.
[14] *Ibid.*, 19 December 1830.

33 Tobias and the Fish 1834

Oil on canvas $9\frac{7}{8} \times 11\frac{5}{8}$ (251 × 295)
Inscribed on the reverse: 'peint par Damby [sic]
1834 | à Geneve'; inscribed on the stretcher: 'Damby
celebre peintre irlandaise [sic]'
PROV: probably the 'Landscape with Tobit and the
Fish, Evening', $10\frac{1}{2} \times 12$ in, at the Joseph Gillott
sale, Christie's 19 April 1872 (37)
LIT: H. W. Häusermann, *The Genevese Background*,
1952, pl.8; Adams (33)
Frau Irene Dubs

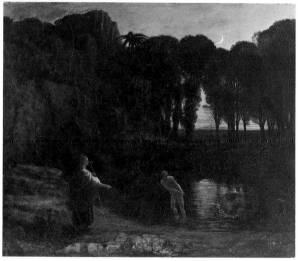

33

After a year at Rapperswil on Lake Zurich, Danby and his family were turned out by their landlord and moved to Geneva.[1] Despite the imminent starvation of his children, now reported as numbering eleven, Danby indignantly refused charity. He was rescued largely by the kindness of Madame Munier 'a lady painter of great talent' and wife of the Director of the Academy of Arts in Geneva who 'immediately raised a subscription among the proprietors and frequenters of the Museum' and commissioned the large and magnificently framed 'The Baptism of Christ' (fig.18), presented to the Musée Rath in 1833.[2] Before it was finished Danby could report that '. . . it quite pleases the connoisseurs who like deep toned pictures as well as myself, and you know in this I am incurable'.[3]

'Tobias and the Fish', which is dated 1834 on the back, may have resulted from this commission and was perhaps requested by one of the group of amateurs who had contributed towards 'The Baptism of Christ'.[4] Danby depicts the incident in the story where Tobias catches a big fish on the orders of his companion Azarias, who is the Archangel Raphael in disguise. Tobias kept the fish's gall, heart and liver. The miraculous properties of this offal enabled him to defeat a demon on his wedding night.

In using a religious subject as a premise for what was, in effect, a poetic landscape, Danby was returning to a more traditional format. If the choice of the story of Tobias was his own, it is possible that he was inspired by engravings of the same subject by or after Adam Elsheimer (1578–1610).

At the time of writing, the painting is in course of conservation in Switzerland. The foreground rocks have been badly rubbed in the past and on the far side of the lake a band of very resinous paint has decayed, but much of the painting appears to be in excellent condition.

[1] Gibbons Papers, F. Danby to J. Gibbons, 30 August 1832.
[2] *Ibid.*, J. King to J. Gibbons, 31 December 1834–3 January 1835. King, a Swiss, visited Geneva in October 1834 and met Madame Munier whom he found 'very original extremely clever and unaffected'. She was then trying to get employment for Danby's older sons.
[3] *Ibid.*, F. Danby to J. Gibbons, 2 January 1833. 'The Baptism of Christ' is now in the Musée d'Art et d'Histoire, Geneva. It is obscured by several layers of discoloured varnish.
[4] John King in his letter to Gibbons, quoted above, writes that Danby took him to see the collection of Mr Duval 'who had some small pictures of Danby's' and whom Danby mentioned on 25 October 1832, as having a very fine collection of Dutch pictures (Gibbons Papers).

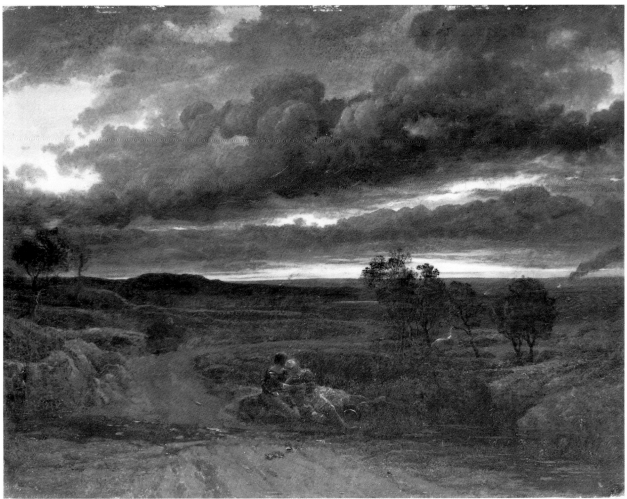

34

34 The Baptism of Clorinda* 1834
Oil on paper laid on board[1] 9½ × 12¾ (241 × 324)
Signed and dated: 'F DANBY 1834' [or 5?]
PROV: Töpffer Bequest, 1910
EXH: *Danby* 1961 (25)
LIT: Adams (41)
Musée d'Art et d'Histoire, Geneva

A forbidding dawn sky above a bleak landscape adds drama
and pathos to a tragic story. The subject is one of the
sub-plots of love and adventure in Torquato Tasso's
Gerusalemme Liberata completed in 1574. Brave Clorinda,
one of the 'lovely pagan women, so touching in their
sorrows, so romantic in their adventures, so tender in their
emotions',[2] is about to die after fighting a duel with her own
beloved Tancredi and receiving baptism from his hands.

The heroes of Tasso's great epic poem were well-known
throughout the seventeenth and eighteenth centuries. His
poetry had inspired John Milton, and the legend of his
love for Leonora d'Este was immortalised in the poetry of
Goethe and Byron.

Although telling of the First Crusade, *Gerusalemme
Liberata* would have been enjoyed as a medieval tale of
romance and chivalry. There are similarities with Edmund
Spenser's *Faerie Queene*, written just a few years later,
which Revd John Eagles encouraged the Bristol artists to
read and whose spirit is certainly present in many of the
sepia drawings of the evening sketching meetings.[3]

It could be argued that Danby departed from the text in
which the dying Clorinda fixes her eyes upon the heavens,
and the sky and the sun seem to turn towards her with pity.[4]
However, Danby's boldly painted dawn sky, brilliantly
observed, has an uncertainty of mood aptly suited to the
story. The figures and the frightened white horse with its
red saddle seem a natural part of the landscape.

[1] Stamped on reverse: 'Rowney and Foster milled ground board
51 Rathbone Place'.
[2] John Addington Symonds, *The Encyclopaedia Britannica*, 14th
edition, 1929, vol.21, p.830 (under 'Tasso, Torquato').
[3] Eagles, pp.57, 65, 71.
[4] E gli occhi al cielo affisa, e in lei converso
Sembra per la pietate il cielo e'l sole:

35 'Liensfiord', Norway* c.1835
Oil on poplar panel $16\frac{1}{8} \times 21\frac{3}{8}$ (411 × 542)
Signed: 'F.DANBY'
Inscribed on batten on reverse, possibly by the
artist: 'Liens Fiord Norway'
PROV: sold from a Swiss private collection,
Sotheby's 21 November 1984 (71); bought Anthony
Dallas and Sons Ltd, from whom purchased 1985
Trustees of the Tate Gallery

'Liens Fiord Norway' is inscribed on the reverse of this panel, perhaps by Danby himself. A watercolour[1] and the Victoria and Albert Museum's large oil painting of 1841 (cat.no.41) of a similar landscape also include the identification 'Liensfiord' in their original titles. No such place exists and Danby was clearly confused by the haste of his tour in Norway in July and August 1825. Dr E. H. Schiøtz has tentatively reconstructed Danby's journey through Norway and suggests that Danby may be referring to Lifjord, an arm of the Sognefjord north of Rutledal on the western coast.[2]

Topographical accuracy, however, would have been of no particular concern. George Cumberland, meeting Danby very briefly as he hurried through Bristol in November 1827, wrote that 'his views of the fiords will not be like our facts, but like Turners, embellished views – none else will sell'.[3] At this time Danby may only have done a small number of finished watercolours of Norway and it is unlikely that any oil paintings based directly on his sketches were completed until after he arrived in Switzerland in 1831. This painting may well be the earliest.

Danby expressed disappointment with Norway. It lacked grandeur but 'God knows the country is <u>wild enough</u>'.[4] The landscape in Danby's painting is inhospitable and unwelcoming; the rock formations are unusual, perhaps purposely anthropomorphic; a storm is brewing; ducks breed and wolves hunt undisturbed. It is the sense of utter remoteness from man that so distinguishes this precise, almost fastidious, work.

In October 1834 Danby wrote from Geneva that his pictures were either 'of Norway or poetical'.[5] Of the four landscapes that he exhibited in the summer of 1835 at the Musée Rath, one was a Norwegian scene: 'Vue d'un lac en Norvège, avant que le soleil ait dissipé les vapeurs du matin'.[6] This cannot be the same painting, as the recent Sotheby's sale catalogue proposed,[7] but the review of it in Geneva's *Le Fédéral* deserves mention despite the obvious difference of mood:

. . . finally, the *Norwegian Lake*, from which one cannot tear oneself away – so beautifully is it painted; so simple and tranquil is its poetry that none of the great masters would disclaim it; but we must stop. Suffice it to say that *Norwegian Lake* is the most beautiful picture in the Salon; every artist will tell you the same; but the public seems to have no idea of it, and barely glances at the painting.[8]

1 Gibbons Papers, F. Danby to J. Gibbons, 19 May 1831, mentions a watercolour 'Approach of a Storm on Liensfiord in Norway'.
2 Dr Eiler H. Schiøtz, *Itineraria Norvegica, Foreigners' Travels in Norway until 1900*, Oslo, 1976, vol.II, pp.44–5, and correspondence, including MS map, with Dr Schiøtz 1976–1988 (City of Bristol Museum and Art Gallery: artist files).
3 BL Add. MS 36512 fo.48, G. Cumberland Sr to G. Cumberland Jr, 26 November 1827.
4 Gibbons Papers, F. Danby to J. Gibbons, 26 August 1825, quoted at length in the introduction, p.25.
5 *Ibid.*, 17 October 1834.
6 Häusermann, p.228.
7 Martin Butlin has kindly passed on Madame Renée Loche's observation that the painting exhibited in 1835, from the collection of Monsieur James Audéoud, was described in detail in a catalogue of the collection published in 1848, and cannot be the painting now in the Tate Gallery.
8 Häusermann, p.228.

36 The End of Lake Geneva* 1835
Oil on canvas 30 × 45 (761 × 1142)
Signed and dated: 'F.DANBY 1835'
PROV: Christie's 28 October 1949 (100), bought
Thos Agnew & Sons Ltd; H.R.H. Woolford;
Sotheby's 22 November 1967 (70), bought Agnew;
Paul Grinke; Paul Mellon Collection
EXH: *Danby* 1961 (24)
LIT: Adams (35)
Yale Center for British Art, Paul Mellon Collection

When Danby sent a watercolour view of Lake Wallenstadt to England in 1832 he explained that it was not much in the style 'of my drawings of Norway, but the character of the country is different. Switzerland (at least what I have seen) is not so wild, but extremely beautiful, calm fine weather suits it best'.[1] Danby probably painted no oil paintings of Switzerland until 1835,[2] the year of this work, and in all three views so far recorded fine weather prevails.[3]

The view looks towards the town of Villeneuve at the far eastern end of Lake Geneva. On the extreme left is the Ile de Peilz opposite the Château de Chillon at the foot of Mont Sonchard, the mountain in the centre.[4]

1 F. Danby to G. F. Robson, 23 March 1832, from Rapperswil: letter in the Henry Bicknell album, Yale Center for British Art.
2 See cat.no.35, text and fn.5.
3 Cat.nos.36 and 37 and 'Villeneuve on Lake Geneva', private collection, South Africa: Adams (36). This last is the same scene as cat.no.36 from a very slightly different viewpoint with the sun higher, the shadows shorter and the colours cooler.
4 I am grateful to Mlle Carole Derivaz for this information.

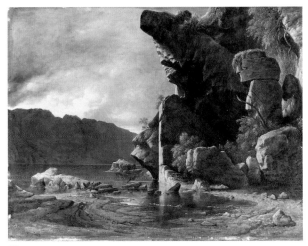

35

36

37

37 Mont Blanc *c*.1835
Oil on panel $18\frac{1}{2} \times 24\frac{7}{8}$ (470 × 630)
PROV: purchased in the south-west of England
c.1950
LIT: Adams (38)
Aubrey J. Tarr, Exmouth, Devon

In October 1834 Dr John King visited Danby who was then living near Geneva. He was warmly welcomed. King, born Johann Koenig in Berne, would have been eager to know how the pioneering traveller in Norway had responded to his own native scenery – the Alps. He would have gleefully told Danby of his ascent up the Rigi a few days earlier. He had climbed by moonlight in the company of the poet Thomas Lovell Beddoes, and watched the sunrise from the summit. King was almost seventy years old. With obvious disappointment he had to report to Danby's patron, John Gibbons, that Danby had said that he 'had never seen any scenery suited to his style of composition, nothing but commonplace views, and I found indeed that he had never gone at all out of the beaten track'.[1]

Danby was clearly embarrassed and sent a long letter almost immediately to his patron, as if anticipating King's criticism. 'Surgeon King is amazingly enthusiastic for Swiss scenery', he wrote. He was ashamed to say he knew little of Swiss scenery and had painted none of it but promised to tour the mountains in the following year.[2]

When Eric Adams called this painting an 'evident pot-boiler', much of its quality was obscured by extensive overpaint added to disguise drying cracks.[3] It does have something of the character of many of the outstanding aquatints of Swiss scenery of this period, whose cosier images of a domesticated landscape were far from the sublime visions of the Alps preferred by English Romantic poets and painters. Part of the painting could illustrate Percy Bysshe Shelley's poem, *Mont Blanc*, written in 1816 in the very house in which Danby was now living:[4]

Far, far above, piercing the infinite sky,
Mont Blanc appears, still, snowy and serene . . .

However, there are no parallels with the next three lines:

Its subject mountains their unearthly forms
Pile around it, ice and rock; broad vales between,
of frozen floods, unfathomable deeps.

For that sense of remoteness so magnificently evoked in Shelley's *Mont Blanc* one should look instead at Danby's paintings of Norway (cat.nos.35 and 41) – poetic landscapes, drawn from memories of powerful first impressions.

[1] Gibbons Papers, J. King to J. Gibbons, 31 December 1834 – 3 January 1835.
[2] *Ibid.*, F. Danby to J. Gibbons, 17 October 1834.
[3] The painting is being conserved at the time of writing.
[4] Häusermann, p.229.

38 **Landscape with Heron** 1835
Oil on canvas 16 × 21⅜ (406 × 543)
Signed and dated: 'F DANBY 1835'
PROV: a member of the Diodati family, Geneva;
bought from Geneva by Mrs Charlotte Frank, 1966;
Gooden and Fox, London, 1967; Mr and Mrs Paul
Mellon; Yale Center for British Art; Sotheby's
18 November 1981 (43), bought David Dallas;
Christie's 30 January 1987 (42)
LIT: Adams (34)
Private Collection

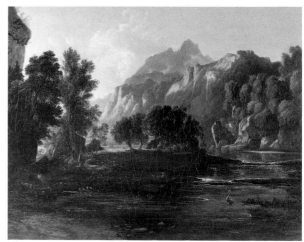

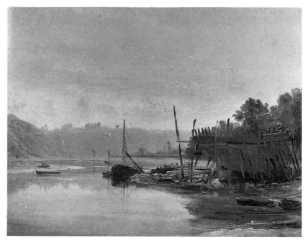

38

This oil painting, which bears a label on the stretcher
inscribed 'Diodati', and the watercolour of a very similar
landscape (cat.no.117) made for the album of Madame de la
Rive, who held a distinguished Sunday salon in Geneva,
suggest the character of both the pictures and the clientele
of Danby's last year in Geneva. One of the Diodati,
Edouard, owned the Villa Diodati which Byron had rented
at Montalègre.[1] This was very near Danby's home, which
in 1816 had been occupied by Shelley, Mary Godwin, their
son and Claire Clairmont, Byron's mistress of the moment.

Despite the tentative identification of the scene of the
watercolour, both are probably largely imaginary land-
scapes based loosely on scenery near Geneva but em-
ploying a vocabulary that goes back to 'An Enchanted
Island' (cat.no.21).

The apparent concentration of Danby's Swiss oil
paintings around 1835 may not be fortuitous. He had
begun his time in Geneva with watercolours and the large
commission 'The Baptism of Christ'.[2] He had got back into
serious debt by the autumn of 1834,[3] probably partly as a
result of his boat-building activities during that summer.[4]
It could have been the impetus of these debts and the
exhibition at the Musée Rath in the summer of 1835 that
prompted so much work. In October 1835, the *Chambre des
Etrangers* renewed his resident's permit and noted that his
debts were all settled and his pictures were selling well.[5]

[1] Adams, p.158, fn.24.
[2] See cat.no.33.
[3] Häusermann, p.228.
[4] Gibbons Papers, J. King to J. Gibbons, 31 December 1834–3 January
1835; F. Danby to J. Gibbons, 17 October 1834.
[5] Häusermann, p.228.

39

39 **Boat-building near Dinan*** *c.*1838
Oil on paper laid on panel 9¼ × 11¾ (235 × 298)
PROV: Christie's 17 April 1964 (121), bought
Colnaghi; Mr and Mrs Paul Mellon
LIT: Adams (43)
Yale Center for British Art, Paul Mellon Collection

The identification of the scene is based only upon an entry
in the catalogue of Danby's posthumous sale at Foster's,
London, on 15 May 1861.[1] Lot 58 was 'Boat Building near

Dinan – Brittany'. This would imply a date in the summer
of 1838 when Danby probably spent some weeks near the
French coast.[2] The unusually light tone of the painting,
together with the pale greens and greys, are reminiscent of
some contemporary French painting, which Danby could
have seen in Paris.

Although the attribution to Danby is traditional this
painting has not been shown before with other late and
similarly naturalistic and free studies by the artist. It is to
be hoped that the exhibition will give substance to the
attribution which has been questioned.[3]

[1] Messrs Foster, 54 Pall Mall, London, copy in RA Library, Anderdon
Coll. vol.XXIV, p.135. See Adams, pp.144–5, for a full transcription of
the sale catalogue.
[2] Gibbons Papers, F. Danby to J. Gibbons, 4 February 1838 and
26 June 1838; see also cat.no.40.
[3] When exhibited at the Royal Academy, Winter 1964–5, *Painting in
England 1700–1850 from the Collection of Mr and Mrs Paul Mellon*
(124), it was 'attributed to' Francis Danby.

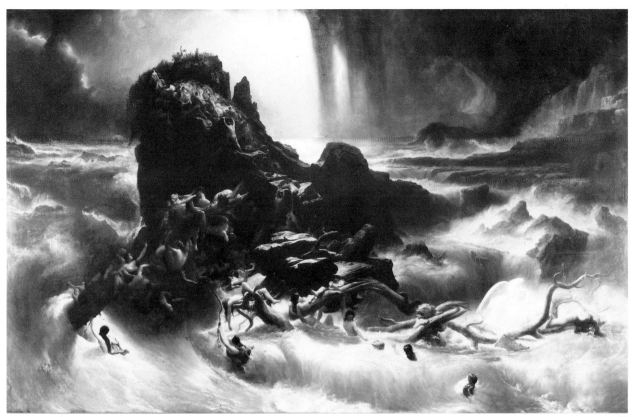

40

40 The Deluge* 1837–40

Oil on canvas 112 × 178 (2845 × 4520)

PROV: commissioned by William Jones, 1837; his
sale Christie's 8 May 1852 (125), bought in; by
descent to Miss Gladys Herbert, sold to John
Baskett for the Mellon Collection; purchased by the
Friends of the Tate Gallery 1971

EXH: 213 Piccadilly, London (private room)
May–June 1840; Horticultural Rooms, Park Street,
Bristol, August 1840; *International Exhibition*,
Dublin, 1853 (60)

LIT: *Fraser's Magazine*, 1840, pp.120–2; Tate
Gallery, *Catalogue of British Paintings*, 1972,
pp.55–6; Adams (47); *Bristol School* 1973, pp.45–8

Trustees of the Tate Gallery

(Exhibited at the Tate Gallery only)

It has hitherto been assumed that 'The Deluge', much
the largest work Danby ever painted, was a determined
attempt to re-establish his reputation on his return to
England after a decade abroad. Although it may well be
that it was this intention that saw the vast undertaking
through, the painting was actually the product of a highly
calculated commission.

By August 1837 Danby had been in Paris for over a year
together with his large family. His letters to his patron give
very little indication of his source of income and John
Gibbons was clearly concerned. On 31 August Danby
wrote to him at length, outlining the story.[1] In Paris in
November 1836, Danby had met William Jones, a picture
dealer and painter. They later struck a deal by which
Danby would paint 'The Deluge' to the size of ten by
fifteen feet, beginning work on 1 August 1837 and finishing
in ten months. Danby was to be paid in instalments of
£200. The intention was to exhibit the work in Paris,
London and America, making at least £5,000 without even
selling the painting itself. Danby had already done two
months work and had taken a studio for the purpose. Now,
however, Danby claimed that the political situation in
America had halted the project, and Jones had also
apparently been caught exporting copies of paintings in the
Louvre to America as originals. Danby himself had several
commissions from members of the Gibbons family for
copies of Old Masters at the Louvre and one must wonder
if he and his sons were involved in Jones' dubious trade.[2]
Danby now resolved to paint small pictures of familiar
landscapes but for the rest of his time in Paris he was to be
largely occupied with copying Old Masters, and with the
deaths of Ellen Evans, his beloved mistress, in November
1837 and of three if not four of his children by June 1838.

In a letter of June 1838, the last before a gap of three
years, Danby wrote that he was going to Brittany with his
family for the sake of their health.[3] A tradition in the Jones

family, the former owners of 'The Deluge', supposed that the background was derived from the coast of Brittany.[4] This seems very likely. Since there is also nothing in the painting of the 'destruction of an antedeluvian city' which had been the subject matter of 'The Deluge' which he had described a year earlier,[5] the painting was probably composed afresh and this huge canvas was largely painted in 1839, when Danby had returned to England.

Danby's name reappears in the London street directories in 1839.[6] His address is given as 15 Rathbone Place, next door to his old friend James O'Connor, but it is most unlikely that there was space enough for 'The Deluge' there. There is the added complication of Danby's own statement that: 'Having in 1840 finished a large picture of The Deluge, I returned to London by the advice of my ceaseless friend and patron John Gibbons Esq.'[7]

Whether or not 'The Deluge' was painted in Paris, its debt to French painting is considerable. Danby had called Géricault's 'Raft of the "Medusa"' (1819) 'the finest and grandest historical picture I have ever seen' when he first visited Paris in 1829.[8] Eight years later he described it as 'the only instance of a noble and sublime French picture'.[9] It was to Géricault that Danby was perhaps largely indebted for the inspiration to undertake this gigantic canvas and the simplicity of the composition and its strong diagonal emphasis may derive from the 'Raft of the "Medusa"'.[10] Danby also greatly admired Poussin's 'Deluge' (1660–4) which he had copied in the Louvre in 1837 for William Gibbons. It was possibly the most famous French painting at that time and had already been copied by Peyron, Géricault and Etty. It had also inspired Delacroix and Turner and been profusely praised by Constable.[11] Danby was, however, critical of the treatment of the story and, unusually, promised to paint a lighter work, perhaps as a result of the agreement with William Jones.[12]

'The Deluge' was exhibited on its own at 213 Piccadilly in 1840. Danby doubtless regarded the event as in exactly the same tradition as the display of Géricault's 'Raft of the "Medusa"' in Piccadilly twenty years earlier. The painting appears to have been a modest success.[13] Its chief enthusiast was the novelist and critic William Makepeace Thackeray to whom Danby could easily have acquired an introduction. Thackeray was a frequent visitor at Clevedon Court, near Bristol, whose owner, Sir Charles Abraham Elton, was a close friend of the Bristol artist, E. V. Rippingille. Thackeray regretted the 'episode of the angel' (to the right of the picture) but found the work far superior to the paintings of 'The Deluge' by Poussin, Turner and Martin:

> He has painted *the* picture of 'The Deluge'; we have before our eyes still the ark in the midst of the ruin floating calm and lonely, the great black cataracts of water pouring down, the mad rush of the miserable people clambering up the rocks[14]

Danby personally handed to Thackeray an account of the painting in his own 'queer wild words', as Thackeray called them. There is a peculiar and personal pessimism in his account:

> Man is against man; friendship is no more; the loveliness of woman, the innocence of childhood, or the low moan of suffering, no longer gain the sigh of pity or of love; fear and rage alone possess the human breast.[15]

As Eric Adams observed, the loss of Ellen Evans and three or four of his children must have added to the monumental gloom of 'The Deluge'.[16] Danby's next two important works 'Liensfiord Lake' (cat.no.41) and 'The Enchanted Castle – Sunset' (cat.no.42) have not the same mood of despair but are characterised by a heightened sense of melancholy and of loneliness.

Despite this apparent introspection, the genesis of this remarkable work goes back almost fifteen years. In February 1826, Danby claimed to have been making studies for a painting of 'The Deluge' 'for some years'.[17] He gave it up for the 'Sixth Seal' (cat.no.24) which, in turn, he temporarily abandoned because of Martin's plagiarism. He mentioned 'The Deluge' again in March 1828[18] and in November 1829, when about to flee from his creditors to Paris, he argued that Paris would 'be of great use to me, in my studies which I am about to make for my Deluge, of which I shall etch and engrave a large print myself, as Martin has made so much money in this way'.[19]

1 Gibbons Papers, F. Danby to J. Gibbons, 31 August 1837.
2 J. L. Roget in *A History of the 'Old Water-Colour' Society*, 1891, vol. II, p.421, says that Thomas Danby first made a living copying paintings at the Louvre and Danby, in the letter of 31 August 1837, says rather ambiguously that 'next year 3 of my sons will be able to give me some little assistance' (Gibbons Papers).
3 F. Danby to W. Gibbons, 26 June 1838, Wexford Municipal Archives, Eire, quoted by Adams, p.99.
4 Letter from Miss Gladys Herbert, Tate Gallery archives.
5 Gibbons Papers, F. Danby to J. Gibbons, 31 August 1837.
6 *Pigot's London Directory*, see Adams, p.159, fn.38.
7 BL Add. MS 28509, F. Danby to Richard Griffin, 12 April 1860, quoted in full by Adams, pp.141–2.
8 Gibbons Papers, F. Danby to J. Gibbons, 10 December 1829.
9 F. Danby to W. Gibbons, 8 October 1837, Wexford Municipal Archives, quoted by Adams, p.104.
10 The Tate Gallery's *Catalogue of British Paintings*, 1972, p.55, suggests that the technique is also influenced by French academic painting.
11 Richard Verdi, 'Poussin's "Deluge": The Aftermath' *The Burlington Magazine*, CXXIII, no.940, July 1981, p.389; (Jean-François-Pierre Peyron (1744–1814), Eugène Delacroix (1798–1863)).
12 F. Danby to W. Gibbons, 8 October 1837, quoted by Adams, p.102.
13 Adams, p.106.
14 *Fraser's Magazine*, 1840, p.420, quoted by Adams, pp.106–7.
15 *Ibid.*, quoted by Adams, p.104.
16 Adams, p.105.
17 Gibbons Papers, F. Danby to J. Gibbons, 13 February 1826.
18 *Ibid.*, 2 March 1828.
19 *Ibid.*, 22 November 1829.

41 Liensfiord Lake, in Norway: a sudden storm,
 called a flanger, passing off – an effect which on
 their lonely lakes occurs nearly every day in
 autumn 1841
 Oil on canvas $32\frac{1}{2} \times 46$ (825 × 1167)
 Signed: 'F.DANBY'
 PROV: purchased from the artist by William Jones;
 his sale, Christie's 8 May 1852 (118); bought Smith,
 presumably for John Sheepshanks, by whom
 presented 1857
 EXH: Royal Academy, 1841 (527); *Danby* 1961 (28)
 LIT: Adams (48)
 Board of Trustees of the Victoria and Albert Museum

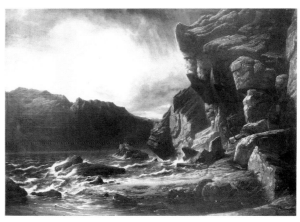

41

The long title is taken from the catalogue of the Royal
Academy's exhibition of 1841. The general features of the
landscape are the same as those in the Tate Gallery's
smaller painting of about 1835 (cat.no.35) and the same
sketch may have been used for both paintings. However,
the shape of the rocks and particularly their sharp outlines
have been altered. Danby was not concerned with topo-
graphical accuracy and, as earlier explained, Liensfiord
does not exist.

 None of Danby's darker paintings have survived so well
as this work, indeed many have not survived at all. There is
an impressive richness and translucency to the blacks, and a
confidence in the technique which enhances the expressive
character of the painting. There was a feeling of remoteness
in the smaller, earlier work. Here there is a more terrifying
sense of a desolate and inhospitable landscape where the
only animal presence is the skeleton of a seal. In the
foreground a small inlet is unruffled by the wind and water-
lilies grow, and, behind the storm, the sky is brighter, but
these intimations of the coming calm are dwarfed by the
overpowering gloom.

 The origin of the painting may lie in a particular event,
for Danby had had a frightening experience with a sudden
squall or flanger. Edward Price who visited Norway in
1826, a year after Danby, tells the story:

 Mr Danby, the painter, was very awkwardly situated
 on one of the western fiords . . . The mountains on all
 sides rose abruptly from the water, which was perfectly
 still, and canopied by an azure heaven. The boat was
 resting under the stillness of the day. At this moment
 the silver line of a cloud rose above the lofty barrier in
 front, the fiord heaved its bosom, and an approaching
 gale flapped the sail; fear was depicted on the faces of
 the boatmen, who lowered the sail and lashed the mast
 and a pair of oars across the boat; immediately the
 heavens were black with clouds, and the fiord boiled
 like a cauldron; destruction seemed inevitable, when
 the boat swung against the rock, the projecting mast
 snapped, and the boat whirled again into the ebullition.
 The violence of the storm was now over, and at length
 the fiord resumed its wonted quiet.[1]

In 1838 Danby had made a faithful copy of Jacob Ruisdael
(1628 or 9–1682) 'The Storm' in the Louvre for William
Gibbons, John Gibbons' cousin.[2] He referred to the
simplicity and truth of Ruisdael, and although there is
no compositional debt, Danby's faith in the expressive
potential of landscape may have been strengthened by the
emotive gloom of Ruisdael's later landscapes.

[1] Edward Price, *Norway, Views of Wild Scenery* . . . , 1834, pp.43–4,
 quoted by Adams, p.53.
[2] Gibbons Papers, F. Danby to J. Gibbons, 12 March 1838, 17 March
 1838, 28 March 1838.

42 The Enchanted Castle – Sunset* 1841
 Oil on canvas 33 × 46 (838 × 1168)
 Signed: 'F.DANBY'
 PROV: purchased from the artist by William Jones;
 his sale, Christie's 8 May 1852 (123) as 'Calypso on
 the Enchanted Island'; bought Smith, presumably
 for John Sheepshanks, by whom presented 1857
 EXH: Royal Academy, 1841 (549); *Danby* 1961 (15);
 Hayward Gallery, London, *The Art of Claude
 Lorrain*, 1969 (142)
 LIT: Adams (49)
 Board of Trustees of the Victoria and Albert Museum

The title is a clear reference to Claude's 'The Enchanted
Castle', then one of this artist's most famous paintings.[1]
But despite Danby's deep admiration for Claude, he makes
no reference either to Claude's composition or to the
character of Claude's landscape which, as Michael Kitson
has written, 'breathes the very air of romantic loss'.[2]

 Instead Danby sought to paint a landscape of enchant-
ment given poignancy by the grieving figure of Psyche who
walks on the shore outside Cupid's palace. She has been
banished by the god after gazing upon him at night, in
defiance of his instructions.

 In the Royal Academy's catalogue of 1841, two lines of
verse followed the title of this painting:

O! how can mortals hope for bliss
When fairies grieve in place like this.

It is in this spirit, wistful rather than melancholic, that this work is painted. The picture has none of the forbidding gloom of 'The Deluge' (cat.no.40) or 'Liensfiord Lake' (cat.no.41), exhibited in the same year, and is much closer to the pure fantasy of 'An Enchanted Island' (cat.no.21).

This painting is in very much better condition than previous references would suggest and serious drying cracks are limited to the darkest areas.

1 'The Enchanted Castle' ('Landscape with Psyche at the Palace of Cupid'), 1664, National Gallery, London, purchased 1986. The title, 'The Enchanted Castle', dates from an engraving of 1782 by William Woollett.
2 Michael Kitson, *The Art of Claude Lorrain*, exhibition catalogue, Arts Council, 1969, p.29.

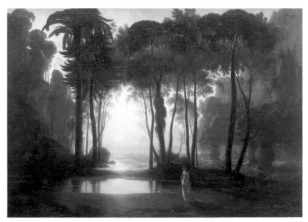

42

43 The Gate of the Seraglio – Constantinople
c.1845
Steel engraving by J. T. Willmore after Francis Danby 7 × 9$\frac{15}{16}$ (179 × 252)
Inscribed in the plate: 'F. DANBY, A.R.A. PINXT. J.T. WILLMORE A.R.A. SCULPT. | GATE OF THE SERAGLIO – CONSTANTINOPLE. | FROM THE PICTURE IN THE ROYAL COLLECTION. | LONDON. PUBLISHED FOR THE PROPRIETORS.'
Published in the *Art Journal*, 1857, p.344
City of Bristol Museum and Art Gallery

This engraving reproduces Danby's large painting 'The Gate of the Harem', exhibited at the British Institution early in 1845 and purchased by Queen Victoria for Osborne House on the Isle of Wight.

A surprising number of Danby's exhibited works of the 1840s and 1850s have failed to survive or remain untraced. Three large works from this period were destroyed during the Second World War[1] and two others appear to have been ruined long ago by over-cleaning.[2] 'The Gate of the Harem' had the distinction of being destroyed by order of Queen Mary in April 1927 shortly after it had been removed from Osborne House to Windsor Castle.[3] Like most of the untraced works, many of which are moonlight, sunrise or sunset scenes, 'The Gate of the Harem' was probably very dark. This, together with dirt, darkening of the varnish and perhaps some deterioration of the more resinous parts of the medium, probably made its condition look a great deal worse than it was.

To the title of the painting in the catalogue of the British Institution, Danby added these words: 'The effect intended, is the full-orbed moon rising at sunset, while the sun behind the spectator is reflected on the Palace windows of an ancient Eastern city.' Clearly Danby was successful for the Pre-Raphaelite painter Ford Madox Brown (1821–1893) recalled these effects with particular enthusiasm:

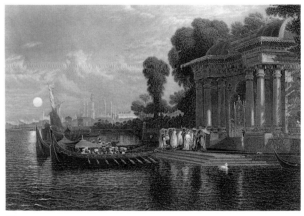

43

The setting sun was ablaze in the windows, and behind the minarets was a round, full moon, rising as in defiance of the declining day, one of the most beautiful effects in all nature.[4]

Equally exotic in its setting as in its rich and contrasting light effects, the painting was described by Danby as 'at least the most careful Picture I ever painted'.[5]

Far-eastern scenes had been familiar subjects amongst the monochrome wash drawings of the Bristol artists' evening sketching meetings of the later 1820s. Dr John King wrote an enthusiastic letter describing William West's eastern scenes in April 1829, four months before Danby re-visited Bristol and attended a drawing party.[6]

1 'Contest of the Lyre and the Pipe in The Valley of Tempé', RA 1842, Mappin Art Gallery, Sheffield; 'Calypso's Grotto', BI 1844, Gibbons family; 'Sunrise – the Fisherman's Home', RA 1846, Tate Gallery.
2 'The Painter's Holiday', RA 1844, Yale Center for British Art (Adams (53) illus. in col.pl.5); 'Lake at Sunset', 1849, Musée d'Art et d'Histoire, Geneva (Adams (60) illus. in col.pl.6).
3 Information kindly supplied by the House Governor of Osborne House, Surgeon Captain R. S. McDonald and the Assistant to the Surveyor of The Queen's Pictures, Caroline Crichton Stuart, 1984.
4 *Magazine of Art*, 1888, pp.122–4, quoted by Grigson, p.76.
5 Gibbons Papers, F. Danby to J. Gibbons, 22 November 1844.
6 *Ibid.*, J. King to J. Gibbons, 8 April 1829, quoted in *Bristol School* 1973, p.198.

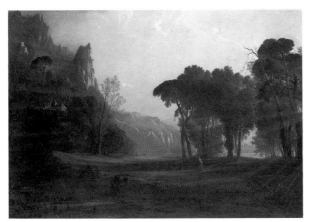

44

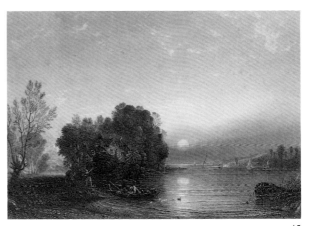

45

44 **The Wood-Nymph's Hymn to the Rising Sun**
1845
Oil on canvas $42\frac{1}{4} \times 60$ (1073 × 1523)
Signed and dated: 'Frs Danby 1845'
PROV: purchased from the artist by John, 2nd Lord
Northwick, 1845; Phillips at Thirlestaine House, 12
August 1859 (1163), bought in by George, 3rd Lord
Northwick, thence by descent; Capt. E. G. Spencer-
Churchill, Christie's 25 June 1965 (116), bought
Frank with Thos Agnew & Sons Ltd; purchased by
the Friends of the Tate Gallery 1969
EXH: Royal Academy, 1845 (272); *Danby* 1961 (29)
LIT: Adams (54)
Trustees of the Tate Gallery

Danby here returns to a subject of his own invention. It
is a fantasy that complements the sunset theme of 'An
Enchanted Island' (cat.no.21) painted twenty years earlier.

This painting is referred to only once in the corre-
spondence with John Gibbons.[1] On 22 November 1844
Danby still hoped to get it ready for the British Institution
in January, but he was only to complete 'The Gate of the
Harem' (see cat.no.43) in time and 'The Wood-Nymph's
Hymn to the Rising Sun' was exhibited later in 1845 at the
Royal Academy. It was purchased there on behalf of Lord
Northwick for 250 guineas.[2] Soon after its purchase Robert
Huskisson (fl.1832–1854) painted a charming view of
'Lord Northwick's Picture Gallery at Thirlestaine House'
(Gloucestershire)[3] and Danby's painting is shown promi-
nently hung (fig.20). It was paired with a classical
landscape which is almost certainly the Claude Lorrain
'Poetical Landscape' mentioned in the 1859 catalogue.[4]
Whether or not Danby knew of this arrangement, it was a
compliment that he would have greatly appreciated.

'The Wood-Nymph's Hymn' is thinly, but finely rather
than hurriedly, painted. It has suffered from over-cleaning
and retains some discoloured varnish, especially in the sky.
Some of the solidity of form of the trees and bushes has
been lost and the tonal changes in the sky have been affec-
ted. However, the originality and sensitivity of Danby's
treatment of landscape effects are clearly evident. Mist
clings to the mountain hollows and the warm rays of the
sun suggest the moist early-morning atmosphere. The
wood-nymph's joy is echoed by the skylark high above her.
The pink of the reflected sunrise changes with considerable
subtlety across the painting. One reviewer observed that
'. . . colour was never brought forward with such dazzling
effect as in those touches which exhibit the light of the sun
breaking upon the cliffs'.[5]

[1] Gibbons Papers, F. Danby to J. Gibbons, 22 November 1844.
[2] I am indebted to Revd David Addison, who is researching Lord
 Northwick's collection, for these details and the following information
 on the Claude Lorrain.
[3] *c*.1846–7, Yale Center for British Art, illus. in col. on cover of
 Malcolm Cormack, *A Concise Catalogue of Paintings in the Yale Center
 for British Art*, New Haven, 1985.
[4] The Claude has not yet been identified but showed a piping herdsman.
[5] *Art Union*, 1845, p.185.

45 **Sunrise – the Fisherman's Home** 1851
Steel engraving by A. Willmore after Francis Danby
$6\frac{7}{8} \times 10\frac{1}{10}$ (175 × 255)
Inscribed in the plate: 'F.DANBY, A.R.A. PAINTER.
A.WILLMORE, ENGRAVER. | THE FISHERMAN'S
HOME. | FROM THE PICTURE IN THE VERNON
GALLERY. | SIZE OF THE PICTURE | 3FT. 6.IN. BY
2FT. 6.IN. PRINTED BY HORWOOD & WATKINS |
LONDON, PUBLISHED FOR THE PROPRIETORS.'
Published in the *Art Journal*, 1852, p.152
City of Bristol Museum and Art Gallery

The painting which this engraving reproduces was ex-
hibited at the Royal Academy in 1846. Having sold 'The
Gate of the Harem' (see cat.no.43) to Queen Victoria in
1845, Danby now sold 'Sunrise – the Fisherman's Home'
to Robert Vernon who presented his collection to the
National Gallery in 1847. Danby reported to John Gibbons

in August 1851, that Willmore had engraved the picture, but that it was 'plain I have no friends in the directors of that gallery for the picture has hitherto been hung in a dark hole high up'.[1]

The painting passed to the Tate Gallery and was destroyed by enemy action during the Second World War. The loose composition, the peculiar rocky promontory on which the cottages are perched and the trees which here appear out of scale, suggest that the painting's survival would not have enhanced Danby's reputation.

[1] Gibbons Papers, F. Danby to J. Gibbons, 24 August 1851.

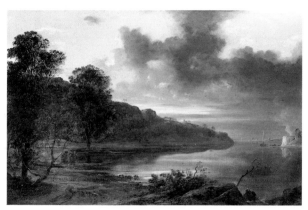

46

46 Figures Fording the River Dart at Sunset
c.1850
Oil on canvas $13\frac{3}{4} \times 19\frac{1}{2}$ (349 × 495)
Signed: 'F DANBY'
PROV: E. H. W. Meyerstein; F. R. Meatyard, 1954; Spink & Son Ltd, 1972
LIT: E. H. W. Meyerstein, 'At Danby's Grave', a poem, *The Oxford Magazine*, 1 May 1952, p.288
Private Collection

The identification of this scene as a view on the river Dart, in Devon, is perfectly plausible. A combination of steeply wooded banks and a working lime-kiln could once be found on the lower tidal reaches of the river. There is a pencil drawing of the River Dart, perhaps of the late 1820s, which is inscribed 'From the bank of the Dart one mile below Totnes'.[1] It is possible that this oil painting derives from a similar drawing, but its free and confident handling suggests that Danby was responding with renewed enthusiasm to the Devon landscape. He had moved to Exmouth in 1846.

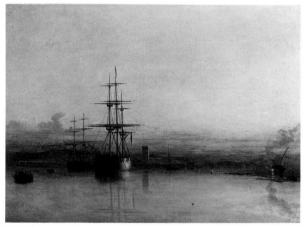

47

[1] Collection of Max Browne, $7\frac{5}{8} \times 13\frac{1}{2}$ in, watermark: J. Whatman, 1817.

47 Dead Calm – Sunset, at the Bight of Exmouth*
1855
Oil on canvas $30\frac{1}{2} \times 42$ (774 × 1070)
Signed: 'F DANBY'
PROV: probably purchased from the artist by Thomas Miller, thence by descent; Thomas Pitt Miller, Christie's 26 April 1946 (27), bought Geoffrey Grigson; Christie's 14 July 1972 (72); purchased 1976
EXH: Royal Academy, 1855 (563); *Danby* 1961 (34)
LIT: Grigson, pp.66, 75; Adams (71)
Royal Albert Memorial Museum, Exeter

Twilight is here closing in over an estuary in which, in the nearer section, is a ship at anchor. Both sky and water are enriched with the fading lines of what has

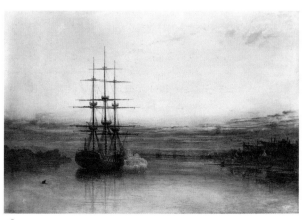

48

been a glorious sunset. But the sentiment of the picture is a perfect tranquility, and so fully is this realised that the spectator is sensibly affected by the voiceless stillness of the scene.[1]

The 'voiceless stillness of the scene' is heightened by the very activity occurring within it. A fishing vessel is being caulked on the right, its smoke a foil to the sunset. Around the merchantman, now relegated to a timber ship, vast logs are being manoeuvred. On the vessels beyond, sails are being furled and, below the train, two ferry boats cross to Exmouth.

Whether or not Danby actually visited the Royal Academy exhibition of 1839, he would have known of Turner's 'The Fighting "Temeraire" tugged to her last berth', a vision of the heroic achievements of a past era, emphasised by a belching tug and a dramatic sunset. Danby sought no such symbolism or poignancy in the once-proud merchantman or in any of the incidents or objects he so carefully disposed through the composition. His concern was for a precisely observed moment and for the evocation of mood, 'the sentiment of . . . perfect tranquility'.

Although the author of these words appears to have taken the topographical accuracy of the painting for granted, its detail is of considerable interest. The viewpoint is from well off the shore at Exmouth and looks across the estuary to Starcross. For a few months after Danby's arrival in Exmouth in 1846 he would have seen smoke belching from the tower depicted in the centre of this painting, as well as trains running, smokeless, along the far bank. The Exeter to Newton Abbot section of Isambard Kingdom Brunel's Atmospheric Railway had been ready for use in 1846 and it had operated intermittently the following year.[2] It was converted to conventional use with normal steam engines in 1848 and the red sandstone tower of the Starcross Pumping Station was, thus, already a relic of Brunel's genius when Danby completed this painting in 1855.[3]

'Dead Calm' was bought by Geoffrey Grigson, writer, poet and critic, for 14 guineas in 1946 when the collection of the Liverpool merchant, Thomas Miller, was sold at Christie's. It prompted Grigson to write the only modern account of Danby's life and painting[4] before Eric Adams' thesis and subsequent book, published in 1973. In this pioneering essay Grigson attacked current attitudes to British art which he called 'uncritical, unhistorical, un-inquisitive', and the essay is a very early milestone in the process of the 'stiff and sensitive revision' of English painting that Grigson demanded.

1 *Art Journal*, 1857, p.41.
2 K. A. Forrestier, *What was an Atmospheric Railway?*, no place of publication, 1982.
3 The top section of the tower was removed in the later nineteenth century after being damaged in a storm but the remainder survives today. Danby has perhaps exaggerated its size in relation to the train itself.
4 G. Grigson, 'Some Notes on Francis Danby, A.R.A.', *Cornhill Magazine*, 968, 1946, pp.99–109; reprinted with alterations in Grigson, *The Harp of Aeolus, . . .*, 1948, pp.66–78.

48 **The Evening Gun** 1857
Oil on canvas 20 × 30 (508 × 761)
Signed and dated: 'F DANBY 1857'
PROV: commissioned by Mrs John Gibbons, 1856; Miss M. Gibbons sale, Christie's 29 November 1912 (93), bought Capt. Bidder; Mrs Charlotte Frank, London *c.*1960, from whom purchased
EXH: *Danby* 1961 (33)
LIT: Grigson, pp.75–6; Adams (72)
Private Collection

John Gibbons, Danby's patron, died in 1851 and 'The Evening Gun' was commissioned by his widow in 1856,[1] apparently as a smaller version or replica of the much larger 'The Evening Gun – A Calm on the Shore of England', which was once the best-known of Danby's later paintings, but is now presumed to have been destroyed.[2]

The large version had been exhibited at the Royal Academy in 1848. In 1855 it was shown at the Paris International Exhibition when, said David Roberts RA, it 'was *the* picture . . . all the painters were talking about it'.[3] It was shown also in 1857 at the Manchester Art Treasures exhibition, where the American writer Nathaniel Hawthorne bowed down before it.[4] Ford Madox Brown was to call it 'a most solemn and beautiful work'[5] but the most lyrical description came from Théophile Gautier. His long account ended:

> On ne saurait imaginer l'effet poétique de cette scène: il y a dans cette toile une tranquillité, un silence, une solitude qui impressionnent vivement l'âme. Jamais la grandeur solennelle de l'Océan n'a été mieux rendue.[6]

It is likely that Mrs Gibbons' smaller version differs considerably in its landscape detail. This is not an ocean scene but a quiet river or estuary, probably derived from, or perhaps quite accurately depicting, a view looking up the Exe from just above Exmouth.

1 Gibbons Papers, F. Danby to Mrs J. Gibbons, 5 November 1856.
2 Adams (193), bought in at Christie's 4 November 1955 (184).
3 Richard Redgrave, *Richard Redgrave: A Memoir*, compiled from his diary by F. M. Redgrave, 1891, p.251.
4 Randall Stewart (ed.), *English Notebooks of Nathaniel Hawthorne*, 1941, quoted by Grigson, p.76.
5 *Magazine of Art*, 1888, pp.122–4, quoted by Grigson, p.76.
6 *Les Beaux-Arts en Europe*, Paris, 1855, quoted at length by Grigson pp.75–6. (It is impossible to imagine the poetic effect of this scene: in this work there is a tranquillity, a silence, a solitude which make a deep impression on the soul. Never has the solemn grandeur of the Ocean been better portrayed.)

49 **Phoebus Rising from the Sea, by the lustre of
his first vivifying rays, through the drifting
foam of a rolling wave, calls into worldly
existence 'The Queen of Beauty'** 1860
Oil on canvas 40 × 60 (1016 × 1524)
PROV: purchased from the artist by Thomas
Pemberton; Christies's 30 April 1874 (71), bought
J. Watson of Warley Hall, Birmingham; thence
by descent
EXH: Royal Academy, 1860 (219)
LIT: Adams (75)
Private Collection

'Phoebus Rising from the Sea', or 'The Birth of Venus' as it
was soon to be called,[1] was exhibited at the Royal Academy
in 1860, a year before Danby died.

Complex classical mythology, which here includes
Neptune and a whole pantheon of gods seated on the
clouds, is applied to a seascape bare of any conventional
Claudian stage-setting. Danby deliberately places the sun
just below the actual centre of the painting and puts the
distant land beyond the hard, straight outline of the

horizon, which is broken only by Venus. This stark
compositional structure is enlivened by Danby's per-
sistently fresh observation of effects of light, best exem-
plified by the smoke of the volcano which rises, changes
direction and subtly alters its colour and tone as it crosses
the sun. The Mediterranean blue which dominates the
underlying naturalism is reminiscent of the watercolour
'Amphitrite' (cat.no.100).

[1] *Art Journal*, 1861, p.118.

50 **At Killarney** *c.*1840
Oil on paper laid on canvas 7¾ × 9¼ (197 × 235)
Inscribed in ink on the stretcher in James Danby's
hand: 'At Killarney – Francis Danby ARA'
Private Collection

There is no reason to believe that Danby ever returned to
Ireland after his departure in 1813. He is known to have
brought drawings of Irish scenes to England and he still
had some 'sketches' of Ireland with him in Paris in 1837.[1]

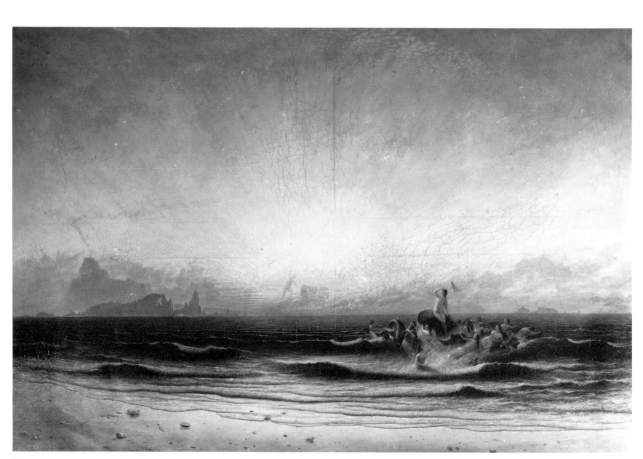

49

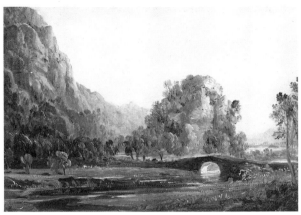

50

51

52

1 Gibbons Papers, F. Danby to J. Gibbons, 15 July 1837. Amongst the fourteen oil sketches and small paintings sold by Thomas Pemberton at Christie's on 17 June 1865 was 'A View near Killarney' (lot 19). It is likely that this and the present work are one and the same even though the Pemberton sale catalogue states that his pictures 'were obtained direct from the artist' while the inscription on the stretcher of 'At Killarney' implies that the painting was still in the artist's studio at his death. Lot 47 in Danby's posthumous sale at Foster's in May 1861 was 'Near the Lakes of Killarney' which may also be a reference to this same work (see cat.no.39, fn.1).

51 **Wooded Landscape – Sunset** *c.*1840
Oil on paper laid on canvas $6\frac{1}{2} \times 9$ (165×229)
PROV: Christie's 3 February 1978 (111 part lot)
Private Collection

Although this is certainly an imaginary landscape, the effects of light have been very carefully observed. The trees, for example, are seen against the light and have a dense black-green colour and flat velvety effect of considerable quality.

The paint layer is thin in parts, now revealing a detail of an earlier study of the Eagle's Nest at Killarney which emerges from behind the clouds. The cliff face is emblazoned by the setting sun and is reminiscent of the early Avon Gorge oil sketches (cat.nos.6 and 7). The cave, wooded pool and fleeing deer were familiar ingredients of the Bristol School monochrome wash drawings.

This landscape was sold at Christie's in 1978 together with two other oil sketches, both bearing inscriptions by James Danby (cat.nos.55 and 60). It is likely that it was amongst the oil sketches in Francis Danby's posthumous sale, and was possibly 'River Scene – Twilight', lot 15.[1]

1 See cat.no.39, fn.1.

52 **A Boat-building Shed** *c.*1840
Oil on paper $4\frac{3}{4} \times 7\frac{1}{4}$ (121×184)
Inscribed in ink on backing card in James Danby's hand: 'Francis Danby. ARA.'
PROV: Maas Gallery, London
LIT: Adams (46)
Mr and Mrs J. A. Gere

The very limited range of colours, which are both cool and quiet, sets this work apart from the other oil sketches. Although Danby was to build his own yacht on the Maer at Exmouth in the 1850s, this painting may well be considerably earlier. Eric Adams grouped it with two other oil sketches both of which are now untraced, and suggested that they showed the influence of Jean-Baptiste-Camille Corot (1796–1875).[1]

1 Adams (44) and (45).

53 Sunset: Sketch *c.*1855
Oil on thin card $6\frac{5}{8} \times 7$ (168 × 178)
Inscribed in ink on backing card in James Danby's
hand: 'Francis Danby. ARA.'
PROV: Roland, Browse and Delbanco, London,
1952, from whom purchased by the Very Revd Eric
Milner-White, Dean of York; his gift 1958
EXH: *Danby* 1961 (21)
LIT: Adams (64)
York City Art Gallery

This is probably a view across the Exe with an Exmouth
boatyard on the left.

**54 Shore Scene with Breakwater and Hulk at Low
 Tide** *c.*1855
Oil on white ground on card $3\frac{3}{8} \times 5\frac{11}{16}$ (85 × 144)
Inscribed on the former backing card, on which the
painting was mounted, in James Danby's hand:
'Francis Danby. <u>ARA.</u>'
LIT: Adams (65)
Private Collection

This is probably a view on the River Exe from near
Exmouth, with the hills before Dartmoor in the distance. It
is possibly the oil sketch 'On the Exe – evening' in Danby's
posthumous sale in May 1861, lot 37.[1]

¹ See cat.no.39, fn.1.

**55 A Two-Masted Yacht at Anchor in a Bay,
 Sunset** *c.*1855
Oil on paper laid on card $3\frac{3}{4} \times 6\frac{3}{4}$ (95 × 172)
Inscribed on the card in James Danby's hand:
'Francis Danby <u>ARA.</u>'
PROV: Anthony Reed Gallery, London, and Davis &
Langdale Co. Inc., New York
Private Collection

It is tempting to identify the sailing vessel as either *The
Chase* or *Dragon Fly*, Danby's yachts, both of which he
probably built himself. The mountainous landscape may
be an imaginary setting.

56 Sunset across the Exe* *c.*1855
Oil on paper laid on card $5\frac{1}{2} \times 7\frac{3}{4}$ (140 × 197)
Inscribed in ink on backing card in James Danby's
hand: 'Francis Danby. <u>A.R.A.</u>'
PROV: Andrew Wyld, London, 1986
Barbara Kafka

Perhaps the boldest and most immediate of the oil sketches,
this is a hasty, dramatic and personal record of an actual
sunset. It has no likely relevance to any exhibition painting

53

54

55

and confirms Danby's enduring enthusiasm for landscape.

From 1847 to 1856 Danby lived at Rill Cottage above North Street, Exmouth. The view from the cottage would have been similar to this painting, whose viewpoint was probably a mile up-river.

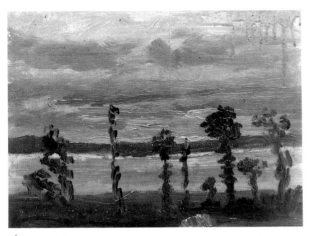

56

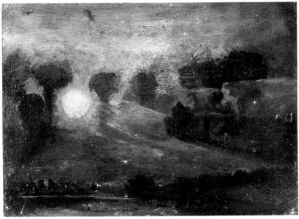

57

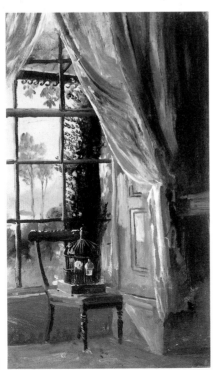

58

57 Sunset through Trees* *c.*1855
Oil on card 5 × 7 (126 × 178)
Inscribed on former backing card in James Danby's hand: 'Francis Danby. <u>ARA</u>'
PROV: Mrs Charlotte Frank, London, from whom purchased 1970
LIT: Adams (58)
Private Collection

The sun sets beyond a screen of elm trees, its rays catching a small lake in the foreground and corn stooks to the right. Eric Adams described it as a 'hallucinatory effect sketched from imagination in old-masterish tones'.[1] The emergence of a more coherent group of these late oil sketches now enables us to presume that most are records of exciting landscape effects, probably painted on the spot or possibly soon afterwards. Similar scenery surrounds the church of St. John-in-the-Wilderness behind Exmouth, in the corner of whose churchyard Danby was buried.

Most of the oil sketches are laid on card, bearing the inscription in James Danby's hand, 'Francis Danby ARA'. They come from a folio of sketches and other personal mementoes of Danby, which was bought from a member of the Danby family living near St. Albans by a local dealer about 1930.[2]

[1] Adams (58).
[2] *Ibid.*, pp.178–9 under (46).

58 View from the Drawing Room of the Artist's House at Exmouth* *c.*1855
Oil on paper laid on card 9¾ × 5⅝ (247 × 143)
PROV: Anthony Reed Gallery, London, and Davis & Long Co. Inc., New York, 1978; Andrew Wyld, London; Spink & Son Ltd
By kind permission of His Grace, the Duke of Westminster, D.L.

No work better demonstrates both Danby's enduring enthusiasm for depicting effects of light, and the apparent tranquillity of the last years of his life at Exmouth. The sketch was probably still in the artist's studio at his death.[1]

Shell House on the Maer at Exmouth, where Danby lived from 1856 until his death in 1861, was an early nineteenth-century house with a continuous awning on the south front and tall windows on the ground floor. However, James Danby's drawing of the house shows that it was closely surrounded on three sides by a wall, high on the east

and west sides, low on the south side, which looked towards the dunes and the sea (cat.no.147). Rill Cottage, where Danby lived for his first ten years in Exmouth, was more modest in scale. It is possible, therefore, that this painting does not depict either of the artist's homes.

59

¹ It was on the art market in 1977 together with cat.nos.51, 55 and 60.

59 Study of a Leafless Tree *c.*1855
Oil on paper laid on board 6⅝ × 4¾ (168 × 121)
Inscribed on former backing card in James Danby's hand: <u>Francis Danby. ARA.</u>
PROV: Maas Gallery, London
LIT: Adams (59)
Anthony Reed Gallery

This oil sketch, presumably painted in winter, depicts a hawthorn with rich green lichen on the trunk and a creeper entwined in the branches. The flower at the foot of the tree may be imaginary but the tree itself can only have been painted from life.

60 Sailing Ship in a Stormy Sea *c.*1855
Oil on thin card 6¼ × 7¾ (159 × 197)
Inscribed in ink on the backing card in James Danby's hand: 'Francis Danby. ARA.'
PROV: Anthony Reed Gallery, London, and Davis & Langdale Co. Inc., New York, 1982; David Cross Fine Art, Bristol, from whom purchased 1987
Private Collection, Bristol

60

This hurried imaginary scene has much subtlety in the control of the varied dark tones. The low viewpoint is a reminder of Danby's own intimate experience of the sea. He had built his own sailing vessels at Geneva and Exmouth and was to be shipwrecked off Axmouth just six months before his death.

Watercolours and Drawings

61 View in County Wexford *c.*1810
Watercolour 7 × 10½ image (178 × 266)
Signed: 'F Danby.'
Inscribed in ink on reverse, probably by the artist:
'Veiw [sic] in County Wexford'
PROV: Mrs E. Hand, Surrey, from whom purchased
1968
EXH: *Bristol School* 1973 (29)
LIT: Adams (76); Frances Gillespie and others, *Fifty
Irish Drawings and Watercolours*, National Gallery of
Ireland, 1986, p.21, illus. in col.
National Gallery of Ireland

This is a view of St Nicholas' Church, Clonmines and
Bannow Bay near Wexford. Danby was born just south of
Wexford but had moved to Dublin in 1799. When Danby
and O'Connor arrived in Bristol in 1813 John Mintorn,
the bookseller and stationer, bought 'two small sketches
of the Wicklow Mountains, near Dublin, in a somewhat
dilapidated state, slightly coloured, on letter paper . . .'.[1]

[1] *Western Daily Press*, Bristol, 20 February 1861, p.4, quoted at length
by Adams, p.5.

**62 Castle Archdale on Lough Erne,
Co. Fermanagh*** *c.*1812
Watercolour and pencil 6¾ × 9¾ image (172 × 248)
Signed: 'F Danby'
Inscribed in ink on reverse: 'Castle Archdale on
Lough Erin [sic] | Coote Carroll 17'
PROV: perhaps commissioned by Coote Carroll;
Ulster Museum before 1974
LIT: Martyn Anglesea, 'Five unpublished drawings
by Francis Danby', *The Burlington Magazine*,
CXVII, no.862, January 1975, pp.47–8
Ulster Museum, Belfast

This watercolour and the view near Dublin (cat.no.63)
are from a group of four small watercolours in the Ulster
Museum. They were formerly in a folder together with six
watercolours by the Irish artist John Henry Campbell
(1757–1828).[1] All are inscribed on the reverse 'Coote
Carroll' and numbered, and it seems likely that all are part
of a series of commissioned Irish views. One watercolour
by Danby is watermarked 1811.

These watercolours are surprisingly fresh in colour and
entirely lack the strong black underlying wash drawing of
J. H. Campbell whose watercolours are more picturesquely
composed and are close to the work of William Payne

61

62

(*c.*1760–*c.*1830). Another prominent painter of views in
watercolour, whose work Danby would have known in
Dublin, was Thomas Sautelle Roberts (1760–1826). His
watercolours are superior to Campbell's in quality but
similarly drawn and tinted.

Danby was to paint watercolours of Irish views after
arriving in England in 1813 and the British Museum's large
watercolour, 'The Eagle's Nest, Killarney – Evening' of
about 1818, is an example.[2] However, Danby's Ulster
Museum watercolours, together with the 'View in Co.
Wexford' (cat.no.61) form a coherent and distinctive group
and were certainly drawn before 1813.

[1] Martyn Anglesea, *op.cit.*
[2] BM Print Room, 1982.5.15.23, 13 × 18⅝ in, purchased 1982. The
slight, pencil and wash drawing of a similar view (1982.5.15.24) is very
close to the earliest and weakest of drawings of the Avon Gorge and
has nothing in common with the Ulster Museum group.

63 Ringsend from Beggar's Bush, Co. Dublin
 *c.*1812
 Watercolour $5\frac{3}{4} \times 8\frac{1}{8}$ image (147×204)
 Signed: 'F Danby'
 Inscribed in ink on reverse: 'Rings' end – from
 Beggar's bush | Coote Carroll 19'
 PROV: perhaps commissioned by Coote Carroll;
 Ulster Museum before 1974
 LIT: Martyn Anglesea, 'Five unpublished drawings
 by Francis Danby', *The Burlington Magazine*,
 CXVII, no.862, January 1975, pp.47–8
 Ulster Museum, Belfast

Ringsend, now within the city, was a prosperous fishing
village to the east of Dublin beyond the Dodder river.

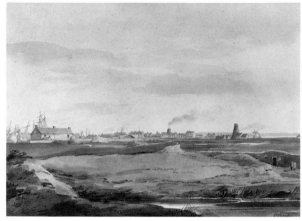

63

64 Cader Idris *c.*1815
 Watercolour and pencil 12 × 18$\frac{1}{2}$ (305 × 470)
 Signed: 'F Danby'
 EXH: *Bristol School* 1973 (32)
 LIT: Adams (77)
 Courtauld Institute Galleries (Witt Collection)

Although faded, there remains much subtlety in this very
carefully drawn view. The complex structure of the land-
scape and its forms are well managed.

 William Stokes, in his *Life of George Petrie*, describes the
visit to London of the three Irish artists, Petrie, O'Connor
and Danby in 1813. He states that these artists visited
Wales together during that year but this seems unlikely.[1] In
the National Gallery of Ireland there are five pencil views
of the Welsh coast drawn by Petrie while crossing over
from Ireland and dated 30 May 1813,[2] but there is no
evidence of a visit into Wales. It seems unlikely that Danby
could have afforded a tour in Wales until the following year
at the earliest.

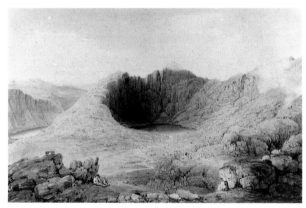

64

[1] William Stokes, *Life and Labours in Art and Archaeology of
 George Petrie*, 1868, p.10.
[2] Adrian Le Harivel, *Illustrated Summary Catalogue of Drawings . . .*,
 National Gallery of Ireland, 1983, pp.635–6, nos.6742–6746; for
 better illustrations of two of these drawings see John Hutchinson,
 James Arthur O'Connor, exhibition catalogue, National Gallery of
 Ireland, 1985, p.53.

**65 The Avon Gorge from above Sea Walls looking
 towards Clifton** *c.*1815
 Watercolour and pencil 5$\frac{1}{2}$ × 9$\frac{1}{8}$ (140 × 232)
 Signed: 'F Danby'
 EXH: *Bristol School* 1973 (34)
 Private Collection

This diligently drawn watercolour is much superior in both
quality and condition to the many slight and faded water-
colours of the Avon Gorge which survive from Danby's
earlier years in Bristol.

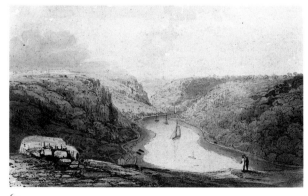

65

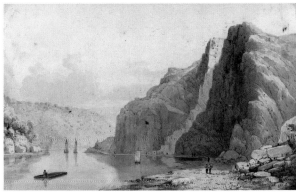

66

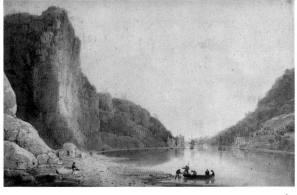

67

66　St. Vincent's Rocks and the Avon Gorge* *c.*1815
Watercolour and pencil $7\frac{1}{2} \times 11\frac{3}{4}$ (190 × 298)
Signed: 'FD'
PROV: Sir Marchant Williams Bt, 1906; Andrew
Wyld, London, 1981; Davis & Langdale Co. Inc.,
New York
Collection of Mimi and Sanford Feld

The light colour-washes of Danby's early watercolours
have made them particularly vulnerable to fading, but this
view from just below the Hotwell is in exceptionally good
condition.

When Danby and James O'Connor arrived in Bristol in
the summer of 1813, they succeeded in selling some
'slightly coloured' drawings of the Wicklow Mountains to
John Mintorn, stationer of College Green. John Mintorn Jr
was present during the transaction and later wrote:

> I put the question to Danby if he was aware of the
> beautiful scenery of the district. Receiving his answer
> in the negative, I induced him and his friend to stop
> and make a few drawings of the locality, my father
> undertaking to purchase them. The following morning
> they took their breakfast with me. I accompanied them,
> and four sketches were taken from the Downs of the
> river scenery; two were sketched by my friend, one by
> O'Connor, and the other by myself. They were
> coloured by Danby. The originals are at this time in the
> possession of my father, and highly valued by him.
> Of these views he painted many sets, which brought
> him into considerable notoriety. Thus encouraged, he
> became strongly attached to a locality affording great
> scope for the pencil of an artist; to this I may add his
> introduction to the many men of taste and literature of
> which then old Bristolia could boast – Messrs King,
> Gould, Eagles, Rippingale, Smith, Jackson etc, etc.[1]

There is an assurance about this drawing which would
suggest it was painted a year or two after his arrival in
Bristol. He was beginning to retrieve the confident and
direct handling of colour that characterises his few Irish
watercolours (cat.nos.61–3).

There are many pairs of Avon Gorge views by Danby
but Mintorn's reference to sets of views is only given
credence by the series of which the present drawing is a
part.[2] The group consists of six views of the Avon
progressing from the Hotwell, at the beginning of the
gorge, to the mouth of the river. This watercolour and
cat.no.67 were at the beginning of the sequence. The
concept and some of the viewpoints follow closely on
Nicholas Pocock's series of watercolours over etched
outlines, sometimes with aquatint, which were produced
throughout the 1780s and 1790s.[3]

[1] *Western Daily Press*, Bristol, 20 February 1861, p.4. The Bristol men
listed are: Dr John King, Francis Gold, Revd John Eagles, E. V.
Rippingille, Henry or Richard Smith (see cat.no.69, prov.) and
Samuel Jackson.
[2] The six watercolours were lent to the Third Loan Exhibition at
Bristol Art Gallery, 1906, by Sir Marchant Williams Bt (321, 322,
325–8). 'The Avon from Durdham Down with Cook's Folly' was sold
at Sotheby's 19 March 1981 (122) together with the two drawings
exhibited here, cat.nos.66 and 67. A less common view of 'Blaise
Castle' and 'The Mouth of the Avon with Penpole Point' are now in a
private collection. The sixth view in the series, another view of
St. Vincent's Rocks, is at present unidentified.
[3] Francis Greenacre, *Marine Artists of Bristol, Nicholas Pocock
(1740–1821) and Joseph Walter (1783–1856)*, Bristol, 1982, pp.44–7,
figs.22–9.

67　Hotwells in the Avon Gorge *c.*1815
Pencil and watercolour $7\frac{3}{4} \times 11\frac{3}{4}$ (197 × 298)
Signed: 'F Danby'
PROV: Sir Marchant Williams Bt, 1906; Sotheby's
19 March 1981 (124), bought Thos Agnew & Sons
Ltd
Private Collection

This view looks up-river, in the opposite direction to its
pendant (cat.no.66). The same precipitous face of St.
Vincent's Rocks is shown in both watercolours which, like
most of Danby's earlier Bristol views, concentrate on the
dramatic and picturesque scenery enjoyed by visitors to
Clifton and the Hotwell.

68 Cheddar Gorge, Somerset *c.*1816
Pencil and watercolour $14\frac{5}{8} \times 10\frac{5}{16}$ (372 × 262)
PROV: purchased at the sale of A. M. Hale, White
House, Rake, Hampshire, Jacob & Hunt, Petersfield,
8 April 1960 (325 part lot) and presumed to be from
the collection of George Weare Braikenridge
City of Bristol Museum and Art Gallery

When this watercolour was acquired by Bristol Art Gallery
it was attributed to Samuel Jackson. However, the pencil
work, figures and especially the distinctive dotting can
leave little doubt that it is by Danby.

The subject matter is an example of Danby's early
concentration on the more obvious scenic wonders of the
Bristol region. Although he suggests the spectacular and
picturesque nature of the Cheddar Gorge, the view lacks
the drama that some of Danby's contemporaries, notably
J. M. W. Turner, would have brought to such a scene.
Instead there is already an emotive stillness foreshadowing
his best Bristol drawings.

68

69 View near Killarney* *c.*1817
Pencil and watercolour $12\frac{3}{4} \times 18\frac{5}{8}$ (323 × 474)
PROV: probably purchased from the artist by
Richard Smith, surgeon, or by his brother Henry
Smith, attorney, both of Bristol; thence by descent
until 1986; Andrew Wyld, London; Davis &
Langdale Co. Inc., New York, from whom
purchased
*Mellon Bank Corporation, Pittsburgh, Pennsylvania,
U.S.A.*

Although now known as 'View near Killarney' this is
almost certainly an imaginary landscape. The evening
sunlight appearing from beyond the elegant group of trees
is perhaps the first instance of Danby's lasting enthusiasm
for the classical landscape tradition of the seventeenth
century, and especially for the work of Claude Lorrain.
The colour range is limited but subtle, and there is
impressive control of aerial perspective.[1]

The pair to this watercolour, unfortunately much faded,
is a view of 'Carrick Castle, Argyllshire',[2] a reminder that
in 1817 a 'G. Danby' of 'Clifton' exhibited a 'View in
Scotland' at the Royal Academy. It is just possible that this
was Francis Danby. Two other Scottish scenes are known.
They are small views of 'Newark Castle with Dumbarton
Rock' and 'Dumbarton Rock from the South Side of the
Clyde'[3] and are close to 1813 in date. There are, however,
no references in Danby's letters to a Scottish journey nor
were there any Scottish drawings remaining in his studio
sale. It seems more likely that the Scottish subjects were
worked up from someone else's drawings, a common
practice at the time.

69

[1] Danby's watercolour of 'Conway Castle' in the British Museum (BM
1890.5.12.42: Adams (79)) is of a similar size with bold shafts of
sunlight bursting through clouds. Eric Adams points out that it has
several similarities with two etchings in J. M. W. Turner's *Liber
Studiorum*, both of which were published in January 1816, and that it
is, perhaps, the first occasion on which Danby attempts a romantic
scene. But 'Conway Castle' is prosaic and self-conscious beside this
more personal and imaginative watercolour 'View near Killarney'.
[2] With Andrew Wyld, London, 1987, $12\frac{1}{2} \times 18\frac{1}{2}$ in.
[3] Both signed 'F Danby', and with James Mackinnon, London, 1988,
$6\frac{3}{4} \times 9\frac{3}{4}$ in and $6\frac{7}{8} \times 9\frac{7}{8}$ in.

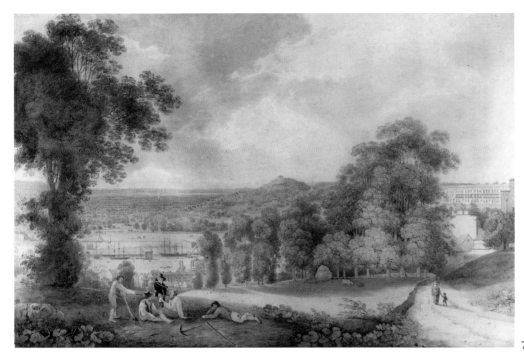

70

70 View from Clifton Hill *c.*1818
Pencil and watercolour 25 × 36 (635 × 914)
Signed: 'F: DANBY'
EXH: *Bristol School* 1973 (35)
LIT: Adams (78)
Private Collection

The topographical accuracy and detail are matched by
Danby's impressive management of moving clouds and
scattered sunlight. The Somerset fields stretch away into
the distance, an echo of the Roman Campagna in a Claude.[1]
Less sophisticated is the foreground foliage and it is,
perhaps, the large size of this watercolour that has led
Danby to employ a rather archaic technique for the leaves
and branches of the tree on the left.

The view looks out from the top of what is now Goldney
Avenue, Clifton and across the Floating Harbour and New
Cut towards Long Ashton, with Dundry Hill on the far left.
On the right is Royal York Crescent.

A much smaller and almost identical view is known.[2] It
is probably earlier and, although it confirms the careful
accuracy of Danby's architectural detail, it was probably
not used as a study for the present work.

71

**71 The Avon Gorge from the Stop Gate below Sea
Walls** *c.*1818
Pencil and watercolour $7\frac{1}{6} \times 10\frac{5}{16}$ (180 × 262)
PROV: Heber Mardon Bequest, 1925 (extra-
illustrated volumes of J. F. Nicholls & John Taylor,
Bristol Past and Present (Bristol, 1881) vol.10, p.3)
EXH: *Bristol School* 1973 (36)
City of Bristol Museum and Art Gallery

This is the most perfectly preserved of Danby's earlier
Bristol drawings.

Beyond the gate are the wide flat-bottomed quarry boats
with short masts. In the distance are the ruins of the
windmill above St. Vincent's Rocks, later to be converted
to an observatory.

[1] Specifically one of the great 'Altieri' Claudes, 'Landscape with the
 Father of Psyche sacrificing to Apollo' then in the Miles collection at
 Leigh Court, near Bristol, and now The National Trust, Anglesey
 Abbey, Cambridgeshire.
[2] Christie's 15 November 1983 (193), $7\frac{5}{8} \times 12$ in; with Andrew Wyld,
 London, 1984.

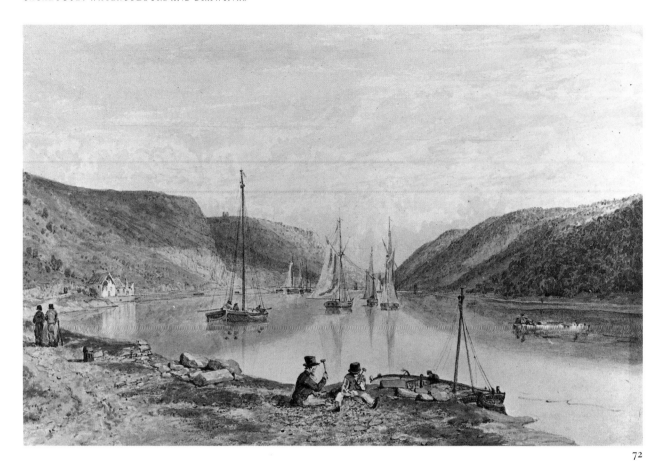

72

72 **A View of the Avon Gorge from beneath Sea Walls*** 1820
Pencil, watercolour and bodycolour $5\frac{3}{8} \times 7\frac{7}{8}$
(137×202)
Signed and dated on the boat's stern: 'F.DANBY
1820'
PROV: George Weare Braikenridge; Braikenridge
Bequest, 1908
EXH: *Danby* 1961 (38); *Bristol School* 1973 (38)
LIT: Adams (85)
City of Bristol Museum and Art Gallery

This is Danby's only dated Bristol watercolour, and, when
compared to the previous watercolour of almost the same
view, it demonstrates how radically his style and technique
changed. Much brighter colours are now employed with a
tentative, almost stippled technique, using opaque body
colour, rather than transparent washes. The incidental
detail of the figures and the boats with their slack sails
has become a central feature. The more picturesque or
spectacular aspects of the Avon Gorge are played down.
The composition is more open and less conventional, and,
to the still reflections in the water, Danby has added warm
evening sunlight and the shadows of moving clouds.

73

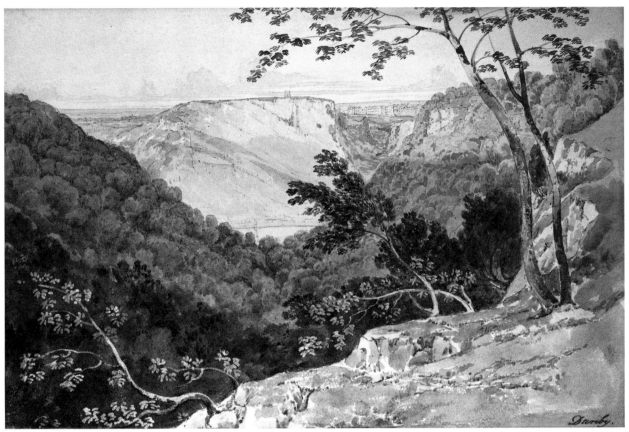

74

73 St. Vincent's Rocks from Nightingale Valley
*c.*1819
Pencil and watercolour $9 \times 12\frac{3}{8}$ (228×314)
Mrs Kate Davies, Oxford

This watercolour is one of the very few sketches or un-finished drawings by Danby to have survived. Attached to the back is a letter written in 1848 from an unknown correspondent recording that the watercolour had been removed long ago by the writer from one of Danby's sketch books.[1]

The watercolours of Nightingale Valley, the favourite haunt of Bristol artists, may well mark Danby's entry into the circle of Bristol's cognoscenti and the beginning of his friendship with John King, George Cumberland and Revd John Eagles. Danby is first mentioned in the Cumberland correspondence early in 1820 in connection with the 'Upas Tree' (cat.no.18).[2]

In this drawing the broad free pencil work of the foreground is similar to Eagles' technique and in distinct contrast to the sharp and precise line of varying density in the distance. The colouring, particularly the purplish tint, is also found in some of Eagles' imaginary wash drawings.

[1] 'My dear Miss Edward | I send you my | two original Frank | Danbys, which I hope | you will do me the | favour to take your choice | of. I

took them | from his sketch book | I am now afraid to | say how long ago. | . . . I also soon after | paid a visit to the | Evening Gun. It is a | great Gun indeed, and | Yours Ever C P.'
[2] BL Add. MS 36508 fo.153, G. Cumberland Sr to G. Cumberland Jr, 2 January 1820 (mis-dated 1821).

74 St. Vincent's Rocks from Nightingale Valley *c.*1819
Pencil and watercolour $8\frac{3}{8} \times 12\frac{5}{8}$ (213×320)
Inscribed in ink, perhaps in George Weare Braikenridge's hand: 'Danby'
PROV: probably George Weare Braikenridge; Mrs I. M. McKeag, Bristol, from whom purchased 1984
LIT: Adams, p.186 under (92)
City of Bristol Museum and Art Gallery

Nightingale Valley is largely in the shade well before sunset and, here, Danby takes advantage of this time to emphasise the detachment of Leigh Woods from Clifton. Revd John Eagles, who was so often to recall the Elysian delights of Leigh Woods, of which Nightingale Valley is a part, described how the woods were separated from 'the cares and turmoils of a busy and commercial world' by 'the muddy Avon'.[1]

Eagles also recognised the particular compositional

problems that the view from near the top of Nightingale Valley could cause the artist.[2] St. Vincent's Rocks became a confining wall and there were no compositional links between the two sides of the river which, from a little lower down, was unseen. Danby employs the foreground trees to unite the succeeding planes, and for their habit he may well have turned to the seventeenth-century French artist, Gaspard Dughet, for whom Eagles was the most passionate advocate, and whose works Danby could have seen at Leigh Court.

[1] Eagles, p.100.
[2] *Ibid.*, pp.123–4.

75 The Avon Gorge with Clifton and the Hotwells *c.*1820
Pencil, watercolour and bodycolour $17\frac{5}{8} \times 31\frac{3}{4}$ (447×805)
Private Collection, U.K.

The broad expanse of foreground vegetation almost masks this unusual panoramic sweep of the Avon Gorge. In the distance vessels sail up-river towards Bristol and are about to pass the Hotwell and Windsor Terrace. On the right the evening sun catches the upper slopes of Nightingale Valley.

An impressive variety of techniques has been employed including sponging and dabbing out, as well as the use of gum-arabic glazes.

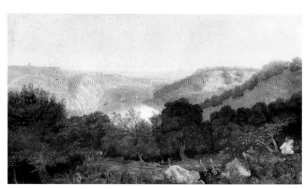

75

76 Chepstow Castle on the Wye *c.*1820
Pencil $8 \times 17\frac{1}{2}$ (203×444)
Signed: 'Danby Chepstow Castle'
PROV: Andrew Wyld, London, from whom purchased 1983
Yale Center for British Art, Paul Mellon Fund

No watercolour based on this very detailed study is known, but six watercolours of views on the Wye and one oil are recorded (fig.9).[1]

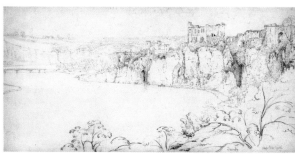

76

[1] Watercolours: 'Chepstow Castle from across the river' *c.*1814, $7 \times 10\frac{3}{8}$ in, private coll. Luxembourg; 'Longstone, New Weir on the Wye' *c.*1814, $8 \times 11\frac{1}{2}$ in, Andrew Wyld, 1988; 'View of the Wye' *c.*1818, $7\frac{3}{8} \times 11\frac{7}{8}$ in, private coll. London: Adams (80) (as 'View of the Severn'); 'A View on the Wye' *c.*1820, $7\frac{1}{2} \times 11\frac{1}{4}$ in, City of Bristol Museum and Art Gallery (K2778); 'Wye Valley' *c.*1824, $7\frac{5}{8} \times 12\frac{7}{8}$ in, City of Bristol Museum and Art Gallery (K4502). Oil: 'View down the Wye Valley' *c.*1818, $13\frac{1}{16} \times 9\frac{11}{16}$ in, Yale Center for British Art: Adams (10) (as 'The Avon Gorge').

77 Pine Trees at Cotham, Bristol 1820
Pencil $9\frac{5}{8} \times 7\frac{1}{2}$ (245×190)
Inscribed in ink: 'Pine Trees in the Avenue leading from Pugsley's field to Redland – sketched by Danby – 1820'

77

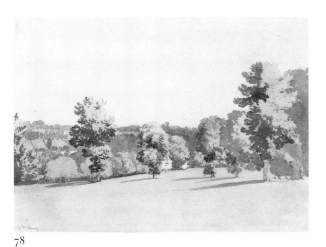

78

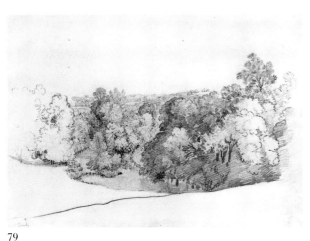

79

PROV: probably acquired from the artist by Joseph Walter
Nicholas Guppy

This drawing comes from a bound volume of drawings and engravings probably compiled by Lucy Walter, daughter-in-law of the Bristol marine artist Joseph Walter (1783–1856), and the inscription is probably in his hand. Pugsley's field was near Kingsdown Parade where Danby lived from 1819 to 1822.[1]

It is just possible that Danby was prompted to make this study after seeing John Martin's *Characters of Trees*, first published in 1817. This folio of seven etchings includes one of extremely tall and strikingly unnaturalistic pine trees.[2]

[1] For the story of Mother Pugsley's Well, see Greenacre & Stoddard, p.28.
[2] Illus. in J. D. Wees and M. J. Campbell, '*Darkness Visible': The Prints of John Martin*, exhibition catalogue, Sterling & Francine Clark Art Institute, Williamstown, Mass. U.S.A., 1986, p.11.

78 View towards the Avon from near Leigh Court

c.1821
Pencil and watercolour $7\frac{1}{10} \times 10\frac{3}{10}$ (180 × 261)
Inscribed in pencil: 'Mr Danby'
Private Collection, Melbourne, Australia

This delicate watercolour is one of a group of five unusually informal pencil and watercolour studies (see also cat.nos.79 and 80) of views in the grounds of Leigh Court, near Bristol. These drawings have descended in the family of the former owners of the neighbouring mansion of Ham Green.

Leigh Court contained the most impressive collection of paintings in the Bristol region. Danby would have visited the collection, especially to see the two great 'Altieri' Claudes, and Revd John Eagles would certainly have pressed him to pay particular attention to the paintings by Gaspard Dughet.[1] Philip John Miles, the owner, was not known as a patron of local artists.

[1] John Young, Keeper of the British Institution, was the author of *A Catalogue of the Pictures at Leigh Court . . .*, 1822. He was in correspondence with Francis Danby in 1820 and 1825 (BM Print Room, Anderdon Coll. vol.IX, 1825, undated letter, F. Danby to J. Young); see cat.no.21.

79 View from near Leigh Court with Blaise Castle

c.1821
Pencil $7 \times 9\frac{3}{4}$ (178 × 247)
Inscribed: 'Mr Danby.'
Private Collection, Melbourne, Australia

The view looks across the Avon, here entirely obscured by trees, probably from near Paradise Bottom on the edge of Leigh Woods.

80 View across the Avon from near Leigh Court with Cook's Folly and Sea Walls *c.*1821
Pencil $7\frac{1}{5} \times 9\frac{9}{10}$ (198 × 249)
Private Collection, Melbourne, Australia

This is the only drawing in this group (see cat.no.78) which has the character of a carefully composed study for an intended oil or watercolour.

81 Rownham Ferry, Bristol *c.*1820
Pencil and watercolour $7\frac{1}{2} \times 17\frac{5}{8}$ (190 × 447)
PROV: purchased 1885
EXH: *Bristol School* 1973 (39)
LIT: Adams, p.186 under (91)
Trustees of the British Museum

This is the only certain instance of the survival of a careful watercolour study for a known watercolour (cat.no.82).[1] Perhaps entirely executed on the spot, the distinctive grey-green and pale yellow colouring is reminiscent of the many watercolour sketches by George Cumberland, in whose company Danby certainly visited Leigh Woods. They would have crossed by Rownham Ferry and then walked along the tow-path depicted here.

[1] The Victoria and Albert Museum's 'Avon Gorge with the Hotwell' (E.307-1948) mis-titled and mis-dated in *Bristol School* 1973 (48) is close in style, technique and date. It differs slightly from a large and faded watercolour of the same view in a private collection, Bristol.

82 Rownham Ferry, Bristol* *c.*1820
Watercolour and bodycolour $10\frac{1}{2} \times 18\frac{3}{8}$ (267 × 467)
Signed: 'F: DANBY'
PROV: George Weare Braikenridge; Braikenridge Bequest, 1908
EXH: *Danby* 1961 (41); *Bristol School* 1973 (40)
LIT: Adams (91)
City of Bristol Museum and Art Gallery

The study for this watercolour (cat.no.81) gives no hint of the dramatic light effects depicted here. The light on the distant trees and buildings is set against the darkening clouds, successfully transforming a meticulous topographical drawing into a depiction of an oncoming storm.

The foreground has been reduced in extent but it is still awkward. Danby omits the large capstan-like object on the right of the study, and has turned rather unsuccessfully for help with the foreground figures to W. H. Pyne's *Microcosm*, a book designed to supply artists with appropriate figures for their landscapes.[1] This is the only occasion on which Danby is known to have used this publication but Samuel Jackson, the Bristol watercolourist and Danby's lifelong friend, used it regularly in his early work and perhaps to better effect.[2]

The Rownham Ferry of the title is the diminutive boat in

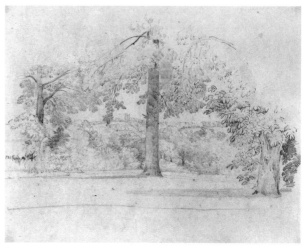

80

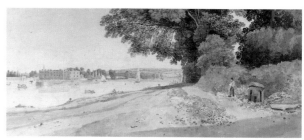

81

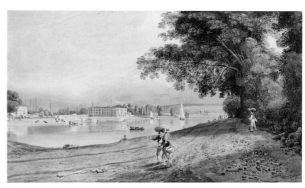

82

the centre transporting people and their animals across the Avon. On the opposite bank the lock gates mark the entrance to the Cumberland Basin and Bristol's harbour.

[1] W. H. Pyne, *Microcosm: or a picturesque delineation of the arts, agriculture, manufactures, etc. of Great Britain . . . for the embellishment of landscape . . .*, vol.1, 1806, 'Gypsies', pl.1.
[2] Greenacre & Stoddard, p.97.

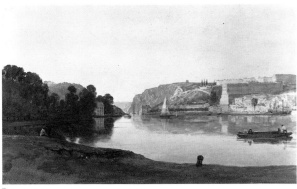

83

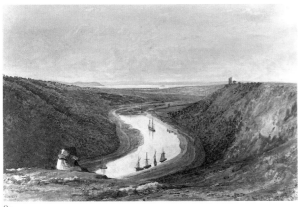

84

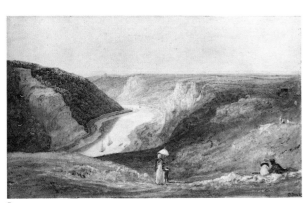

85

83 The Avon at Clifton* *c.*1821
Pencil, watercolour and bodycolour $5\frac{1}{16} \times 8\frac{1}{2}$
(129×217)
Signed: 'F: DANBY'
PROV: presented by L. Cruger Miles to the Mansion
House, Bristol, 1875
EXH: *Danby* 1961 (39); *Bristol School* 1973 (45)
LIT: Adams (86)
City of Bristol Museum and Art Gallery

In this masterpiece of British watercolour drawing, mood
has come to dominate and to elevate the simple record of a
particular scene. The careful drawing of the buildings and
of the steam packet about to enter Cumberland Basin,
together with the suggestion of crowded quaysides, serves
only to emphasise the calm and contemplative mood
epitomised by the detached onlooker on the bank. Few of
Danby's watercolours have more careful observation of the
actual effects of the last moments of sunset.

84 The Avon from Durdham Down* *c.*1821
Watercolour and bodycolour $5 \times 7\frac{3}{4}$ (127×197)
Signed: 'F.DANBY'
PROV: presented by L. Cruger Miles to the Mansion
House, Bristol, 1875
EXH: *Danby* 1961 (40); *Bristol School* 1973 (46)
LIT: Adams (87)
City of Bristol Museum and Art Gallery

Amongst Danby's earlier drawings dating from his first two
or three years in Bristol, there are more slight and faded
views taken from this spot than from any other. This later
view looks down-river to the mouth of the Avon with the
Bristol Channel and Welsh hills beyond. Quarry boats are
moored below Sea Walls and Cook's Folly breaks the
skyline.

85 The Avon Gorge from Clifton Down *c.*1821
Watercolour and bodycolour $4\frac{1}{2} \times 7\frac{1}{4}$ (114×184)
Signed: 'F.DANBY'
Private Collection

Danby brings interest and variety to his later views from
the Downs by the differing effects of sunlight, and by the
livelier and less self-consciously placed figures. These
views along the Avon convey a relaxed, familiar, even
possessive, delight in the scenery, that is unmatched by any
other Bristol artist. His name deserves to be as naturally
associated with the Avon Gorge as Constable's is with
Dedham Vale.

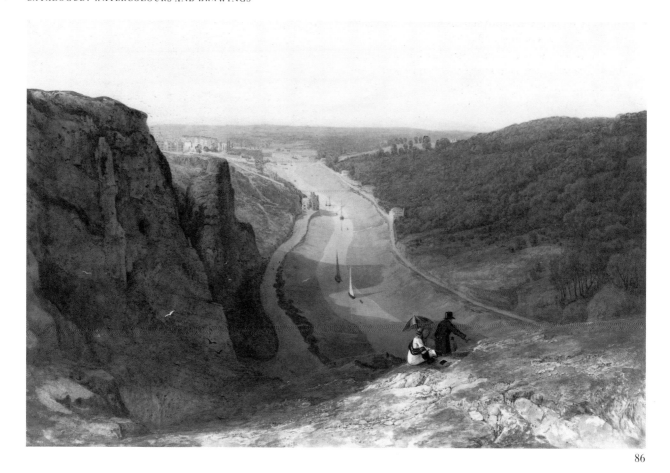

86

86 The Avon Gorge looking towards Clifton *c*.1821
Watercolour with bodycolour 19 × 29 (482 × 736)
PROV: Frederick Hawkins Poole; Christie's
4 February 1888 (40), bought by 'E.P.'; by descent
to Mrs Patricia Farr née Poole; Christie's
24 October 1975 (114)
Yale Center for British Art, Paul Mellon Collection

This spectacular viewpoint was seldom employed by
Bristol's artists; it is also unusual to see the Avon depicted
at low tide, its muddy banks revealed. Danby breaks the
parallel lines of the river with the early morning shadows
cast by St. Vincent's Rocks. From the summit of the
further of the two cliffs, the Clifton Suspension Bridge now
springs. Beyond this promontory, Sion Hill, Prince's
Buildings and the back of Windsor Terrace are carefully
drawn.

In the centre the Old and New Hotwell Houses stand
side by side. By the early nineteenth century the reputation
of the Hotwell spa was declining and a contributory factor
was the difficulty of access from Clifton which had been
expanding fast. In 1819 an Act of Parliament allowed the
road to the Hotwell to be continued along the river below
St. Vincent's Rocks and up what is now called Bridge
Valley Road to the Downs. It was opened in 1822. It
necessitated the demolition of the Old Hotwell House built

in 1696. Before the demolition occurred during the winter
of 1821–2 a smart new Hotwell House was built in an
ultimately unsuccessful attempt to revive the spa's for-
tunes.[1] It therefore seems likely that this large watercolour
was based on sketches made in the summer of 1821.[2]

[1] A watercolour in the City of Bristol Museum and Art Gallery (M3370)
by H. O'Neill is dated October 1821 and shows the New Hotwell
House beside a very dilapidated Old Hotwell House.
[2] Samuel Jackson's watercolour of 'The New and Old Hotwell Houses
by Moonlight' omits the new road and still has the lime-kiln at the foot
of St. Vincent's Rocks: see Greenacre & Stoddard, pl.24.

87 A View of the Avon from Clifton Down *c*.1822
Watercolour $6\frac{5}{8} \times 11\frac{1}{4}$ (168 × 286)
Signed: 'FD'
PROV: P. Clark, London; Andrew Wyld, London,
1979; Davis & Long Co. Inc., New York, 1980
Mr and Mrs Deane F. Johnson
(Exhibited at the Tate Gallery only)

In superb condition and painted with a limited palette, but
with great freedom and sureness of touch, this is one of the
most striking of Danby's Bristol watercolours. It is possible
that much of it was painted on the spot with some careful
washes of colour added later. Throughout, the structure of

the landscape is clear, and depth and distance are conveyed with subtle variations of tone and colour.

In the distance the line of trees marking the far side of Durdham Down is seen against the Welsh hills which are outlined against the evening sky. To the left the sun catches the Bristol Channel and, in the centre, Sea Walls. The ochre-red of the nearer cliff face can still occur in a muted form today but would have been much stronger in Danby's time, when the cliff face was being quarried. Two water-colours by Samuel Jackson from the same viewpoint show the rich colours of this cliff face at sunset. Both are especially close in style to Danby.[1]

[1] Both City of Bristol Museum and Art Gallery: K5051 is illus. in col. in Greenacre & Stoddard, pl.35; K2744 is illus. in col. in *Bristol School* 1973, p.28.

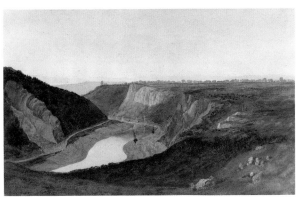

87

88 A View of Kingsweston Hill, near Bristol *c.*1822
Pencil and watercolour $6\frac{3}{4} \times 11\frac{1}{4}$ (168 × 286)
Signed: 'F.D'
PROV: Baskett and Day, 1979; Andrew Wyld, London, from whom purchased 1981
Syndics of the Fitzwilliam Museum, Cambridge

The view looks out over the stables, house and parkland of the King's Weston estate, four-and-a-half miles north-west of Bristol, overlooking the mouth of the Avon and the Bristol Channel. To the right of John Vanbrugh's distinctive chimneys on King's Weston House (built 1709–19) are the 'eye-catcher' gateway and Penpole Point.

The viewpoint is very close to that in Danby's lithograph 'View from Kingsweston Hill' (cat.no.130) on which he was working during the winter of 1822–3.

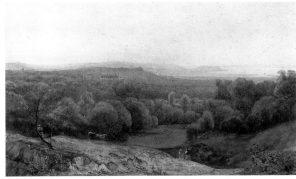

88

89 Blaise Hamlet, near Bristol *c.*1822
Pencil, watercolour and bodycolour $6\frac{1}{2} \times 11\frac{1}{2}$
(165 × 292)
Inscribed in ink on reverse in G. W. Braikenridge's hand: 'Danby No 16'
PROV: George Weare Braikenridge; Braikenridge Bequest, 1908
EXH: *Bristol School* 1973 (41)
LIT: Adams (93)
City of Bristol Museum and Art Gallery

The fading of blue from the sky and yellow from the greens has exaggerated the tonal contrasts of this watercolour and given it more of the character of a topographical record than it probably once had.

Blaise Hamlet, which Pevsner called 'the *nec plus ultra* of picturesque layout and design',[1] is in the village of Henbury just a mile from Kingsweston and was completed in 1811 to the designs of John Nash.

This watercolour and the following two were owned by George Weare Braikenridge (1775–1856), who amassed a collection of some fifteen hundred watercolours and

89

drawings of Bristol in the 1820s.[2] However, most of his watercolours and oils by Danby are not in character with the collection as a whole and it seems possible that few, if any, were painted specifically for him.[3]

[1] Nikolaus Pevsner, *The Buildings of England: North Somerset and Bristol*, Harmondsworth, 1958, p.468.
[2] Sheena Stoddard, *George Weare Braikenridge 1775–1856: a Bristol Antiquarian and his Collections*, unpublished M. Litt. thesis, Univ. of Bristol, 1983.
[3] Sixteen oils and watercolours by Danby have been identified as coming from the Braikenridge Collection: cat.nos.2, 8, 12, 13, 16, 68, 72, 74, 82, 89, 90, 91, and drawings K510, K845, K2778, M947 in the City of Bristol Museum and Art Gallery. Eight bear inscriptions and numbers (from 10 to 24) in G. W. Braikenridge's hand, implying that the majority were bought as a single group, perhaps at the time of Danby's departure from Bristol.

90 Farm at Abbots Leigh, near Bristol *c.*1822
Watercolour and bodycolour $8\frac{11}{16} \times 12\frac{1}{2}$ (220 × 317)
Inscribed in pencil on reverse probably in
G. W. Braikenridge's hand: 'Farm at Leigh | Danby'
PROV: George Weare Braikenridge[1]; Braikenridge
Bequest, 1908
*Somerset Archaeological and Natural History Society,
Taunton*

This watercolour is unusual both for its early autumn
effects and for the contrast of the more prosaic landscape
on the right with the solidity of form and crispness of light
on the left. Here the oak tree, figures and foreground are
painted in bodycolour with the assurance of 'The Frome at
Stapleton, Bristol' (cat.no.91).

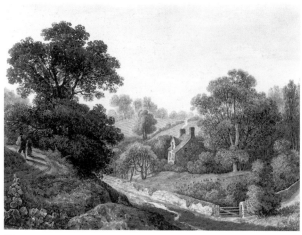

90

[1] This watercolour was formerly part of G. W. Braikenridge's extra-
illustrated volumes of J. Collinson, *History and Antiquities of the
County of Somerset* (Bath, 1791), and has not been exhibited before.

91 The Frome at Stapleton, Bristol* *c.*1823
Pencil, watercolour and bodycolour $5\frac{3}{4} \times 8\frac{1}{2}$
(146 × 215)
Signed: 'F: DANBY'
Inscribed in pencil on reverse in
G. W. Braikenridge's hand: 'No 15 | F. Danby'
PROV: George Weare Braikenridge; Braikenridge
Bequest, 1908
EXH: *Danby* 1961 (43); *Bristol School* 1973 (47)
LIT: Adams (88)
City of Bristol Museum and Art Gallery

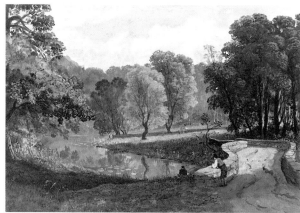

91

Bodycolour, with varying density and opaqueness, is used
extensively and with great confidence. The technique,
brilliantly employed to convey the richness and variety of
summer greens in both sunlight and shade, has no obvious
parallels in English watercolour painting of the time.

Eric Adams suggested that this work may have been
influenced by Constable, and it was in July 1824, perhaps
a year after the execution of this watercolour, that Danby
was 'delighted' by a visit to Constable's studio.[1] Danby's
small oil painting 'Boy Fishing, Stapleton' (cat.no.16) im-
plies some careful examination of Constable's technique.
However, it is likely that Constable's influence upon Danby
lay principally in enhancing his appreciation of landscape
itself, and in widening his understanding of the pictorial
possibilities of local domesticated English scenery.

Wickham Bridge on the Frome below Stapleton church
is a short distance downstream from the narrower and
steeper part of the valley depicted in Danby's oil paintings
(cat.nos.12 and 16).

[1] R. B. Beckett (ed.), *John Constable's Correspondence*, Ipswich, vol.2,
1964, p.355.

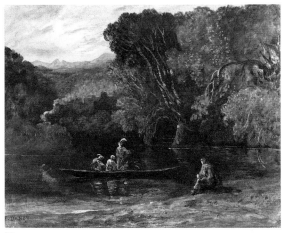

92

93

94

92 River Scene with Boat and Figures* *c.*1825
Watercolour and bodycolour $4\frac{1}{4} \times 5\frac{1}{4}$ (106 × 134)
Signed: 'F. DANBY'
PROV: L. G. Duke C.B.E., from whom purchased
1962
EXH: *Danby* 1961 (51)
LIT: Adams (135)
City of Bristol Museum and Art Gallery

Although previously dated to the 1830s it is more likely that this drawing was executed while Danby was still in Bristol. Both the colouring and the extensive use of bodycolour are close to the previous work, and the very similarly curving boughs are seen in an early sepia wash drawing (cat.no.119). The seated foreground figure, the boat and its exotic figures with plumed hats, the overhanging trees, shaded lake and distant castle, are all familiar ingredients in the sepia drawings by other Bristol artists, and especially those by Samuel Jackson and Revd John Eagles, made at the evening sketching meetings.[1]

Eagles repeatedly exhorted the sketcher to read such authors as Ovid, Ariosto or Spenser, before going off to Leigh Woods, so that with poetry in his heart, nature would be inspiration to his imagination, 'for Nature will often give him but a glimpse, where he must imagine a great deal'.[2]

[1] See illustrations in *Bristol School* 1973, pp.12, 13, 159, 246.
[2] Eagles, p.65; see also *ibid.*, pp.57, 71, 124–6, 286 and 338 for other references to Ovid (43 B.C.–A.D. 18) Latin poet, Ludovico Ariosto (1474–1533) poet and author of *Orlando Furioso*, and Spenser, as well as to Milton and Samuel Johnson's *Rasselas* (1759).

93 In Kensington Gardens *c.*1824
Pencil $5 \times 6\frac{1}{2}$ (127 × 165)
Signed: 'F: Danby'
Inscribed: 'Kingsington Gardens'
EXH: *Bristol School* 1973 (43)
LIT: Adams (89)
Trustees of the British Museum

This drawing may date from soon after Danby's move to London early in 1824.

94 A Garden Nook *c.*1825
Black and white chalk on blue paper $7\frac{3}{8} \times 5\frac{3}{8}$
(187 × 136)
EXH: *Bristol School* 1973 (44)
LIT: Adams (95)
Trustees of the British Museum

Although known as 'A Garden Nook' the landscape has much of the character of Stapleton Glen and the drawing may date from Danby's Bristol period. However, the very small number of such surviving studies makes dating particularly tentative.

95 Norwegian Landscape 1825
Pencil, watercolour and bodycolour $5\frac{1}{2} \times 8\frac{1}{4}$
(138 × 210)
PROV: Maas Gallery, London
LIT: Adams (104)
Eric Adams

In 1825, soon after selling the 'Delivery of Israel out of Egypt' (cat.no.22) at the Royal Academy for £500, Danby was planning a holiday. At first he intended to go to Austria with friends from Bristol, but abruptly left on his own for Norway towards the end of June, returning two months later.[1]

This is the only surviving drawing that can reasonably be presumed to have been executed on this journey.[2] It is an unusual view, without a skyline, and looks across a lake or fiord to where three waterfalls drop down the precipitous face of a mountain.

[1] See introduction, p.25.
[2] The pen drawing 'Hop, near Bergen', Yale Center for British Art, Adams (139), is almost certainly a later compositional sketch for a watercolour or painting and is based on studies now lost.

95

96 Mountain Landscape with a Wolf, Norway
1827 or later
Pencil, watercolour and bodycolour $7\frac{1}{8} \times 9\frac{5}{8}$
(181 × 244)
Signed: 'F DANBY'
PROV: Christie's 1 June 1972 (96)
Sabin Galleries

Francis Danby at first expressed disappointment with Norway,[1] although he later called it 'the country of Ossian', and compared it very favourably with Switzerland.[2] He was slow to take advantage of the journey, probably painting no Norwegian scenes in oil until after he arrived in Switzerland six years later.

In the autumn of 1827 Danby 'made a small drawing for an album which led to others, in consequence of this I have orders for drawings at good prices'.[3] He spoke briefly to George Cumberland in Bristol about his Norwegian views at much the same time, and it is likely that he painted 'embellished' Norwegian views in watercolour intermittently from 1827.[4] One of the watercolours sent back for sale in 1831, soon after Danby's arrival in Switzerland, was a Norwegian view.[5]

[1] Gibbons Papers, F. Danby to J. Gibbons, 26 August 1825.
[2] *Ibid.*, 25 October 1832.
[3] *Ibid.*, 17 December 1827.
[4] See cat.no.35.
[5] See cat.no.107.

96

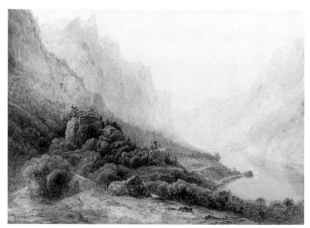
97

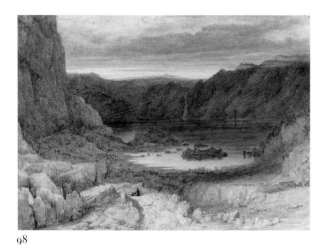

98

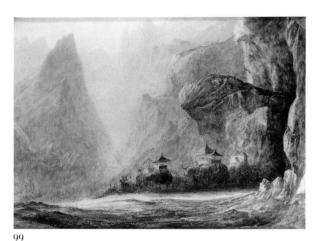

99

97 A Norwegian Fiord 1827 or later
Pencil and watercolour $5\frac{1}{4} \times 7\frac{1}{4}$ (133 × 184)
Signed: 'F DANBY'
Inscribed in pencil on reverse: 'Horse Vann,
Norway'
PROV: Andrew Wyld, London, 1981; Davis &
Langdale Co. Inc., New York; private collection,
U.S.A.; Davis & Langdale Co. Inc., New York;
Thos Agnew & Sons Ltd, 1988
Private Collection U.K.

'Horse Vann', inscribed on the reverse, is not a Norwegian
place-name. It has been pointed out that some of the rock
formations 'are a little rare in Norway', but that Danby
might have been inspired by the landscape in the region of
Romsdalen and in particular by Lake Eikesdalsvatnet.[1]

[1] Letter to the compiler from B. Skaar of the Statenskartverk 3500
Hønefoss, Norway, 1 July 1988 (City of Bristol Museum and Art
Gallery: artist files).

98 A Mountain Lake, Norway* 1827 or later
Watercolour and bodycolour $7\frac{1}{2} \times 10\frac{3}{8}$ (190 × 263)
Signed: 'F DANBY'
PROV: C. J. Hegen, by whom presented 1935
LIT: Andrew Wilton, *British Watercolours 1750 to
1850*, Oxford, 1977, illus. in col. pl.152
*By kind permission of The Keepers and Governors of
Harrow School, (Old Speech Room Gallery)*

Danby uses a striking mixture of careful detail and broad
brush work in the lake and distance. The distinctive
character of the landscape is also to be found in the only
other recorded Norwegian watercolour, besides the four
exhibited here (cat.nos.95–8). That work (Adams (140)
fig.146), possibly the most dramatic of the group, is at
present untraced.

99 The Procession of Cristna* *c.*1830
Watercolour and bodycolour $7\frac{1}{2} \times 10\frac{1}{2}$ (190 × 266)
PROV: John Gibbons; Miss M. Gibbons sale,
Christie's 29 November 1912 (76) part lot with 'A
Study for the Golden Age' (cat.no.32), unsold;
thence by descent
LIT: Adams (154)
Mrs Edward Gibbons

When put up for sale in 1912, this watercolour was titled
'The Procession of Krishna'.[1] This must refer to Danby's
own epic poem *Cristna*. Both the title and the association
with the poem could be mistaken, for this watercolour has
more of the character of a fanciful poetic landscape than of
an illustration to a particular story. In 1831, Danby did
send to Gibbons from Switzerland 'a sketch which I made a
long time since for part of Cristna's journey in search of the
valley of everlasting life' (see also cat.nos.127–8).[2]
 Although crazed, this work retains much of the extensive
gum-arabic glazing that Danby sometimes used in his
watercolours. The landscape may derive from Norwegian
scenery.

[1] The old backboard to the picture is inscribed in ink: 'The Procession
of Crissa'.
[2] Gibbons Papers, F. Danby to J. Gibbons, 19 May 1831.

100 Amphitrite *c.*1827
Watercolour $7\frac{3}{8} \times 10$ (187 × 254)
PROV: purchased from the artist by Mrs George
Haldimand; Haldimand Collection sale, Christie's
21 June 1861, bought Thos Agnew & Sons;
Christie's 18 March 1980 (219), bought Andrew Wyld
*Private Collection, courtesy of D. Nisinson Fine Art,
New York*

In December 1827 Danby told John Gibbons that some
time before he had done 'a small drawing for an album
which led to others, in consequence of this I have orders for

drawings at good prices'.[1] Most of the drawings in the Haldimand Collection were made in 1826, 1827 and especially 1828. The Haldimand Collection was one of the finest examples of the contemporary fashion for collecting small watercolours by many different artists and placing them in finely bound albums (see cat.no.117).[2] Mrs Haldimand employed George Fennel Robson (1788–1833), the watercolour artist, to select the artists and commission the drawings. A few years later he was to sell watercolours sent from Switzerland by Danby (cat.no.109).

In this watercolour Amphitrite sits in her cockle-shell drawn by dolphins and surrounded by Nereids and Tritons. Further out to sea Neptune rides in his chariot pulled by hippocampi, beasts with the fore parts of a horse and the hind parts of a fish. Amphitrite had fled from Neptune but he sent dolphins in pursuit which persuaded her to return to become his bride.

The figures are very similar in treatment to those in the drawing of 'The Golden Age' (cat.no.32) of 1827.

[1] Gibbons Papers, F. Danby to J. Gibbons, 17 December 1827.
[2] J. L. Roget, *A History of the 'Old Water-Colour' Society*, 1891, vol.I, p. 464; see also cat. no.117 and the introduction to the Haldimand Collection sale catalogue, Christie's 18 March 1980.

101

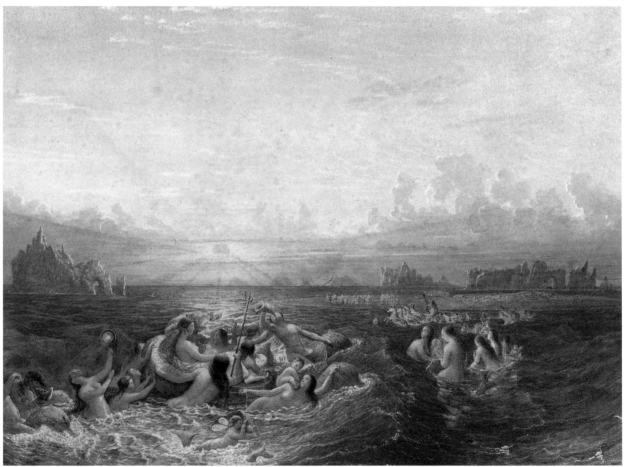

100

102

101 London from Primrose Hill – Moonlight *c.*1828
Watercolour and bodycolour $4\frac{1}{2} \times 5\frac{3}{8}$ (114×136)
Signed: 'F. DANBY'
PROV: Spink & Son Ltd, 1984
Deborah and Joseph Goldyne

This view towards St. Paul's Cathedral from Hampstead may well date from the later 1820s when Danby was living at 14 Mornington Crescent, Hampstead Road. John Gibbons had apparently requested a moonlight subject in 1826.[1] This was never undertaken, but at least four of the ten paintings which Danby exhibited at the Royal Academy and the British Institution between 1826 and 1829 were moonlight scenes.

[1] Gibbons Papers, F. Danby to J. Gibbons, 15 November 1826.

102 Landscape with Crescent Moon *c.*1829
Watercolour and bodycolour $4\frac{1}{2} \times 5$ (114×127)
Signed: 'F. DANBY'
LIT: Adams (126)
Trustees of the British Museum

This watercolour may be connected with 'Moon Rising over a Wild Mountainous Country' exhibited at the British Institution in 1829 (see cat.no.29). Danby had mentioned his wish to paint 'the moon rising over mountains and a lake with a vulcano in the horizon', two years earlier.[1]

[1] Gibbons Papers, F. Danby to J. Gibbons, 6 January 1827.

103 A Son of the Artist *c.*1828
Black chalk $12\frac{1}{4} \times 8$ (311×203)
Inscribed on the former backing card in James Danby's hand: 'By Francis Danby ARA | sketch of one of his children'
PROV: Andrew Wyld, London, 1985
Private Collection, San Francisco

In 1834 Dr King reported on his return from Switzerland that Danby was surrounded by eleven children.[1] He certainly then had ten children, seven by his wife and three by Ellen Evans.[2] Five of his wife's children were boys,[3] as were all three of Ellen's.[4] There can therefore be little chance of identifying with any certainty the sitters of this and the following drawing.

The eldest son Francis James was born on 4 March 1815,[5] James was born in 1817,[6] and John probably in 1818.[7] The fourth son, Thomas, was perhaps born in 1821.[8] William Gibbons Danby, named after Danby's patron, was probably born in August 1827.[9]

James Danby (1817–1875) and Thomas Danby (*c.*1821–1886) were to be successful artists. Danby's letters make it clear that James was the favourite son. He was certainly the most talented and the most loyal.[10] It was he who diligently

103

inscribed many of the drawings and oil sketches left in his father's studio at his death, and both this and the following drawing had inscriptions in his hand on the old backing card.

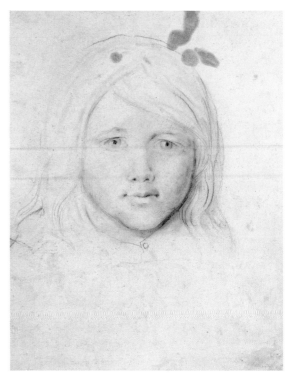

104

1 Gibbons Papers, J. King to J. Gibbons, 31 December 1834–3 January 1835.
2 Häusermann, p.228.
3 Gibbons Papers, F. Danby to J. Gibbons, 12 August 1828.
4 *Ibid.*, 28 November 1837 reporting on Ellen's death and saying that she left three little boys 'beautiful and amiable as herself'.
5 *Ibid.*, F. Danby to J. Gibbons, 29 February 1836; Compton Bishop Parish Register, Avon (Somerset County Record Office, Taunton). I am grateful to Mr Brian Austin and Miss Jane Baker for this and the following reference.
6 Compton Bishop Parish Register, Avon.
7 Gibbons Papers, F. Danby to J. Gibbons, 28 December 1834.
8 See *Bristol School* 1973, pp.101–2.
9 Gibbons Papers, F. Danby to J. Gibbons, 12 August 1828; in a letter of 25 October 1832 Danby says William is six. The 1851 census returns record a son, Frederick, aged twenty, born in Belgium and another son, Alfred, aged fifteen, born in Geneva, both of whom were living with Danby in Exmouth. In a letter of 10 September 1851 to Mrs Gibbons, Danby wrote that a son (probably Alfred) was dying.
10 Gibbons Papers, F. Danby to J. Gibbons, 28 December 1834; Adams, p.108; see also *Bristol School* 1973, pp.101–2.

104 A Son of the Artist *c.*1828

Black chalk 8¼ × 7 (209 × 178)
Formerly inscribed on the original backing card, now destroyed, in James Danby's hand
Private Collection, U.K.

These two portraits, drawn with great confidence and evident affection, may date from the summer of 1828 when Danby visited four of his sons who were then at school in Yorkshire.[1]

1 Gibbons Papers, F. Danby to J. Gibbons, 12 August 1828.

105 A Fishing Village with a Figure Climbing on a Sea Wall *c.*1828

Watercolour and bodycolour 4¼ × 7 (105 × 178)
Signed: 'F. DANBY'
PROV: Spink & Son Ltd, 1978; Andrew Wyld, London, from whom purchased 1981
Trustees of the British Museum

This is probably a view on the Devon coast; Starcross has been suggested. Danby travelled extensively in the years between his Norwegian journey in 1825 and his flight to the Continent in 1829. In the summer of 1826 he visited the north of England, perhaps Cumberland, and North Wales.[1] In July he was thinking of moving to Southampton.[2] In the autumn of 1827 he may have gone to Lynmouth, Devon,[3] and in the summer of 1828 he visited Derbyshire, Yorkshire and Wales as well as travelling up the Meuse in Belgium with the artist William Collins.[4]

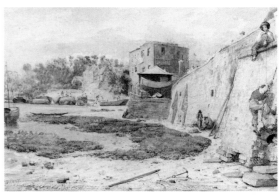

105

1 Gibbons Papers, F. Danby to J. Gibbons, 15 June 1826 and 6 July 1826.
2 *Ibid.*, 22 July 1826.
3 BL Add. MS 36512 fo.41, G. Cumberland Sr to G. Cumberland Jr, 3 November 1827.
4 Gibbons Papers, F. Danby to J. Gibbons, 12 August 1828 and 17 August 1828.

106 Pont de la Concorde with L'Assemblée Nationale, Paris* 1831
Pencil, watercolour and bodycolour $7\frac{1}{2} \times 10\frac{1}{4}$ (190 × 260)
Signed and dated: 'F: DANBY. 1831. PARIS'
PROV: Christie's 20 November 1979 (164); bought David Messum; Christie's 15 November 1983 (195)
Fine Art Society, London

Danby fled from his creditors to Paris late in 1829[1] returning briefly for Sir Thomas Lawrence's funeral in January 1830.[2] In May he moved to Bruges where his seven children joined him.[3] Danby's letters to his patron, John Gibbons, imply that he did not return to Paris again before going to Switzerland in May 1831.[4] This watercolour, dated 1831, was probably completed in Switzerland and was amongst those drawings sent back to John Gibbons in May, or to the artist George Fennel Robson in June or July.[5]

The precise drawing of the architecture and the clarity of atmospheric effect rival some of the Paris watercolours of Thomas Shotter Boys. Boys, William Callow, John Scarlett Davis and James Holland were all in Paris in 1831.[6] The detail of the incidental activity on both banks is exquisitely drawn and the foreground figures are impressively uncontrived.

[1] Gibbons Papers, F. Danby to J. Gibbons, 10 December 1829.
[2] *Ibid.*, 24 January 1830.
[3] *Ibid.*, 25 May 1830 and 16 June 1830.
[4] *Ibid.*, 19 May 1831.
[5] *Ibid.*, 26 August 1831, in which Danby says he had had a reply a month earlier from Robson, concerning a packet of drawings Danby had sent to him.
[6] Thomas Shotter Boys (1803–1874), William Callow (1812–1908), John Scarlett Davis (1804–1845 or 6), James Holland (1800–1870).

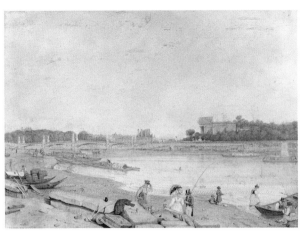

106

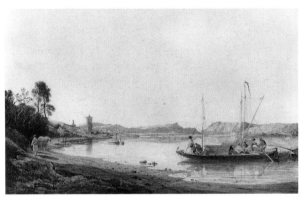

107

107 On the Rhine 1831
Pencil and watercolour $6\frac{1}{8} \times 9\frac{3}{4}$ (154 × 248)
Signed and dated: 'F Danby 1831 | On the Rhine near Coblentz'
Private Collection

Danby and his eight children, of whom the eldest was almost sixteen, spent part of the winter of 1830–1 in Germany near Coblenz.[1] On 1 January Danby wrote to John Gibbons outlining his plan to float up the Rhine on a home-made raft constructed of four thirty-foot floats, with a deck and 'paper' cabin. The craft was to be dismantled at certain stages so that, by way of Lakes Constance, Zurich and Geneva and of the river Rhone, they could reach the Mediterranean, the children learning 'all the continental languages' *en route*.[2] This watercolour, in which the children on the barge are battling to keep it from being towed on to the bank, may make reference to Danby's plan. He did not carry through the plan, however, and

went direct to Switzerland with his mistress and children, lodging with an impoverished Italian aristocrat, Curti, near Rapperswil on Lake Zurich, where he had arrived by May 1831.[3]

On 19 May, Danby sent John Gibbons a parcel of at least nine drawings which included the present watercolour priced at £3.[4] There was a large 'Evening in a wild uninhabited country' with 'the effect of the setting sun upon snow' at £15 and a drawing relating to his poem *Cristna* (see cat.no.128). Also at £3 each were watercolours of the 'Approach of a Storm on Liensfiord in Norway', two views of Lynmouth and one of 'Carnarvon Castle, North Wales'. The remaining two drawings were by other artists.

[1] Gibbons Papers, F. Danby to J. Gibbons, 3 December 1830 and 1 January 1831.
[2] *Ibid.*, 1 January 1831.
[3] *Ibid.*, 19 May 1831.
[4] *Ibid.*

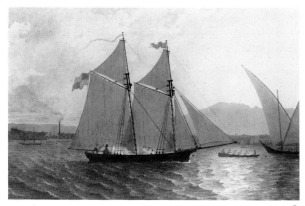

108

108 La Sorcière on Lake Geneva* 1832

Pencil and watercolour $7\frac{3}{4} \times 11\frac{1}{4}$ (197 × 286)
Signed: 'F DANBY'
Inscribed on reverse: 'Yauchts sur le lac Leman |
Commandé à | l'auteur Danby | Val f 100'
Inscribed on the original mount: Portrait de ma
Chalaupe – Goëlette | La Sorciere | Danby celebre
artiste Anglais | 1832' [sic]
PROV: Princess Galitzine; Andrew Wyld, London,
1980; Davis & Langdale Co. Inc., New York;
private collection, U.S.A.; Thos Agnew & Sons Ltd,
from whom purchased 1988
Private Collection

In the summer of 1832, after Danby had been just over a
year at Rapperswil, his landlord refused to allow him
further credit and Danby, his mistress and children fled,
penniless, to Geneva. After two months of hardship Danby
received a generous commission to paint a large oil for the
museum, as well as commissions for portraits from the
English community and for some 'little pictures', of which
this may be an example.[1]

Although 'La Sorcière' was almost certainly a commis-
sioned drawing, its subject also reflects Danby's own
personal enthusiasm for boats and for sailing. After his visit
to Geneva in the autumn of 1834, Dr John King reported
that Danby had built a boat himself during the summer,
'by way of improving the structure of boats used in the
place and giving useful employment to his boys'.[2] The
characteristic and relatively unstable barque on the right of
this drawing may be the type of local vessel upon which
Danby felt he could improve.

[1] Gibbons Papers, F. Danby to J. Gibbons, 15 June 1832, 30 August
1832, 25 October 1832; for the generous commission see under
cat.no.33.
[2] *Ibid.*, J. King to J. Gibbons, 31 December 1834–3 January 1835.

109 Scene from 'A Midsummer Night's Dream'

1832
Watercolour $7\frac{3}{4} \times 11$ (197 × 279)
Signed and dated: 'F DANBY 1832'
PROV: Charles E. Lee Gift, 1888
EXH: *Danby* 1961 (52)
LIT: Adams (131)
Oldham Art Gallery

In March 1832, Danby sent this watercolour from Rapper-
swil, Switzerland, to George Fennel Robson, commenting:

> ... I have done as well as I could with the difficult
> subject which you gave me, the materials are much
> against it as it is more calculated for an oil picture, from
> the closeups and depths that are necessary to such a
> scene by moon light. I most sincerely hope however
> that it will give some satisfaction to your Friend who
> has done me the favour to order it, as I have always
> conceived glowworms to be a very favourite light of the
> Fairies, I have attempted to paint them, but I fear I
> should have written their names under them, yet I
> need not tell you how difficult it is to catch the likeness
> when they sit for their portraits, and the good little
> people are not much better.[1]

The commission from Robson probably took into account
Danby's previous interest in the subject. Early in 1827
Danby had considered painting a large oil to be entitled
'Fairyland'. This was to depict 'a visit from Oberon
attended by his court, to the wild retreats of Titania and
her fairie luxuries'.[2] The idea was mentioned again in
February[3] but was probably submerged by the demands of
'Cleopatra' (see cat.no.27) and the 'Sixth Seal' (cat.no.24).
Robson, who had been commissioned by Mrs Haldimand
to assemble her album of watercolours, would have been in
touch with Danby at about this time, 1827, concerning the
watercolour 'Amphitrite' (cat.no.100).

[1] F. Danby to G. F. Robson, 23 March 1832, letter in the Henry
Bicknell album, Yale Center for British Art.
[2] Gibbons Papers, F. Danby to J. Gibbons, 23 January 1827.
[3] *Ibid.*, 7 February 1827.

110 Oberon and Titania* 1837

Pencil, ink, watercolour and bodycolour $6\frac{1}{16} \times 8\frac{1}{4}$
(156 × 210)
Inscribed on original backboard: 'Oberon and
Titania – Francis Danby, A.R.A., 1837'
PROV: Andrew Wyld, London, from whom
purchased 1977
EXH: Yale Center for British Art, *Shakespeare and
British Art*, 1981 (45)
Yale Center for British Art, Paul Mellon Fund

Painted in Paris in 1837, this watercolour may be the re-
sult of a commission made through Danby's patron,

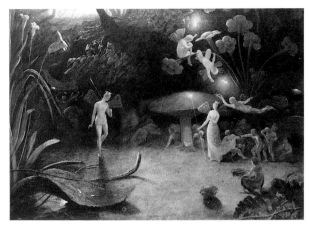

109

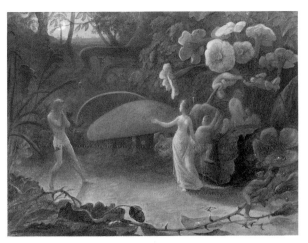

110

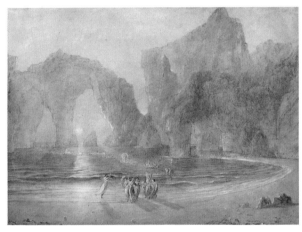

111

John Gibbons. In December 1835 Danby had promised Gibbons that he would paint a small picture of fairies when he got to Paris, if Gibbons' order on behalf of an unknown lady still stood.[1]

Danby appears to illustrate Act II, Scene I, lines 60–3 of Shakespeare's *A Midsummer Night's Dream*:

Oberon: Ill met by moonlight, proud Titania.
Titania: What! jealous Oberon, Fairies, skip hence:
 I have forsworn his bed and company.
Oberon: Tarry, rash wanton! am not I thy Lord?

This watercolour, in comparison with the previous work, relies more exclusively on moonlight for illumination; Danby observes with enthusiasm the effects of near darkness upon colour.

Eric Adams argues the influence of William Blake's imagery on Danby and specifically of *The Book of Thel* upon the previous work.[2] The present watercolour, now at Yale, was not known to Adams, but, in the curving rose briars in the foreground, and in the children playing on the primrose stems, it comes closer still to Blake. However, although Danby may have been familiar with Blake's work through the Cumberlands and Linnell, the allusions may be fortuitous.

[1] Gibbons Papers, F. Danby to J. Gibbons, 5 December 1835; Danby had earlier (25 October 1832) expressed his desire to paint 'the meeting of Oberon and Titania' in oil.
[2] Adams, p.99.

111 Fairies on the Seashore 1832–3
 Pencil, watercolour and bodycolour $7\frac{1}{8} \times 10\frac{1}{8}$
 (181 × 257)
 PROV: W. A. Brandt
 ENGR: see cat.no.139
 LIT: Adams (169)
 Thos Agnew & Sons Ltd

This drawing was probably commissioned by Alaric A. Watts, one of the most successful producers of the lucra-

tive illustrated annuals. It was engraved for his *Literary Souvenir* of 1833. Its delicate, but unusually transparent handling, and the absence of the detailed finish and glazes which are associated with other watercolours of this period, probably reflect its purpose. Danby included little more information than that required by the engraver who was likely to be paid very much more than the artist.[1]

In a letter written from Rapperswil in March 1832 to G. F. Robson, who was selling watercolours on his behalf, Danby lamented the failure of Alaric Watts to follow up his 'very extensive order'.[2] Watts had asked Danby to quote his prices before starting work and this Danby had done 'mentioning what I know to be a low price, but I received no answer, I wrote again, and again . . .'. Presumably Danby got his reply soon afterwards and the work was undertaken in Geneva in 1832 or early 1833.

[1] Thomas Balston, *John Martin, 1789–1854, His Life and Works*, 1947, pp.91–3, discusses the annuals, and mentions fees of 30 to 180 guineas. Danby asked only £3 for 'On the Rhine' (cat.no.107) in 1831. Danby would also have included a substantial copyright fee for Watts. Mary L. Pendered, *John Martin, Painter. His Life and Times*, 1923, pp.163–8 also discusses the annuals.
[2] F. Danby to G. F. Robson, 23 March 1832, letter in the Henry Bicknell album, Yale Center for British Art.

112

112 Ancient Garden* 1834
Watercolour and bodycolour $6\frac{7}{8} \times 10\frac{1}{4}$ (174×257)
PROV: Andrew Wyld, London, from whom
purchased 1977
ENGR: see cat.no.140
LIT: Adams (170)
City of Bristol Museum and Art Gallery

Like the previous work, this watercolour was engraved for
Alaric Watts' *Literary Souvenir*, and, in this instance, was
published in 1835 (cat.no.140).

113 A Romantic Landscape *c.*1835
Watercolour and bodycolour $5\frac{3}{4} \times 8$ (147×203)
Signed: 'F. DANBY'
PROV: Fine Art Society, London, from whom
purchased 1970
Collection of Professor and Mrs E. D. H. Johnson

This is neither a specifically contemporary scene nor a
deliberate evocation of the past, as was the 'Ancient
Garden' (cat.no.112). A girl sits on an elegant garden seat
with a guitar beside her, and gazes at the sunset. Pine trees

113

114

and a pergola are above her. The buildings are vaguely classical and there is a large palazzo by the lake in the centre. 'A Romantic Landscape' is a personal and perhaps nostalgic blend of Claude and the terraces at Tivoli, as well as of memories of the Wye Valley and English gardens.

114 The Crucifixion *c.*1835
Watercolour and bodycolour $3\frac{3}{4} \times 5\frac{1}{2}$ (95 × 140)
PROV: S. Addington, Christie's 22 May 1888 (15);
Abbott and Holder, London, from whom purchased 1971
ENGR: see cat.no.141
LIT: see Adams (171)
Lent Anonymously

This small and intense watercolour was engraved in *The Book of Gems: The Poets and Artists of Great Britain*, published in 1837 (cat.no.141). Danby illustrates verses 45–54 from St. Matthew's Gospel, chapter 27, and includes a remarkable amount of narrative detail. He treats a familiar subject with considerable originality and with particular attention to the architectural setting.

The subject is mentioned in Danby's first letter to John Gibbons after his move to Geneva in the summer of 1832. He says that he has just begun a watercolour of 'The Temple of Jerusalem at the time of the Crucifixion'.[1]

[1] Gibbons Papers, F. Danby to J. Gibbons, 15 June 1832, written from Rapperswil but stamped Geneva.

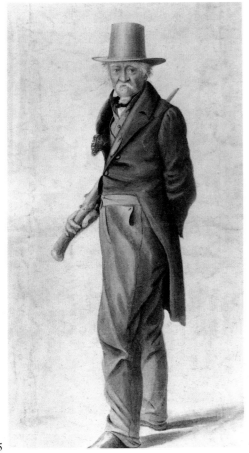

115

115 Sir Samuel Egerton Brydges, (1762–1837) 1833
Watercolour $11\frac{1}{2} \times 6$ (292 × 152)
Signed: 'F.DANBY'
LIT: Adams (132)
Board of Trustees of the Victoria and Albert Museum

This watercolour was engraved for the series 'Gallery of Literary Characters' in *Fraser's Magazine* where it was published in February 1834. Danby mentioned to John Gibbons soon after his arrival in Geneva that he had several portrait commissions. However, his two small portraits of Brydges are at present the only known commissioned portraits.[1]

When Dr John King reported to Gibbons on his visit to Geneva in 1834, he noted that Danby had been much in the company of Sir Egerton Brydges 'whose memoirs have been sickening all Great Britain'.[2] Brydges was an ageing literary amateur, a bibliographer and genealogist. He had been a Member of Parliament and had published small editions of rare Elizabethan books. Since 1826 he had lived in Geneva where he wrote bad blank verse.[3] He tempted Danby to flirt briefly with the idea that he was heir to the earldom of Danby: 'Do not mention this to anyone', Danby wrote coyly to Gibbons, 'as it would appear a folly'.[4]

1 Gibbons Papers, F. Danby to J. Gibbons, 25 October 1832; Adams
(40) gives details of a portrait, present whereabouts unknown,
probably dating from this brief period.
2 Gibbons Papers, J. King to J. Gibbons, 31 December 1834–3 January
1835.
3 This brief account of Brydges is largely taken from Adams, pp.93–4,
who examined both Brydges' autobiography (see cat.no.116) and
M. K. Woodworth, *The Literary Career of Sir Samuel Egerton
Brydges*, Oxford, 1935.
4 Gibbons Papers, F. Danby to J. Gibbons, 28 December 1834.

116 Sir Samuel Egerton Brydges 1834

Etching $4\frac{1}{2} \times 3\frac{3}{4}$ (114 × 95)
Inscribed in the plate: 'DRAWN AND ETCHED BY
FRANCIS DANBY A.R.A. GENEVA, APRIL.
MDCCCXXXIV | The <u>Body</u> may decay – but, by the
might | Of the <u>Soul's</u> flame, <u>Mind</u> will not lose its
light | S.E.B. | LONDON COCHRANE & McCRONE,
WATERLOO PLACE'
LIT: Adams, p.94
Trustees of the British Museum

This etching was used as the frontispiece to the second
volume of Brydges' autobiography published in 1834.[1] It is
Danby's only etching and although rather amateurish in
technique, it is a touching portrait. Brydges was accus-
tomed to write from midnight until seven in the morning
and Danby depicts him meditating rather sadly in his
study.[2] He has been writing by candle-light and sits in his
dressing-gown as dawn breaks.

1 *The Autobiography, Times, Opinions and Contemporaries of Sir Egerton
Brydges Bart.*, 2 vols, 1834.
2 Adams, p.94, publishes a letter in his own possession concerning
payment for this work, and a letter to Brydges from Danby, dated 23
March 1834, is in the BM Print Room, Anderdon Coll. vol.XI: Danby
writes that it has taken three times as long as he expected and he would
like longer but the deadline is past; he sends the plate for printing in
England.

117 Landscape 1836

Watercolour and bodycolour $7\frac{5}{8} \times 10\frac{1}{4}$ (194 × 260)
Signed and dated: 'F. DANBY 1836'
PROV: purchased from the artist by Mathilda de la
Rive; thence by descent and by gift
LIT: Häusermann, p.229; Adams (137)
Private Collection, Geneva

Madame Mathilda de la Rive began collecting for this
album in 1836, as an inscription states.[1] The drawing
would have been one of the last works which Danby
completed in Geneva before leaving for Paris in the spring
of that year.

The album in which this watercolour is still kept is a rare
survivor of a particular fashion in collecting during the
1820s and 1830s. The 1857 edition of the biographical
dictionary *Men of the Time* gives a succinct account of this
fashion in its entry for Danby:

116

The Countess Demidoff in Paris, and a lady of the name of Haldimand in England, had set a fashion for albums of a kind that had never before been seen, either in this country or in France. The collections of these ladies were composed of one or two specimens of every artist of mark who would condescend to make a watercolour drawing. Although liberal prices were paid by Mrs Haldimand, in the first instance, for her drawings, they produced, on their dispersion some years afterwards, more than treble their cost. Whilst the graceful whim lasted, it furnished employment for the leisure hours of some of our most eminent painters, and a seasonable aid to Mr Danby, who, travelling from one place to another, was seldom able to set up an atelier for oil-painting. Some of these drawings partook of all the fancy and careful finish of his more important pictures.[2]

117

Danby's contribution to the Haldimand album was 'Amphitrite' (cat.no.100).

In near perfect condition, the present watercolour shows remarkable technical proficiency. Häusermann felt that it reflected Danby's successful last year in Geneva and expressed the artist's 'joyous sense of fulfilment', but Adams argued that 'the emotional temperature is low', and concluded that 'Danby's Swiss work shows some advance in technique but little extension of his imagination'.[3]

Häusermann identified the scene as the place known as 'the end of the world' on the river Arve near Geneva, but, as with the similar landscape in oils (cat.no.38), the scene is probably partly imaginary.

[1] Inscribed: 'Album de Mathilda De la Rive née Duppa (1808–1850) | commencé en 1836 | possedé apres sa mort par son fils Lucian De la Rive | puis par la fille de celui-ci Madam Isabelle Mallet De la Rive | qui le céda par amitié a Bernard et Georgette Naef en 1949.' The album includes works by leading Swiss and other European artists, including Alexandre Calame (1810–1864) and François Diday (1802–1877), mostly dating from the 1840s and 1850s.
[2] *Men of the Time*, published by Kent & Co. (late D. Bogue), 1857.
[3] Häusermann, p.229; Adams, p.101.

118

118 A Classical City *c.*1855
 Pencil and wash 5 × 7¼ (127 × 181)
 PROV: Andrew Wyld, London, from whom
 purchased 1978
 Yale Center for British Art, Paul Mellon Fund

After his return to England in 1839, Danby produced very few finished watercolours, concentrating almost exclusively on oil paintings. Seven sketchbook drawings in pen and pencil survive, probably all dating from the 1840s and 1850s.[1] The sheets are all approximately 4¼ × 7¼ inches and vary considerably in subject matter.

The present drawing may be related to 'Landscape: Ulysses at the Court of Alcinous. Going to the Athletic Games Instituted in Honour of his Visit' shown at the Royal Academy in 1858.[2] It could also be a study for details in 'The Departure of Ulysses from Ithaca – Morning' or 'The Court, Palace and Gardens of Alcinous – a ruddy morning' which were exhibited at the Royal Academy in 1854 and 1857 respectively, and which are both now untraced. It is also close in detail and composition to the engraving 'Morning – Greece' (cat.no.138) of 1832.

[1] The others are Adams (139), (147), (149), (150), (153) and 'Orpheus', Huntington Library and Art Gallery, San Marino, California.
[2] Adams (74) fig.92, painted for Joseph Gillott, and now in the same collection as 'Phoebus Rising from the Sea' (cat.no.49).

Monochrome Wash Drawings

119 Romantic Woodland Scene *c*.1820
Pencil and sepia wash $8\frac{3}{4} \times 13\frac{7}{8}$ (220 × 353)
Inscribed on reverse in G. W. Braikenridge's hand:
'No 10 | Danby'
PROV: George Weare Braikenridge; Braikenridge
Bequest, 1908
EXH: *Bristol School* 1973 (50)
City of Bristol Museum and Art Gallery

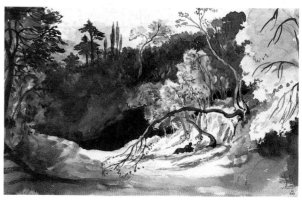

119

The attribution to Francis Danby of this and each of
the sepia or monochrome wash drawings which follow
(cat.nos.120–9) is reasonably certain. The problem of the
attribution of Bristol School sepia drawings, often the
product of the evening sketching meetings of the years
around 1820, has been bedevilled by the mistreatment of
the Branwhite Collection of monochrome drawings. Before
reaching the London art market in the 1960s several of
these drawings acquired false signatures, Danby's or
Martin's, and others had signatures removed. Martin's
style was already well established and little confusion was
caused here, but during the 1960s and early 1970s almost
any sepia drawing in the Bristol School manner was
attributed to Danby.

The style of the other Bristol artists has been slow to
emerge but there are now identifiable groups of mono-
chrome drawings by Revd John Eagles, Samuel Jackson,
N. C. Branwhite and particularly William West. However,
very few new and convincingly documented monochrome
drawings by Danby have reappeared in recent years.

120 Cavern Scene *c*.1820
Black chalk and sepia wash $13\frac{1}{8} \times 18\frac{7}{8}$ (334 × 477)
Inscribed in pencil on reverse: 'Danby?'
PROV: Alderman James Fuller Eberle before 1924;
presented by him to the Bristol Savages and passed
to the City Art Gallery, 1968
EXH: *Bristol School* 1973 (51)
LIT: Adams (90)
City of Bristol Museum and Art Gallery

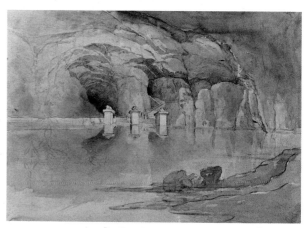

120

This drawing comes from the Eagles Album, a volume of
drawings by Revd John Eagles, Samuel Jackson, Francis
Gold, James Johnson and E. V. Rippingille. Most of the
drawings can be dated to the early 1820s.[1] The inscription
is presumably copied from the original album page, now
lost.

[1] See *Bristol School* 1973 (303).

121

121 A River Ford *c.*1823
Black chalk and sepia wash $8\frac{1}{4} \times 11\frac{1}{4}$ (208 × 285)
PROV : acquired by 1898
EXH : *Bristol School* 1973 (56)
LIT : Adams (116)
National Gallery of Ireland

The drawing of the leaves and of the trees themselves is
very close to that of another sepia drawing by Danby which
once bore the date '1823' and which also came from the
Eagles Album.[1]

[1] *Bristol School* 1973 (52).

122 Lake among Mountains *c.*1823
Pencil and sepia wash $11 \times 17\frac{1}{2}$ (279 × 444)
EXH : *Bristol School* 1973 (64)
LIT : Adams (108)
Trustees of the British Museum

Dr E. H. Schiøtz has pointed out that there is nothing that
is characteristically Norwegian about this landscape.[1] It is
more likely to have been drawn in Bristol before Danby's
move to London in 1824.

[1] Letter to the compiler, 20 October 1976 (City of Bristol Museum and
Art Gallery : artist files).

122

123 Cavern Interior with Statue *c*.1823
Sepia wash 10 × 13⅜ (254 × 339)
PROV: N. C. Branwhite; Branwhite sale, Redland,
Bristol, 9–10 May 1929, bought Yda Richardson;
her sale, Manor House, Abbots Leigh, Somerset,
William Cowlin & Son Ltd, Bristol, 8–10 December
1936, bought H. G. Simpson; A. D. P. Wilson;
Maas Gallery, London; Hon. Mrs A. I. Astor;
Christie's 25 April 1978, bought Stanhope Shelton,
from whom purchased 1978
EXH: *Bristol School* 1973 (63)
LIT: Adams (100)
John Beveridge Esq.

Eric Adams pointed out that the idea of representing the
daylight outside the cavern by its reflection in the water
inside, is typical of the romantic effects which Danby began
to employ in the early 1820s.

123

124 The Delivery of Israel out of Egypt 1824
Sepia wash 9¾ × 13½ (247 × 343)
Inscribed on reverse: 'Feb. 1824'
PROV: Maas Gallery, London, 1965; W. A. Brandt
EXH: *Bristol School* 1973 (57)
LIT: Adams (99)
Private Collection

The date on the reverse would seem to imply that the oil
painting of this subject (cat.no.22), with which Danby was
so successful at the Royal Academy in 1825, was conceived
in Bristol. However, this sepia may not have been drawn as
a study but as an independent work.

124

125 Woodland Pool with Seated Figure 1826
Watercolour and sepia wash heightened with white
6⅞ × 10⅛ (167 × 259)
Signed by scratching out: 'Danby'
Inscribed on reverse: 'Danby 1826'
PROV: John Scott Bequest, 1864
EXH: *Bristol School* 1973 (61)
ENGR: on steel by L. Marvy for W. M. Thackeray,
The Landscape Painters of England . . ., 1848–50; a
soft ground etching by L. Marvy is in the British
Museum Print Room (1855.12.8.4.)
LIT: Adams (112)
National Galleries of Scotland

The date inscribed on the reverse is perhaps later than
might be expected. The subject has the most familiar
ingredients of the Bristol School sepia drawings: a figure
seated by a secluded and wooded pool in the late evening.
Revd John Eagles, Samuel Jackson, James Johnson and
N. C. Branwhite are all known to have done similar scenes.

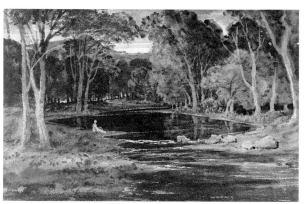

125

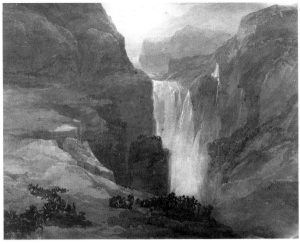

126

126 Cascade in Norway *c.*1826
Pencil and sepia wash $11\frac{7}{8} \times 15\frac{3}{4}$ (303 × 400)
PROV: N. C. Branwhite; Branwhite sale, Redland,
Bristol, 9–10 May 1929, bought Yda Richardson;
her sale, Manor House, Abbots Leigh, Somerset,
William Cowlin & Son Ltd, Bristol, 8–10 December
1936, bought H. G. Simpson, from whom purchased
1961
EXH: *Bristol School* 1973 (59)
LIT: Adams (105)
City of Bristol Museum and Art Gallery

Danby visited Norway in July and August 1825. Dr E. H.
Schiøtz has proposed that this view 'shows almost certainly
the Skjerve-foss . . . between the Hardangerfjord and
Voss'.[1] The inclusion of this drawing in N. C. Branwhite's
collection of monochrome drawings, suggests that
Branwhite might have acquired it direct from Danby.
He visited him in London in June 1825 and doubtless
thereafter as well.[2]

The drawing is inscribed on the reverse 'Francis Danby'
in brown ink in a bogus nineteenth-century hand. It also
has traces of a modern pencil attribution to William West,
as well as H. G. Simpson's familiar pencil inscription
'purchased by Green (on my instructions) at the Yda
Richardson sale, Manor House, Abbots Leigh'. In this
instance there is no reason to doubt Simpson's attribution.

[1] Letter to the compiler, 22 September 1976 (City of Bristol Museum
and Art Gallery: artist files).
[2] BL Add. MS 36515 fo.111, G. Cumberland Jr to G. Cumberland Sr,
undated, presumed June 1825.

127

127 Romantic Valley Scene *c.*1824
Blue-grey wash $9 \times 13\frac{1}{8}$ (230 × 334)
PROV: A. Penraven Bequest, 1922
EXH: *Bristol School* 1973 (58)
LIT: Adams (94)
City of Bristol Museum and Art Gallery

This is possibly an illustration to Danby's poem *Cristna*
(see cat.no.128) and could be the drawing which Danby
sent to John Gibbons in 1831, depicting 'part of Cristna's
journey in search of the valley of everlasting life'. He wrote
that the drawing had been made several years earlier.[1]

[1] Gibbons Papers, F. Danby to J. Gibbons, 19 May 1831. On the
reverse is a slight and hurried view of the Avon Gorge from the New
Inn showing the New Hotwell House built in 1822. Above the Red
Mill is a flag-bedecked pole suggesting the ceremony at the laying of
the foundation stone of the Clifton Suspension Bridge in 1836.
However, two hands are evident and the datable parts are not by
Danby and are perhaps copied from an engraving.

128 An illustration to the artist's poem 'Cristna'
 *c.*1830
 Pencil and sepia wash 9 × 13⅜ (230 × 341)
 Inscribed on original mount in James Danby's hand:
 'Francis Danby. <u>ARA.</u> | an illustration of his | own
 Poem of' [sic]
 PROV: Mrs Charlotte Frank, London, from whom
 purchased 1971
 EXH: *Bristol School* 1973 (68)
 City of Bristol Museum and Art Gallery

128

This is the only certain design for an illustration to Danby's
own long and lost poem, *Cristna*, which he claimed to
have begun in Bristol by about 1820. The manuscript was
stolen in London but with the encouragement of the poets,
Thomas Moore and Samuel Rogers, he took it up again. He
completed it at Rapperswil in Switzerland in 1832, hoping
to sell the copyright and etch his own illustrations. In 1834
the manuscript was with John Murray, the publisher, for
many months, but it was finally rejected in January 1835.
In Paris in 1837 Danby said he was considering beginning
the illustrations, but there are no subsequent references to
the poem.

 Danby himself described the poem as 'no more than a
romance' and defended himself against Gibbons' accu-
sation of imitating Robert Southey's *Thalaba*: '. . . if it is
like him it is a most extraordinary accident, as he is a poet
above all others . . . as well as I remember Thalaba is a
Magician story altogether supernatural . . .'.[1]

[1] *Cristna* is referred to in letters from F. Danby to J. Gibbons dated: 19
 May 1831, 11 January 1832, 13 March 1832, 15 June 1832, 17 October
 1834, 15 January 1835, 27 April 1837 (Gibbons Papers).

129 Lake and Mountains after Sunset *c.*1835
 Black ink and wash 9⅞ × 7⅜ (250 × 185)
 Inscribed on reverse: 'Francis Danby | 1835'
 PROV: H. G. Simpson (earlier prov. probably:
 N. C. Branwhite; Branwhite sale, Redland, Bristol,
 9–10 May 1929, bought Yda Richardson; her sale,
 Manor House, Abbots Leigh, Somerset, William
 Cowlin & Son Ltd, Bristol, 8–10 December 1936,
 bought H. G. Simpson)
 Mrs Nickola Smith

A very similar drawing from the same source was shown in
the *Bristol School* exhibition in 1973 and it was then
pointed out that the signature was probably false and the
attribution doubtful.[1] The reappearance of the present
drawing with a more convincing signature on the reverse
tells us that although the other signature was a forgery, the
attribution was probably correct.

Since writing the catalogue it has been decided that the
inscription on the reverse dates from *c.*1961 and that the
attribution is questionable.

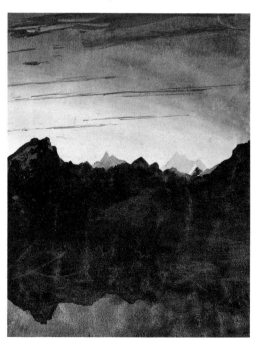

129

[1] *Bristol School* (67), Adams (102) fig.114.

Engravings

130 View from Kingsweston Hill 1823
 Lithograph $8\frac{7}{8} \times 13\frac{1}{8}$ (226 × 334)
 Inscribed on the stone: 'Drawn on stone by
 F. Danley. [sic] VIEW FROM KINGS, WESTON
 HILL. Printed by Rowney & Forster.'
 City of Bristol Museum and Art Gallery

Danby's only lithograph,[1] this rare print was published in a folio together with two other lithographs, a view of St. Mary Redcliffe by James Johnson and another of the Old Hotwell House by Samuel Jackson.[2]

The undertaking was an ambitious one and the results in terms of early lithography were technically impressive. The venture aroused some interest in Bristol. William Tyson, the local historian and antiquary, wrote to G. W. Braikenridge in February 1823 reporting progress[3] and George Cumberland wrote to his son in January 1824

reporting publication. He said that the artists had, 'worked each 6 weeks or two months incessantly on each view and then sold them for 2/6 per view so as to have lost 30 or 40 pounds at least. They are beautiful but it has sickened them'.[4]

1 Thomas Bedford of Bristol published at least three differing editions of lithographs, one dated 1822, based on a watercolour by Danby of Fonthill Abbey ($9\frac{1}{4} \times 12\frac{1}{2}$ in, coll. of Clive Wainwright). The watercolour could be as early as 1813 in style and is signed: 'F.D.d'. The 'd' for 'delinavit' would imply that it was a commission intended for an engraving. In 1825 or soon after, George Davey of Bristol published a lithograph by T. Picken entitled 'View of the Avon from Clifton Down' after a much earlier watercolour by Danby.
2 Titled: *THREE VIEWS ILLUSTRATIVE OF THE SCENERY OF BRISTOL AND ITS VICINITY* and priced at 7s.6d.
3 Avon County Reference Library, Bristol: B9966, vol. VI, p.417.
4 BL Add. MS 36510 fo.19. G. Cumberland also mentions the project in his letters of 2 and 20 May 1823: Add. MS 36509 fos.202 and 212.

130

Drawn on Stone by F. Danley. VIEW FROM KINGS, WESTON HILL. Printed by Rowney & Forster.

131 Disappointed Love *c.*1825
Etching and engraving by an unknown engraver
$8 \times 10\frac{1}{4}$ (202 × 260)
Inscribed in the image: 'F DANBY 1821' and in the
plate: 'Francis Danby, A.R.A. Pinxt'
EXH: *Bristol School* 1973 (71)
LIT: Adams, p.170 under (6)
Trustees of the British Museum

No other impression of this excellent engraving (after
cat.no.19) is known, suggesting an abortive attempt at
publication following Danby's election as an associate
member of the Royal Academy in 1825.

131

132 An Enchanted Island 1825
Mezzotint by G. H. Phillips $8\frac{1}{2} \times 13\frac{3}{8}$ (218 × 339)
Inscribed in the plate, proof lettering: 'Painted by
F.Danby | Engraved by G. H. Phillips'
PROV: John Gibbons, thence by descent
Private Collection

Danby sought to capitalise on the success of 'Sunset at Sea
after a Storm' in 1824 by having it engraved (see cat.no.20).
A mezzotint after Danby's next successful exhibition
painting, 'An Enchanted Island' (cat.no.21) shown at the
British Institution in 1825, became part of the same
project. N. C. Branwhite and James Johnson examined the
progress of this engraving early in June when they dined
with Danby,[1] and in October Danby reported that it was
finished but for the lettering.[2] Both prints were a com-
mercial failure and impressions are now rare.

This impression is probably an early proof sent to the
owner of the painting, John Gibbons, to show progress. No
other impression of the mezzotint is known before its
publication by Colnaghi and Puckle, in March 1841,
following upon the success of the vast oil painting of 'The
Deluge' (cat.no.40) in the previous year.

132

[1] Gibbons Papers, F. Danby to J. Gibbons, 6 June 1825.
[2] *Ibid.*, 14 October 1825.

133 The Passage of the Red Sea 1829
Mezzotint by G. H. Phillips $19\frac{1}{8} \times 30$ (486 × 760)
Inscribed in the plate with verses from Exodus, a
dedication to George Granville, Marquis of Stafford,
the owner of the oil painting, and: 'PAINTED BY
FRANCIS DANBY A.R.A. London, Jany.1.1829,
Published by M.Colnaghi No.23, Cockspur Street,
Charing Cross. ENGRAVED BY G.H.PHILLIPS. |
THE PASSAGE OF THE RED SEA.'
City of Bristol Museum and Art Gallery

In the autumn of 1827, more than two years after Danby's
triumph with the oil painting 'The Delivery of Israel out

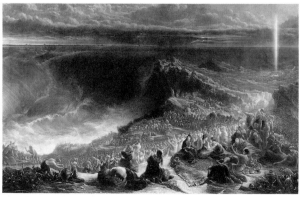

133

of Egypt' (cat.no.22), Colnaghi purchased the copyright for £300.[1] Danby proudly told John Gibbons that the plate was to be bigger than John Martin's print of 1826 of 'Belshazzar's Feast'. The mezzotint was published in January 1829 as 'The Passage of the Red Sea'.

Soon after his flight to Paris, Danby wrote in December 1829 to John Gibbons saying that he was quite well known there, as prints of his works were for sale.[2] This probably refers to the mezzotints after 'The Delivery of Israel out of Egypt' and 'The Sixth Seal', but there was also a large aquatint of 'The Delivery of Israel out of Egypt', engraved by Jazet, which was published in France at about this time.[3]

[1] Gibbons Papers, F. Danby to J. Gibbons, 17 December 1827.
[2] *Ibid.*, dated December 1830, post-marked 13 January 1830, Paris, presumably written in December 1829.
[3] Undated impression in the British Museum. The mezzotint of 'The Opening of the Sixth Seal' (cat.no.134) has the address of three Paris printsellers engraved in the plate.

134 The Opening of the Sixth Seal 1830
Mezzotint by G. H. Phillips $19\frac{1}{4} \times 27\frac{1}{4}$ (490 × 687)
Inscribed in the plate with verses from Revelations and: 'London, Published Jany. 1830. by M. Colnaghi,

23, Cockspur Street. | THE OPENING OF THE SIXTH SEAL. | Engraved by G. H. Phillips, from the Original Picture by F. Danby, A.R.A. | In the Collection of William Beckford Esqre. | Depose a la Direction et se vend a Paris Chez Chaillou Potrelle Rue St Honore Giraldon Bovinet & Cie. Passage Vivienne & Rittner & Cie. Boulevard Montmartre.'
City of Bristol Museum and Art Gallery

The painting of the 'Sixth Seal' (cat.no.24) had been begun in 1825 but it was Colnaghi's agreement to purchase the copyright for £300, made towards the end of 1827, that encouraged Danby to complete the work. The oil was exhibited at the Royal Academy in 1828 but Colnaghi did not publish the mezzotint until 1830.

In 1843, when the painting was shown at Bristol, there were proposals to republish the mezzotint with extensive alterations in order to take into account the changes that Danby had made following the damage to the painting at Rochdale.[1] It is possible that this new edition was never published for only one impression has been noted.[2]

[1] *Felix Farley's Bristol Journal*, 23 September 1843; Bristol Institution, *Exhibition of Pictures*, August 1843, p.15.
[2] Collection of David Dallas, London.

134

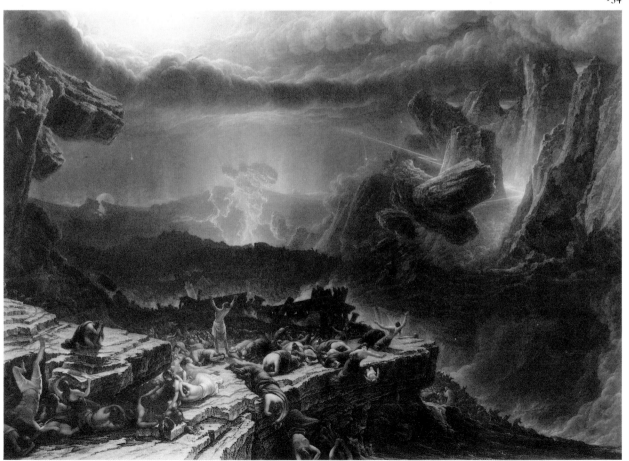

135 Sunset at Sea after a Storm 1849
Line engraving by William Miller $9\frac{3}{8} \times 14\frac{1}{2}$
(238×369)
Inscribed in the plate: 'PAINTED BY F. DANBY,
A.R.A. | ENGRAVED BY WM. MILLER. | SUNSET AT
SEA AFTER A STORM. | CASSELL AND COMPANY,
LIMITED.'
City of Bristol Museum and Art Gallery

135

A mezzotint after 'Sunset at Sea after a Storm' (cat.no.20) was first published in January 1826 by Messrs Hurst Robinson and Co., for the engraver F. C. Lewis. Danby had himself promoted the project, but, like the mezzotint 'An Enchanted Island' (cat.no.132), it was not a success, because neither Danby nor Lewis had the means to market the print.

This much later engraving, published in 1849 by J. Hogarth, who had perhaps deliberately purchased the painting for this purpose at Christie's in 1843, is evidence of Danby's continuing popular appeal.

136 Fête Champêtre 1827
Steel engraving by Robert Wallis $2\frac{7}{8} \times 4\frac{1}{4}$ (72×106)
Inscribed in the plate: 'ENGRAVED BY ROBT.
WALLIS. 1827.'
Published for Alaric A. Watts in the *Literary Souvenir* 1828, p.401
EXH: *Bristol School* 1973 (76)
LIT: Adams (164)
Trustees of the British Museum

136

This engraving is possibly Danby's earliest work for one of the illustrated annuals. The five following engravings, cat.nos.137–141, the engraving after 'The Embarkation of Cleopatra' (cat.no.27) and perhaps that after 'The Precipice' (see cat.no.25) were also published in similar volumes.[1]

Illustrations to annuals, such as the *Literary Souvenir*, were also sold separately and were often printed, as in this instance, on India proof paper.

The oil painting from which this engraving is taken has recently been identified in a private collection.[2] It is worn in condition but also hurried in execution and it is possible that it was a hasty off-shoot of 'The Golden Age' (see cat.nos.31 and 32) with which Danby was struggling in 1827, and that it was painted deliberately to be engraved.

[1] See also cat.no.111.
[2] Private collection, Boston, Lincs., 1985.

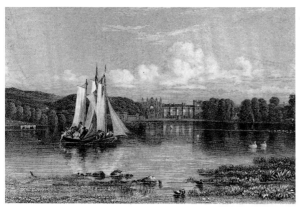

137

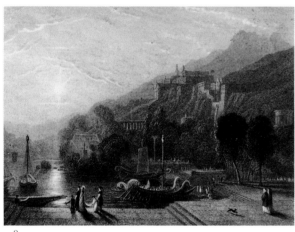

138

139

137 Newstead Abbey – Sunset 1828
Steel engraving by Robert Wallis $3\frac{7}{16} \times 5\frac{3}{8}$ (87×136)
Inscribed in the plate: 'F. Danby A.R.A. pinx | R.
Wallis. sculp. | NEWSTEAD – SUNSET | PUBLISHED
OCT.1. 1828. BY JOHN SHARPE. LONDON.
Published by John Sharpe in *The Anniversary*,
edited by Allan Cunningham, 1829, p.250
Max Browne

Danby wrote to John Gibbons in December 1828 offering
to do a little picture of Newstead Abbey (Nottingham-
shire).[1] It seems likely that Danby was deliberately trying
to capitalise on the commission from the publisher of *The
Anniversary*, which he had already completed, for this
engraving was published in October.

The idea of the setting sunlight reflected on the windows
was to be used again in 'The Gate of the Harem' of 1844
(see cat.no.43).

[1] Gibbons Papers, F. Danby to J. Gibbons, dated only December 1828.

138 Morning – Greece 1832
Steel engraving by E. Freebairn $2\frac{1}{2} \times 3\frac{3}{8}$ (62×86)
Inscribed in the plate: 'F. Danby. A.R.A. |
E.Freebairn'
Published for Alaric A. Watts, *Illustrations to Lyrics
of the Heart with Other Poems*
Trustees of the British Museum

Another impression in the British Museum Print Room
from a bound copy of Alaric Watts' book of poems, pub-
lished in 1851, is dated 1832.[1] Watts' commission for
several illustrations was probably of considerable financial
importance to Danby in Switzerland in 1832 (see cat.no.111).

[1] BM Print Room, 165 b.32.

139 Fairies on the Seashore 1833
Steel engraving by William Miller $3\frac{1}{8} \times 4\frac{7}{16}$
(77×113)
Published for Alaric A. Watts in the *Literary
Souvenir* 1833, p.101
City of Bristol Museum and Art Gallery

Engraved after the watercolour, cat.no.111.

140 Ancient Garden 1834
Steel engraving by W. Hill $3\frac{1}{8} \times 4\frac{5}{8}$ (80 × 118)
Inscribed in the plate: 'F.Danby, R.A. pinxt |
W.Hill, sculpt. | ANCIENT GARDEN. | Printed by
E.Brain. | London, Published Novr. 1834, for the
Proprietor, by Whittaker & Co. Ave Maria Lane.'
Published for Alaric A. Watts in the *Literary
Souvenir* 1835, p.175
Max Browne

Engraved after the watercolour, cat.no.112.

140

141 The Crucifixion 1837
Steel engraving by William Greatbach $2\frac{1}{8} \times 3$
(55 × 75)
Inscribed in the plate: 'Danby A.R.A. | Greatbatch.'
Published in *The Book of Gems*, edited by S. C. Hall,
1837, p.21
Max Browne

Engraved after the watercolour, cat.no.114.

142 Fairies *c.*1840
Steel engraving by J. Lewis $2\frac{1}{2} \times 3\frac{3}{4}$ (62 × 94)
Inscribed in the plate: 'F.Danby. A.R.A. | J.Lewis'
Trustees of the British Museum

This is probably a page from an unidentified annual. The
composition is a rather uninspired variation of 'An
Enchanted Island' (cat.no.21). In the article on Francis
Danby in the *Art Journal*, 1855, 'Fairies' was engraved
with the title 'The Enchanted Island: Sunset' and in the
text it was confused with 'The Enchanted Castle – Sunset'
of 1841 (cat.no.42).[1] Tightening this knot of confusion,
Danby, who perhaps had not seen the article himself,
quickly wrote to the *Art Journal* saying that the illustration
was a variant of 'An Enchanted Island' that had been
painted by a pupil and that he himself had not allowed a
copy to be made.[2]

[1] *Art Journal*, 1855, p.80.
[2] *Ibid.*, p.167.

141

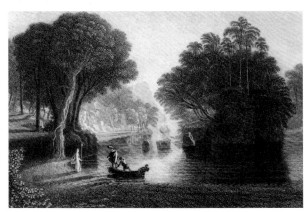

142

Portraits of the Artist

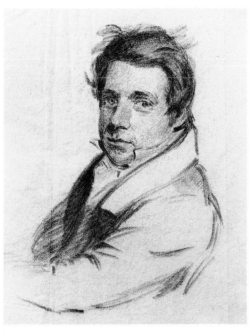

143

144

NATHAN COOPER BRANWHITE
(1775–1857)

143 Portrait of Francis Danby *c*.1825
Photograph of a lost drawing
EXH: *Bristol School* 1973 (78)
City of Bristol Museum and Art Gallery

N. C. Branwhite, Bristol's outstanding miniature-portrait painter, is known to have visited Danby in London after his move from Bristol in 1824.[1] This lost drawing is only known from an old glass negative in the City of Bristol Museum and Art Gallery.

[1] BL Add. MS 36515 fo.111, G. Cumberland Sr to G. Cumberland Jr, undated, presumed June 1825.

JOHN KING (1788–1847)

144 Portrait of Francis Danby 1828
Oil on canvas 49 × 39 (1244 × 990)
Inscribed on reverse by the artist: 'Francis Danby A.R.A. Painted from the life by his friend John King AD. 1828 about the time he was painting his celebrated Opening of the 6th Seal. The back ground from his own sketches made in Norway. Exhibited in Somerset House 1829. J.K.'
PROV: S. Stubbs, from whom purchased 1964
EXH: Royal Academy, 1829 (554); *Bristol School* 1973 (77)
City of Bristol Museum and Art Gallery

Francis Danby is depicted sketching in Norway, which he visited in 1825.

John King, portrait and historical painter, should not be confused with Dr John King, the surgeon, who called his namesake 'an artist possessed of more good nature and good conduct than genius'.[1] In the 1820s and 1830s the painter was resident in both Bristol and London but he was born and died in Dartmouth, Devon.

It is likely that King painted this portrait of his friend, who had had such a triumph with the 'Sixth Seal' (cat.no.24) in 1828, with the intention of enhancing his own reputation in London through its exhibition at the Royal Academy in 1829.

[1] Gibbons Papers, J. King to J. Gibbons, 25 January 1836.

SAMUEL PHILLIPS JACKSON
(1830–1904)

145 Portrait of Francis Danby *c*.1855
Photograph 4 × 3½ (103 × 88)
From the album compiled by Ada Villiers, daughter
of Samuel Jackson
*Private Collection, on loan to the City of Bristol
Museum and Art Gallery*

A photograph from the same album and probably of the
same date, depicting both Danby and Samuel Jackson, has
an inscription beside it stating that Danby was sixty-two
when the photograph was taken at 1 Cambridge Place (now
8 Canynge Square), Clifton, Bristol.[1]

S. P. Jackson, Samuel Jackson's son, was a successful
professional watercolour painter and a good amateur
photographer.

[1] Greenacre & Stoddard, illus. p.95; on p.90 it is incorrectly stated that
the modern address is 7 Canynge Square.

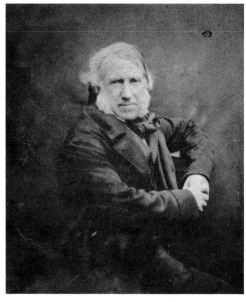

145

JOHN AND CHARLES WATKINS

146 Portrait of Francis Danby *c*.1860
Photograph by the Photographers to the Queen,
London 3½ × 2⅜ (90 × 60)
City of Bristol Museum and Art Gallery

JAMES DANBY (1817–1875)

**147 The Residence of Francis Danby: Shell House
on the Maer, Exmouth** 1861
Pencil on paper 7⅞ × 11⅝ (200 × 295)
Inscribed in pencil: 'The Residence of Francis
Danby | Exmouth'
Inscribed in ink on the mount: 'sketched by James
Damer Danby. Feby 1861'
Royal Albert Memorial Museum, Exeter

Danby died on 10 February 1861 and this drawing by his
favourite son, James, was made a few days later when he
was clearing up the estate.[1] The inscriptions are almost
certainly in James Danby's hand – the same handwriting
that appears on the back-mounts of many oil sketches and
drawings, which were in Francis Danby's studio at his
death.

Danby moved from Rill Cottage to Shell House on the
Maer in 1856.[2] It stood on the low ground behind the sand
dunes overlooking the sea and here Danby indulged in his
passion for boat-building.[3]

[1] Adams, p.108 and p.160, fn.7.
[2] *Kelly's Directory of Devonshire*, 1856.
[3] Demolished 1920s for the benefit of the cricket ground car park:
W. G. N. Gorfin in *Exmouth Journal*, 18 August 1973; E. R.
Delderfield, *Exmouth Milestones*, Exmouth, 1948, p.43.

146

147

Selected Bibliography

Dr Eric Adams' monograph, *Francis Danby: Varieties of Poetic Landscape* (Yale University Press, New Haven and London, 1973) included a substantial bibliography. The following selected works have appeared subsequently.

Anglesea, Martyn, 'Five unpublished drawings by Francis Danby', *The Burlington Magazine*, CXVII, no.862, January 1975, pp.47–8.

Ashton, Geoffrey, and others, *Shakespeare and British Art* (exh.cat.), Yale Center for British Art, New Haven, 1981.

Bishop, Morchard and Malins, Edward, *James Smetham and Francis Danby*, 1974.

Cormack, Malcolm, *A Concise Catalogue of Paintings in the Yale Center for British Art*, New Haven, 1985.

Crouan, Katharine, *John Linnell. A Centennial Exhibition*, Cambridge, 1982.

Fawcett, Trevor, *The Rise of English Provincial Art . . .*, Oxford, 1974.

Feaver, William, *The Art of John Martin*, Oxford, 1975.

[French, Anne], *Gaspard Dughet, called Gaspar Poussin 1615–75* (exh.cat.), The Iveagh Bequest, Kenwood, London, 1980.

Gerdts, William H. and Stebbins, Theodore E. Jr, *'A Man of Genius': The Art of Washington Allston 1779–1843*, Boston, U.S.A., 1979.

Gillespie, Frances, and others, *Fifty Irish Drawings and Watercolours*, National Gallery of Ireland, Dublin, 1986.

Greenacre, Francis, *The Bristol School of Artists: Francis Danby and Painting in Bristol 1810–1840* (exh.cat.), City Art Gallery, Bristol, 1973.

Greenacre, Francis (introduction by), *William Evans of Bristol (1809–1858)* (exh.cat.), Martyn Gregory, London, 1987.

Greenacre, Francis and Stoddard, Sheena, *The Bristol Landscape: The Watercolours of Samuel Jackson 1794–1869*, Bristol, 1986.

Hutchinson, John, *James Arthur O'Connor* (exh.cat.), National Gallery of Ireland, Dublin, 1985.

Le Harivel, Adrian, *The National Gallery of Ireland, Illustrated Summary Catalogue of Drawings*, Dublin, 1983.

Maby, Muriel, *John King*, unpublished biography, copy in Avon County Reference Library, Bristol.

Omer, Mordecai, *The Iconology of the Deluge in English Romantic Art; with special reference to William Blake and J. M. W. Turner*, unpublished PhD thesis, University of East Anglia, 1976.

Paley, Morton D. *The Apocalyptic Sublime*, New Haven and London, 1986.

Pointon, Marcia, *Mulready*, 1986.

Richardson, Sarah, *Edward Bird* (exh.cat.), Wolverhampton Art Gallery, 1982.

Sabin, Sidney F. *Francis Gold*, MS chronology, copy in City of Bristol Museum and Art Gallery, Dept of Fine Art.

Schiøtz, Dr Eiler H. *Itineraria Norvegica, Foreigners' Travels in Norway until 1900*, Oslo, 1976.

Stoddard, Sheena, *George Weare Braikenridge 1775–1856: a Bristol Antiquarian and his Collections*, unpublished M. Litt. thesis, University of Bristol, 1983.

Verdi, Richard, 'Poussin's "Deluge": The Aftermath', *The Burlington Magazine*, CXXIII, no.940, July 1981, pp.389–400.

Wees, J. D. and Campbell, M. J. *'Darkness Visible': The Prints of John Martin* (exh.cat.), Sterling & Francine Clark Art Institute, Williamstown, Mass., 1986.

Whidden, Margaret, *Samuel Colman 1780–1845*, unpublished PhD thesis, University of Edinburgh, 1985.

Wilton, Andrew, *British Watercolours 1750–1850*, Oxford, 1977.

Wilton, Andrew, *Turner and the Sublime*, 1980.

Appendix I

Dr Eric Adams' book *Francis Danby: Varieties of Poetic Landscape*, 1973, included a catalogue of oil paintings (1–75), drawings and watercolours (76–154) and recorded works (155–217). Many works have since reappeared and others have inevitably been reattributed or questioned. The following lists are intended to complement Dr Adams' important catalogue ('1988 cat.no.' refers to the present exhibition catalogue).

A

Works which, when catalogued by Eric Adams, were known only through engravings or written sources, but which have since reappeared.

(155) 'Collecting Wildflowers' possibly 'Landscape, Children by a Brook', (1988 cat.no.15), His Grace, the Duke of Westminster, D.L.

(156) 'Stapleton Mill – Boys Seeking Eels' probably 'A Wooded River Landscape with Boys Fishing in a Stream', oil on panel, 10 × 15 (254 × 381), His Grace, the Duke of Westminster, D.L.

(159) 'Sunset at Sea after a Storm' (1988 cat.no.20), City of Bristol Museum and Art Gallery.

(162) 'Christ Walking on the Sea' (1988 fig.17), oil on canvas, 58 × 86¼ (1470 × 2193), Forbes Collection, London.

(163) 'The Climber of Helvellyn' now called 'The Precipice' (1988 cat.no.25), City of Bristol Museum and Art Gallery.

(164) 'Fête Champêtre' (see 1988 cat.no.136), oil on canvas, approx. 16 × 28 (406 × 711), Private Collection, Boston, Lincs.

(169) 'Fairies on the Seashore', (1988 cat.no.111), Thos Agnew & Sons Ltd.

(170) 'Ancient Garden' (1988 cat.no.112), City of Bristol Museum and Art Gallery.

(171) 'The Crucifixion' (1988 cat.no.114), Private Collection.

(172) 'Rich and Rare were the Gems She Wore' (1988 fig.19), oil on canvas, 48 × 64 (1219 × 1626), Sotheby's, Slane Castle, 12 May 1981 (421).

(175) 'Mary Magdalen in the Desert', possibly the painting: oil on canvas, 11¾ × 17 (300 × 430), Spink & Son Ltd, 1988.

(204) 'A Wild Sea Shore at Sunset', oil on canvas, 29¼ × 41¼ (743 × 1048), Artemis Group.

B

A selected list of works identified since 1973 which were not recorded by Eric Adams and which are *not* included in this exhibition. Only the more important or interesting works have been listed.

OIL PAINTINGS

'View of the Avon and Severn from Durdham Down', c.1818, oil on canvas, 16¼ × 23¼ (413 × 591), The Bishop of Bristol.

'Figures at Wickham Bridge, Stapleton', c.1820, oil on canvas, 15⅛ × 15¼ (384 × 387), see 1988 cat.no.12, fn.1.

'Warriors Reposing in a Mountain Glen', c.1823, oil on board, 9 × 12½ (229 × 318), City of Bristol Museum and Art Gallery (K5195).

'Sunset at Sea after a Storm', c.1824, oil on board, approx. 7 × 9 (178 × 229), Mr and Mrs Paul Mellon.

'Romantic Landscape', c.1825, oil on canvas, 20¼ × 15⅛ (514 × 384), Private Collection, Lincolnshire.

'Conway Castle', c.1825, oil on canvas, 12¾ × 19 (324 × 483), City of Bristol Museum and Art Gallery (K4364).

'An Italianate Landscape', c.1827, oil on panel, 18¼ × 23⅞ (464 × 606), Private Collection, Bradford on Avon.

'Stormy Coast Scene with Lightning and Shipwreck', dated 1834, oil on panel, 9½ × 12 (241 × 305), Spink & Son Ltd.

'A Romantic Lake Landscape at Sunset', c.1835, oil on canvas, 13¼ × 17¼ (337 × 438), Sotheby's, 15 July 1987 (98).

'Figures on a Moonlit Balcony', c.1840, oil on canvas, approx. 12½ × 23½ (318 × 597), Private Collection, London.

'A Landscape in the Savoy', dated 1842, oil on canvas, $11\frac{1}{2} \times 13\frac{3}{4}$ (292 × 349), Sabin Galleries, London, 1974.

'A View across the Artist's Garden from his House at Exmouth', c.1855, oil on paper on card, $6 \times 8\frac{3}{4}$ (152 × 222), Mr and Mrs Paul Mellon.

'Wooded Landscape', c.1855, oil on paper, $6\frac{3}{4} \times 10\frac{1}{4}$ (171 × 260), Huntington Library and Art Gallery, San Marino, California (67.39).

WATERCOLOURS AND DRAWINGS

'Dunleary from the South', c.1812 (see 1988 cat.nos.62, 63), watercolour, $5\frac{3}{4} \times 8\frac{1}{2}$ (146 × 216), Ulster Museum, Belfast (2098).

'Mill near Beggar's Bush', c.1812 (see 1988 cat.nos.62, 63), watercolour, $5\frac{3}{4} \times 8\frac{3}{8}$ (146 × 213), Ulster Museum, Belfast (2096).

'View of the Eagle's Nest, Killarney', c.1813, watercolour over pencil, $6\frac{7}{8} \times 10\frac{3}{8}$ (175 × 264), British Museum (1982.5.15.24). One of a group of four watercolours: also 'Chepstow Castle', 'St. Vincent's Rocks from the Old Hotwell House', and 'Killarney Lake', all c.1813, Andrew Wyld, London, 1982.

'View of the Eagle's Nest, Killarney', c.1818, watercolour and pencil, $13 \times 18\frac{5}{8}$ (330 × 473), British Museum (1982.5.15.23).

'Fisherman by a River in Spate', c.1812–15, watercolour, $17\frac{1}{4} \times 22\frac{1}{4}$ (438 × 565), Andrew Wyld, London.

'Fonthill Abbey, Wiltshire', c.1813, watercolour, $9\frac{1}{4} \times 12\frac{1}{2}$ (235 × 318), Clive Wainwright.

'Bristol from the South', c.1813, watercolour and pencil, $9\frac{1}{4} \times 13\frac{1}{2}$ (235 × 343), City of Bristol Museum and Art Gallery (K1552).

'Newark Castle with Dumbarton Rock', c.1812–15, watercolour, $6\frac{3}{4} \times 9\frac{3}{4}$ (172 × 248), James Mackinnon, London.

'Dumbarton Rock from the South Side of the Clyde', c.1812–15, watercolour, $6\frac{7}{8} \times 9\frac{7}{8}$ (175 × 251), James Mackinnon, London.

'Carrick Castle, Argyllshire', c.1817 (see 1988 cat.no.69), watercolour, $12\frac{1}{2} \times 18\frac{1}{2}$ (318 × 470), Sotheby's, 16 July 1987 (95).

'The Avon from Durdham Down with Cook's Folly', c.1815 (see 1988 cat.no.66, fn.2), watercolour, $7\frac{1}{2} \times 11\frac{3}{4}$ (191 × 298), Private Collection, London.

'Blaise Castle', c.1815 (see 1988 cat.no.66, fn.2), watercolour, $7\frac{3}{8} \times 11\frac{5}{8}$ (187 × 295), Private Collection, Devizes.

'Mouth of the Avon with Penpole Point', c.1815 (see 1988 cat.no.66, fn.2), watercolour, $7\frac{3}{8} \times 11\frac{5}{8}$ (187 × 295), Private Collection, Devizes.

'Blaise Castle, near Bristol', c.1818, pencil, sepia and grey wash, $7\frac{1}{2} \times 10\frac{5}{8}$ (191 × 270), Ulster Museum, Belfast (769).

'View of Star Cross from Exmouth', c.1820, watercolour, $14\frac{3}{8} \times 26\frac{3}{4}$ (365 × 679), Sun Life Assurance.

'View from Clifton Hill, Bristol', c.1818 (see 1988 cat.no.70), watercolour, $7\frac{5}{8} \times 12$ (194 × 305), Andrew Wyld, London, 1984.

'Mouth of the Avon with Penpole Point', c.1818, watercolour, $9\frac{3}{4} \times 14\frac{3}{4}$ (248 × 375), Davis & Langdale Co. Inc., New York.

'A View near Cheddar' (sketch), c.1818, watercolour, approx. $4\frac{1}{2} \times 7\frac{1}{2}$ (114 × 191), J. W. Doney, 1973.

'Trees at Cotham, Bristol', dated 1820 (see 1988 cat.no.77), pencil, $10\frac{1}{4} \times 8\frac{3}{8}$ (260 × 213), Nicholas Guppy.

'Coastal View with Mountains and Castle – "a lesson of Danby's"', dated 1820, watercolour, 6×9 (152 × 229), Andrew Wyld, London, 1984.

'Cader Idris', c.1820, watercolour, $7\frac{3}{8} \times 11\frac{3}{4}$ (187 × 298), Thos Agnew & Sons Ltd, 1986.

'A View on the Wye', c.1820, watercolour, $7\frac{1}{2} \times 11\frac{1}{4}$ (191 × 286), City of Bristol Museum and Art Gallery (K2778).

'The Wye Valley', c.1824, watercolour, $7\frac{5}{8} \times 12\frac{7}{8}$ (194 × 327), City of Bristol Museum and Art Gallery (K4502).

'View of the Avon Gorge with the Hotwells', c.1820, watercolour, $11\frac{1}{2} \times 17\frac{1}{2}$ (292 × 445), Private Collection, Bristol.

'The River Dart One Mile below Totnes', c.1825, pencil, $7\frac{5}{8} \times 13\frac{1}{2}$ (194 × 343), Max Browne.

'Study for a painting, Orpheus', c.1840, pencil and brown ink, $4\frac{1}{4} \times 7$ (108 × 178), The Huntington Library and Art Gallery, San Marino, California (67.40).

C

Works now attributed to other artists by the compiler.

(4) 'Stoke Cottage', Samuel Jackson.

(21) 'Sunset through a Ruined Abbey', James Johnson.

(23) 'The Israelites Led by the Pillar of Fire by Night', William West.

(56) 'The Thames at Greenwich', James Danby.

(66) 'Sark: Sunset', James Danby.

(97) 'On the Avon, near Bristol', Samuel Jackson.

(107) 'A Waterfall', Samuel Jackson.

(113) 'A Woodland Pool', Samuel Jackson.

(125) 'Ancient Lake with Crescent Moon', Samuel Jackson.

(127) 'Llynydwal, North Wales', G. F. Robson.

(133) 'Orlando at the Grotto', Samuel Jackson.

(134) 'The Good Samaritan', Samuel Jackson.

(195) 'View of the Gledur Mountains . . .', Thomas Danby.

(216) 'A Welsh Stream', Thomas Danby.

D

Works which, in the compiler's opinion, are not by Francis Danby.

(21a) 'Wild Romantic Landscape' (perhaps James Johnson).

(25) 'The Deluge'.

(57) 'View from Hampstead Heath, Sunset' (perhaps W. J. Müller or J. B. Pyne).

(67) 'Shipwreck against a Setting Sun' (probably James or Thomas Danby).

(103) 'Two Girls by a Stream in a Wood' (possibly Edward Bird).

(114) 'Dark Wood above a Pool'.

(115) 'Anglers by a Woodland Stream'.

(146) 'Harbour Seascape'.

E

Works which, in the compiler's opinion, are probably not by Francis Danby:

(28) 'Mountainous Landscape at Sunset'.

(39) 'Path through a Wood with Pony-Rider'.

(52) 'St. Michael's Mount'.

(69) 'Scenic Landscape'.

(98) 'Moonlight Landscape with Figures'.

(102) 'Mountains with Afterglow'.

(106) 'Lake in Norway'.

(109) 'A Dark Rocky Lake'.

(119) 'Wooded Landscape with River'.

(141) 'Norwegian Landscape'.

Appendix II

Paintings Exhibited at the Royal Academy and the British Institution

1820 BI (246) The Upas, or Poison-Tree in the Island of Java.

1821 RA (210) Disappointed Love.

1822 RA (325) Clearing up after a Shower.

1823 RA (417) Landscape with Warriors of Old Times in England, retired to the shade of a mountain glen to hear the song of their minstrel.

1824 RA (350) Sunset at Sea after a Storm.

1825 BI (59) An Enchanted Island.
 RA (287) The Delivery of Israel out of Egypt.

1826 BI (129) Solitude, the Moment of Sunset, with the Moon Rising over a Ruined City.
 RA (305) Christ Walking on the Sea.

1827 RA (13) The Embarkation of Cleopatra.

1828 RA (234) Merchant of Venice.
 RA (340) An Attempt to Illustrate the Opening of the Sixth Seal.

1829 BI (56) Moon Rising over a Wild Mountainous Country.
 BI (67) Sunset.
 BI (356) Scene near the Falls of the Conway.
 RA (4) Subject from the Revelations.
 RA (317) Subject from the Revelations.

1831 RA (338) The Golden Age.

1837 RA (465) 'Rich and Rare Were the Gems She Wore'.

1841 RA (466) The Sculptor's Triumph.
 RA (527) Liensfiord Lake in Norway.
 RA (549) The Enchanted Castle – Sunset.

1842 RA (146) Mary Magdalen in the Desert.
 RA (229) A Contest of the Lyre and the Pipe in the Valley of Tempé.
 RA (236) A Soirée at St. Cloud in the Reign of Louis XIV.
 RA (375) The Holy Family Reposing during the Flight into Egypt-Break of Day.

1843 BI (261) Tempe.
 RA (342) The Last Moment of Sunset.

1844 BI (118) Calypso's Grotto. The Goddess Weeps the Departure of Ulysses.
 RA (305) The Painter's Holiday.
 RA (552) The Tomb of Christ Immediately after the Resurrection.

1845 BI (401) The Gate of the Harem.
 RA (272) The Wood-Nymph's Hymn to the Rising Sun.

1846 BI (46) 'The Tempest' of Shakespeare from Miranda's Description.
 BI (457) The Grave of the Excommunicated.
 RA (444) Landscape and Figures. Rasselas and Imlac.
 RA (475) Sunrise – the Fisherman's Home.
 RA (500) The Dawn of Morning.

1847 BI (3) The Lover's Walk.
 RA (530) Blackberry Pickers: A Lane in Devonshire.
 RA (586) A Seaman's Farewell.

1848 BI (1) A Calm after a Heavy Gale off Bury Head.
 BI (12) Landscape, Twilight with the Rising Moon – Death and the Old Man.
 RA (447) Caius Marius in the Ruins of Carthage.
 RA (595) The Evening Gun – a Calm on the Shore of England.

1849 BI (52) A Mountain Chieftain's Funeral in Olden Times.
 BI (446) A Misty Morning on the Sands of the Exe.
 RA (531) Morning on the Banks of Zurich Lake with Pilgrims Embarking on their Way to Einsettlin.

1850 BI (198) A Golden Moment.
 RA (573) Spring.

1851 RA (335) Winter-Sunset; a Slide.
 RA (581) A Ship on Fire: A Calm Moonlight Far at Sea.
 RA (622) A Summer Sunset. 'Home! Home!'.

1852 BI (109) A Scene in the Vale of Tempe.

1853 RA (155) A Wild Sea Shore, at Sunset.

1854 RA (34) The Departure of Ulysses from Ithaca –
Morning.

1855 RA (46) A Party of Pleasure on the Lake of
Wallenstadt in Switzerland.

RA (287) Evening 'In the Rosy Time of the Year'.

RA (563) Dead Calm – Sunset, at the Bight of
Exmouth.

1857 RA (245) The Court, Palace and Gardens of
Alcinous – a Ruddy Morning.

1858 RA (239) A Smuggler's Cove.

RA (290) The Death of Abel.

RA (521) Landscape: Ulysses at the Court of
Alcinous, going to the Athletic Games.

1859 RA (413) A Lake Scene: Going to the Fair.

1860 RA (219) Phoebus Rising from the Sea.

RA (340) 'When even on the brink of wild despair,
the famished mariner, etc.'

Artists Cited

To avoid repetition artist's dates have only been given when the artist is first mentioned in the introduction and catalogue entries.

Agasse, Jacques-Laurent, 1767–1849 *Sporting*
Allston, Washington, 1779–1843 *Landscape and History*
Ashford, William, c.1746–1824 *Landscape* Irish

Bird, Edward, 1772–1819 *Genre and History* Bristol
Blake, William, 1757–1827 *Poet and Painter*
Both, Jan, c.1618–1652 *Landscape* Netherlands
Boys, Thomas Shotter, 1803–1874 *Landscape, Watercolour*
Branwhite, Nathan Cooper, 1775–1857 *Miniature* Bristol
Brockedon, William, 1787–1854 *History*
Brown, Ford Madox, 1821–1893 *Landscape and Genre*

Calame, Alexandre, 1810–1864 *Landscape* Swiss
Callcott, Sir Augustus Wall, 1779–1844 *Landscape and Genre*
Callow, William, 1812–1908 *Landscape, Watercolour*
Campbell, John Henry, 1757–1828 *Landscape Watercolour* Irish
Claude Gellée, (Claude Lorrain), 1600–1682 *Landscape* French
Collins, William, 1788–1847 *Landscape and Genre*
Colman, Samuel, 1780–1845 *History, Landscape and Genre* Bristol
Constable, John, 1776–1837 *Landscape*
Corot, Jean-Baptiste-Camille, 1796–1875 *Landscape* French
Cotman, John Sell, 1782–1842 *Landscape*
Cumberland Sr, George, 1754–1848 *Amateur* Bristol
Cuyp, Aelbert, 1620–1691 *Landscape* Netherlands

Danby, James, 1817–1875 *Landscape*
Danby, Thomas, c.1821–1886 *Landscape*
Davis, John Scarlett, 1804–1845 or 6 *Landscape, Watercolour*
Delacroix, Eugène, 1798–1863 *History* French
Diday, François, 1802–1877 *Landscape* Swiss
Dughet, Gaspard, 1615–1675 *Landscape* French

Eagles, Revd John, 1783–1855 *Amateur* Bristol
Elsheimer, Adam, 1578–1610 *Landscape and History* German
Etty, William, 1787–1849 *Figures*

Friedrich, Caspar David, 1774–1840 *Landscape* German
Frith, William Powell, 1819–1909 *Genre and Portrait*

Géricault, Théodore, 1791–1824 *History and Sporting* French
Gold, Francis, 1779–1832 *Amateur* Bristol
Goodall, Edward, 1795–1870 *Engraver*
Greatbach, William, 1802–c.1885 *Engraver*

Haydon, Benjamin Robert, 1786–1846 *History*
Holland, James, 1800–1870 *Landscape, Watercolour*
Holmes, George, 1776–c.1861 *Landscape* Bristol
Huskisson, Robert, fl.1832–1854 *Figures*

Ibbetson, Julius Caesar, 1759–1817 *Landscape*

Jackson, Samuel, 1794–1869 *Watercolour* Bristol
Jackson, Samuel Phillips, 1830–1904 *Landscape, Watercolour*
Johnson, James, 1803–1834 *Landscape* Bristol

King, Dr John, 1766–1846 *Amateur* Bristol
King, John, 1788–1847 *History and Portrait*

Landseer, Sir Edwin, 1802–1873 *Animals*
Lawrence, Sir Thomas, PRA, 1769–1830 *Portraits*
Leslie, Charles Robert, 1794–1859 *Genre*
Lewis, Frederick Christian, 1779–1856 *Engraver*
Lewis, James, fl.1813–1837 *Engraver*
Linnell, John, 1792–1882 *Landscape*
Loutherbourg, Philip James de, 1740–1812 *Landscape and History*

Martin, John, 1789–1854 *History and Landscape*
Marvy, Louis, 1815–1850 *Engraver* French
Miller, William, 1796–1882 *Engraver*
Morland, George, 1763–1804 *Genre*
Mulready, William, 1786–1863 *Landscape and Genre*
Munier-Romilly, Amélie, 1788–1875 *Miniature* Geneva

O'Connor, James Arthur, 1792–1841 *Landscape* Irish
O'Neill, Hugh, 1784–1824 *Watercolour* Bristol

Payne, William, c.1760–c.1830 *Landscape, Watercolour*
Petrie, George, 1790–1866 *Watercolour* Irish
Peyron, Jean-François-Pierre, 1744–1814 *History* French
Phillips, George Henry, fl.1819–1852 *Engraver*
Pocock, Nicholas, 1740–1821 *Landscape and Marine* Bristol

Poole, Paul Falconer, 1807–1879 *History and Genre*
 Bristol
Poussin, Nicolas, 1594–1665 *History* French
Pyne, James Baker, 1800–1870 *Landscape* Bristol

Redgrave, Sir Richard, 1804–1888 *Landscape*
Rembrandt van Ryn, 1606–1669 *Portrait and History*
 Netherlands
Reni, Guido, 1575–1642 *History* Italian
Rippingille, Edward Villiers, 1798–1859 *Genre* Bristol
Roberts, David, 1796–1864 *Landscape*
Roberts, Thomas, 1748–1778 *Landscape* Irish
Roberts, Thomas Sautelle, 1760–1826 *Landscape* Irish
Robson, George Fennel, 1788–1833 *Landscape,*
 Watercolour

Romney, John, 1786–1863 *Engraver*
Ruisdael, Jacob, 1628 or 9–1682 *Landscape* Netherlands

Stothard, Thomas, 1755–1834 *History and Genre*

Titian, *c.*1480–1576 *Portrait and History* Italian
Turner, J. M. W., 1775–1851 *Landscape*

Wallis, Robert, 1794–1878 *Engraver*
Walter, Joseph, 1783–1856 *Marine* Bristol
West, Benjamin, PRA, 1738–1820 *History*
West, William, 1801–1861 *Landscape* Bristol
Willmore, Arthur, 1814–1888 *Engraver*
Willmore, James Tibbetts, 1800–1863 *Engraver*

Lenders